Harold!

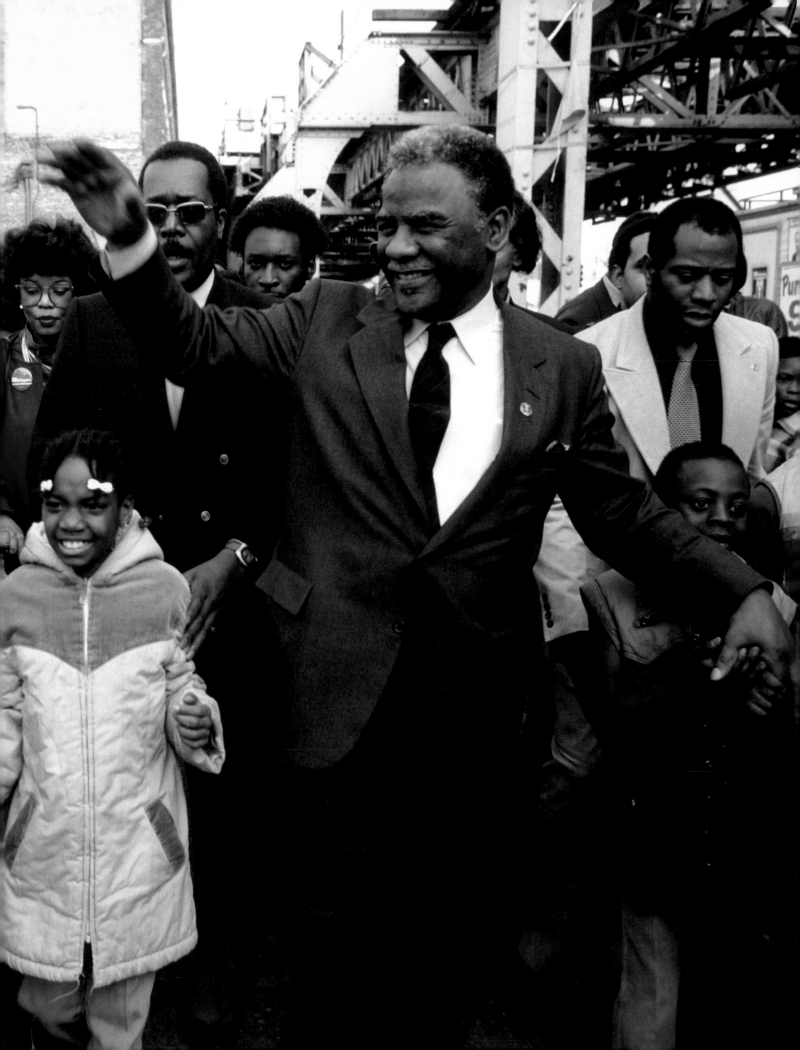

Harold!

PHOTOGRAPHS FROM THE HAROLD WASHINGTON YEARS

Photographs by **ANTONIO DICKEY AND MARC POKEMPNER** Text by **SALIM MUWAKKIL**

NORTHWESTERN UNIVERSITY PRESS EVANSTON, ILLINOIS

Northwestern University Press
www.nupress.northwestern.edu

Printed in Canada

10 9 8 7 6 5 4 3 2 1

Library of Congress Cataloging-in-Publication Data
Harold! : photographs from the Harold Washington years /
 photographs by Antonio Dickey and Marc PoKempner ; text by
Salim Muwakkil.
 p. cm.
 Includes bibliographical references.
 ISBN-13: 978-0-8101-2446-2 (pbk. : alk. paper)
 ISBN-10: 0-8101-2446-7 (pbk. : alk. paper)
 1. Washington, Harold, 1922–1987—Pictorial works. 2. Mayors—
Illinois—Chicago—Pictorial works. 3. Chicago (Ill.)—Politics
and government—1951– —Pictorial works. I. Dickey, Antonio.
II. PoKempner, Marc, 1948– III. Muwakkil, Salim.
F548.54.W36H37 2007
977.3'11043092—dc22

 2007017826

The publication of *Harold! Photographs from the Harold Washington Years*
commemorates the twentieth anniversary of Harold Washington's death
and the twenty-fifth anniversary of his first election as mayor.

Edited by Ron Dorfman

CONTENTS

ACKNOWLEDGMENTS

This book has been several years in gestation, and many people in addition to those whose names are on the title page have had a hand in shaping it.

Salim Muwakkil is especially grateful to Conrad Worrill, coordinator of the Center for Inner City Studies at Northeastern Illinois University; to Timuel Black, professor emeritus of social sciences at the City Colleges of Chicago; and to Gary Rivlin, author of *Fire on the Prairie* (and currently a reporter with the *New York Times*)—all of whom offered the benefit of their valuable experience in providing context for the story of Harold Washington.

For Antonio Dickey, it was the late mayor himself who provided first inspiration and then a career at City Hall. He thanks mentors Norman Hunter, art director at *Jet* magazine, and Metz Lochard, editor of the *Chicago Defender,* both of whom gave inspiration early in his career. Tony also wishes to acknowledge the support of his children, Christopher and Jennifer.

Marc PoKempner thanks his colleagues at the *Chicago Reader* and *In These Times,* especially David Moberg and Gary Rivlin, who made him look smart and diligent by association; Ben Cate and Susie Kellett at *Time* magazine and Linda Witt at *People* magazine, who kept him on the story; and Mark Bussell at the *New York Times Magazine,* who understands the meaning and power of photographs better than anyone else. The enlightened policies of all these publications allowed photographers to retain ownership and control of their work, without which this publication would not have been possible. Marc is also grateful to Hui Min Tsen for her dedicated and

intelligent work fine-tuning and tracking his images, to Debra Evenson for years of encouragement, and, of course, to Harold Washington for inspiration.

The book could not have happened absent the diligence and professionalism of Donna Shear, Serena Brommel, Marianne Jankowski, and their colleagues at Northwestern University Press. Many thanks also to Northwestern alumnus Fred Eychaner for his early and generous support of the project.

The contributors are much obliged for the valuable but freely dispensed advice of Mitch Rogatz, president of Triumph Books, on distribution; Laurie Glenn-Gista on marketing; and Hayward Blake on graphic design. Jeanne Kracher, executive director of the Crossroads Fund, kept us on the right side of the Internal Revenue Service. Mary Gerace has ably undertaken the coordination of events for a Harold Washington commemorative year encompassing the twentieth anniversary of his death and the twenty-fifth anniversary of his first election as mayor.

Finally, Ron Dorfman shepherded this project from conception through completion as its editor. The contributors are immensely grateful for his efforts.

NOTE ON SOURCES

I met Harold Washington directly after the death of Mayor Richard J. Daley in 1976. I was a reporter for an alternative publication and was covering the dispute over attempts by Wilson Frost to temporarily assume the suddenly vacant mayor's office. Frost, an African American, was an alderman and the president pro tem of the city council. According to constitutional procedure, the council's pro tem was temporarily to serve as chief executive in the mayor's absence. A fatal heart attack rendered the mayor suddenly absent, but Daley's vaunted political machine barred Frost from performing even symbolic duties. Washington was a state senator at the time and was among several black legislators protesting Frost's treatment as a racist double standard. The others readily acceded to his leadership; I was impressed by his confidence and poise, and, memorably, his vocabulary. He tossed around words and phrases like "transgress" and "intransigent" and the "culture of totalitarianism" as if he said them regularly. He had the passion of an insurgent but obviously was practiced in the art of practical politics. I avidly followed his career from that point until his death, and much of this text is informed by my attentive gaze.

I was informed also by other texts, including *The Making of the Mayor: Chicago, 1983,* edited by Melvin G. Holli and Paul M. Green; *Chicago Divided: The Making of a Black Mayor* by Paul Kleppner; *Chicago Politics, Ward by Ward* by David K. Fremon; *"Harold": The People's Mayor* by Dempsey Travis; *Fire on the Prairie: Chicago's Harold Washington and the Politics of Race* by Gary Rivlin; *Bitter Fruit: Black Politics and the Chicago Machine,*

1931–1991, by William J. Grimshaw; and the Chicago Public Library's Harold Washington archives and collections.

My rendering of Chicago's history was the combined product of *Land of Hope: Chicago, Black Southerners, and the Great Migration* by James R. Grossman; *The Encyclopedia of Chicago,* edited by James R. Grossman, Ann Durkin Keating, and Janice L. Reiff; *Compton's Encyclopedia; The Autobiography of Black Chicago* by Dempsey Travis; and "History of Chicago from Trading Post to Metropolis," Roosevelt University External Studies Program Web site.

Salim Muwakkil

Harold!

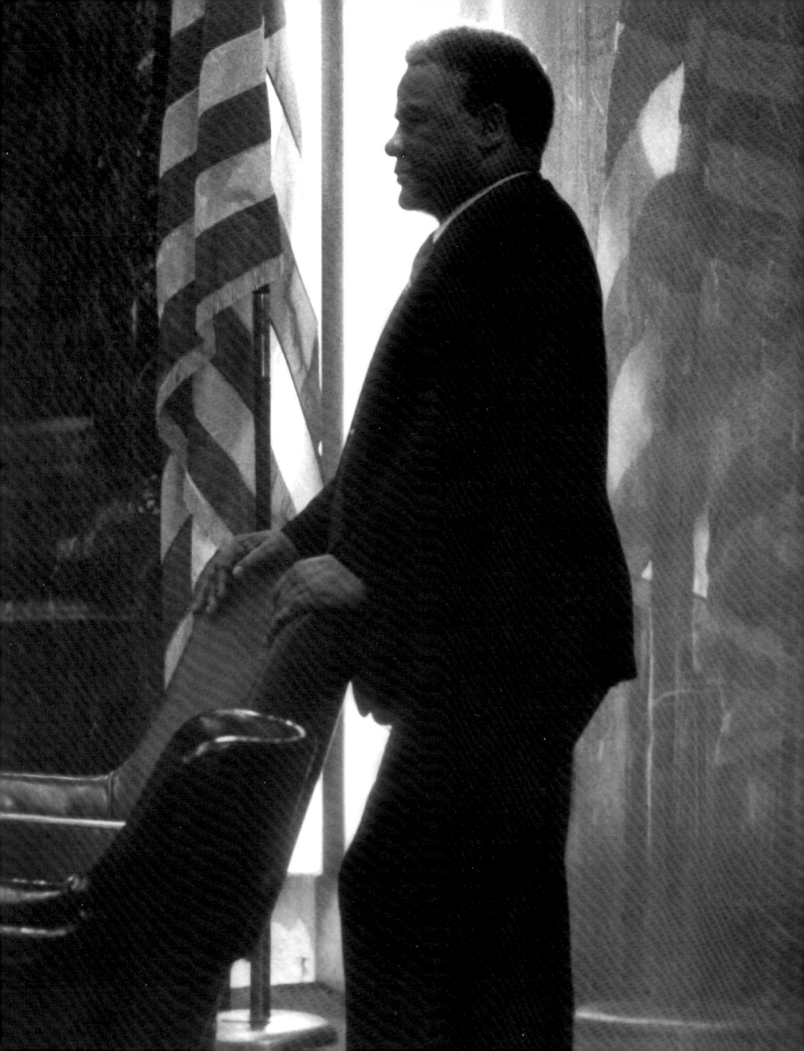

Introduction

Harold in History Harold Washington
was the kind of guy who could resurrect the great man
theory of history. Formulated in 1841 by Scottish historian
Thomas Carlyle, who held that "the history of the world is
but the biography of great men," the theory has been eclipsed
by the modern idea that great individuals are the product
of historical forces. And, of course, the rise of Chicago's
first black mayor was part of a larger freedom narrative.
But historians who examine the life of this pivotal political
figure—reflecting on the power of his personality, the scope
of his influence, and the void left by his 1987 death—might be
excused for giving Carlyle's notion a second look.

Washington was born and raised in Chicago and well
schooled in machine politics by his father. Young Washington
served as a precinct captain and became an outstanding
member of the state legislature. His journey to national
prominence certainly was aided by decades of dedicated
effort, but if ever there was a man in the right place at the
right time, it was Harold Washington. This book attempts to
highlight the unique convergence of man, place, and time.

After six distinguished terms in the state legislature (five as
a state representative and one as a senator), Washington was
elected to represent Illinois' First Congressional District in 1980,
the same year that the nation elected conservative Republican
Ronald Reagan as president. The Reagan campaign employed
a "southern strategy" that exploited the white electorate's
anger at the Democratic Party's embrace of civil rights. It was
a successful tactic; a broad white backlash powered Reagan's
victory, and his administration catered to that constituency.

By the time of his reelection to Congress in 1982, Washington had earned a national reputation as an eloquent critic of the Reagan administration's conservative policies. His national star was rising, so his reluctance to answer black Chicagoans' call to return home to run for mayor was understandable. Washington's destiny was tied too tightly to Chicago for him to resist completely, but he set high hurdles for those trying to draft him into a fight with the Chicago machine.

His supporters met his conditions and exuberantly launched the Washington crusade. He campaigned both as a racial candidate (Washington's bold expressions of racial pride distinguished him from the race-neutral norm) and as a political reformist. African Americans across the nation saw the Washington campaign as another step in the civil rights movement. Political reformers considered it a populist and progressive challenge to the encrusted corruption of machine politics. During a time when conservative forces were amassing national political power, a progressive prairie fire in the heartland gave hope that all was not lost.

Washington's opponents in the 1983 primary election were incumbent mayor Jane Byrne and Cook County state's attorney Richard M. Daley. Daley was the son of the legendary mayor Richard J. Daley, who died in office in 1976. Byrne, Chicago's first female mayor, had won the first regular election held after the elder Daley's death.

Byrne and Daley basked in the headlines, while Washington's candidacy sailed under the media radar. Late in the election campaign, however, Cook County Democratic Party chairman Edward R. Vrdolyak, on Byrne's behalf, warned white Democratic precinct captains that "a vote for Daley is a vote for Washington . . . It's a racial thing," he said, reducing the contest to a primal struggle for tribal dominance. "Don't kid yourself."

It turns out Vrdolyak was right; most of the white vote split between Byrne and Daley. Washington pulled about 85 percent of the black vote and 20 percent of the Latino vote to become the Democrats' first black mayoral nominee.

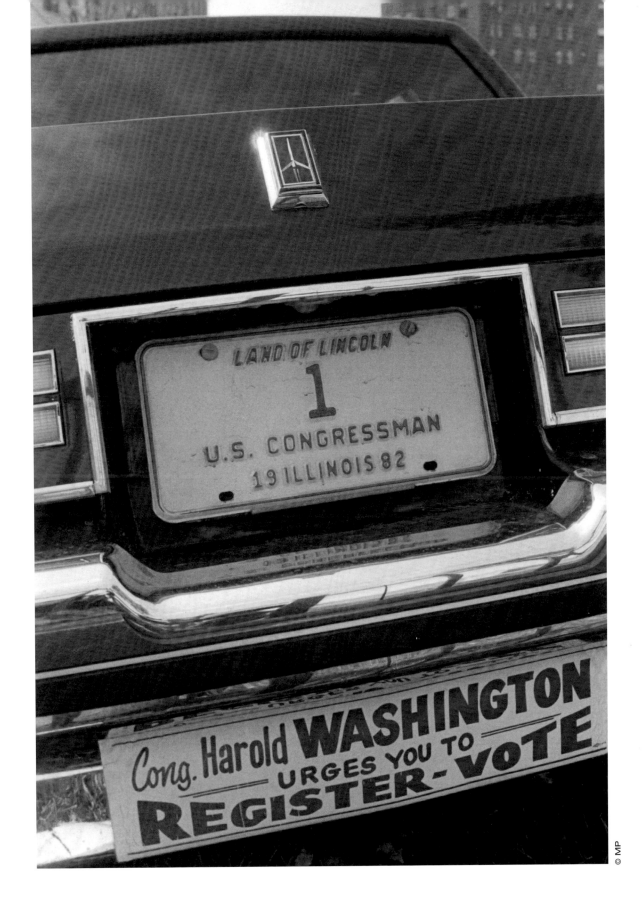

© MP

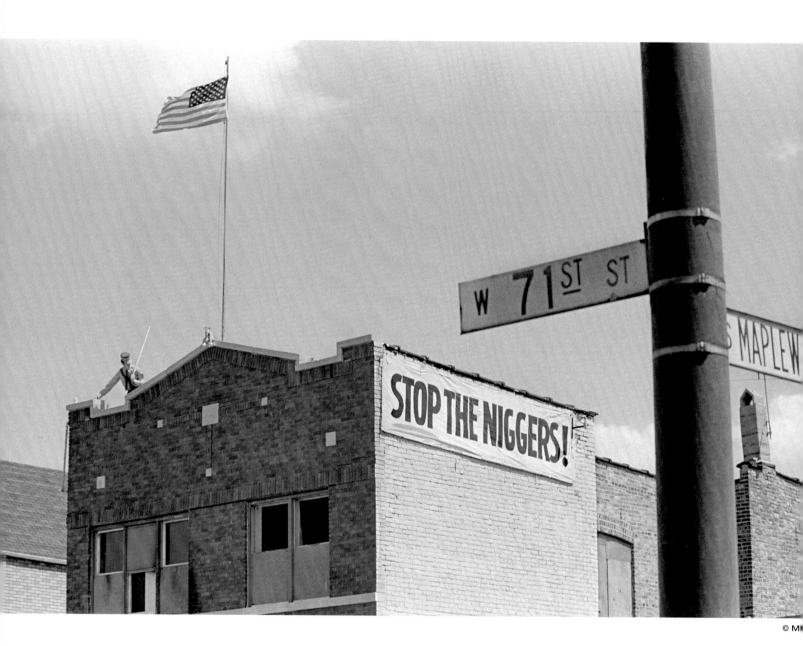

© MI

Neo-Nazi headquarters in the Marquette Park section of
Chicago, July 4, 1977. The Southwest Side neighborhood
became synonymous with resistance to open housing.

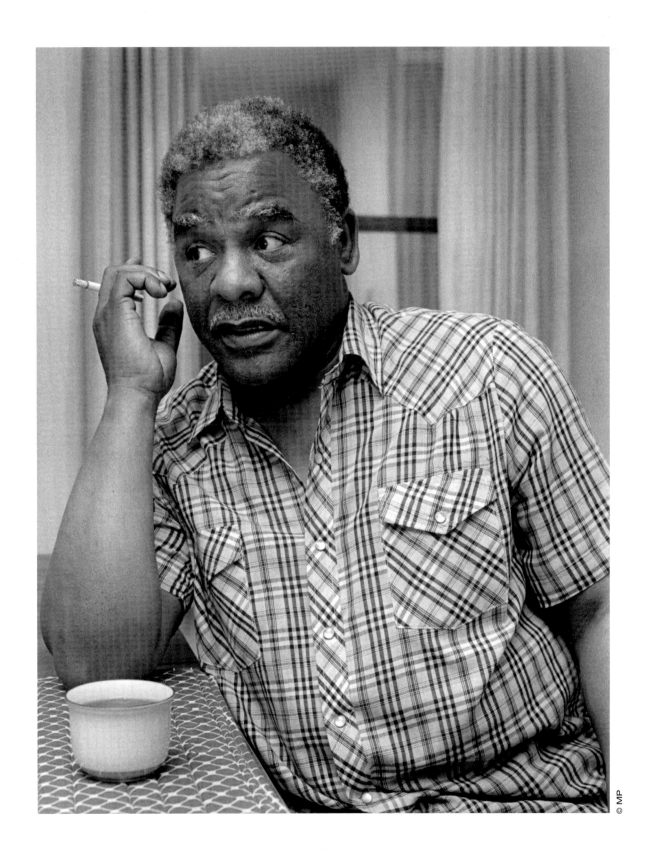

Margaret Burroughs

"I just think he was the best thing that ever happened to Chicago . . . Politics will never be the same as it was before Harold came on the scene. And . . . he left his legacy . . . Everybody has to go sooner or later. Hopefully some later. But he left his legacy and he made a contribution, which will always be remembered . . . And he's still with us. Because the spirit never dies."

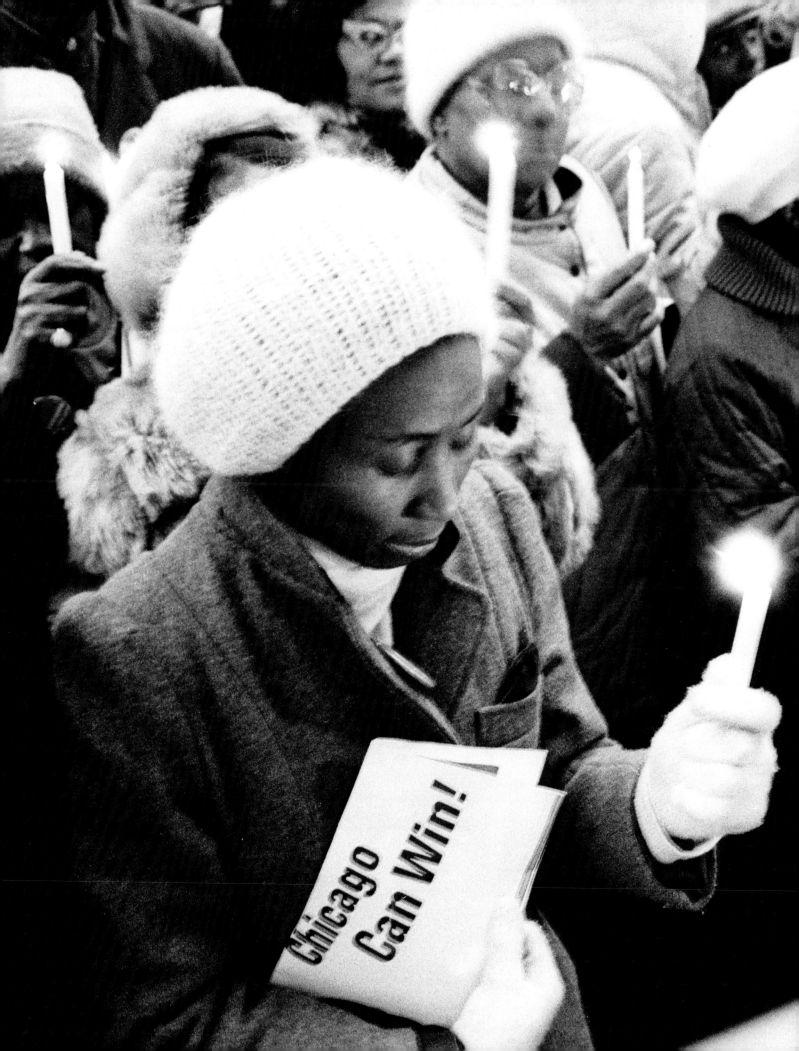

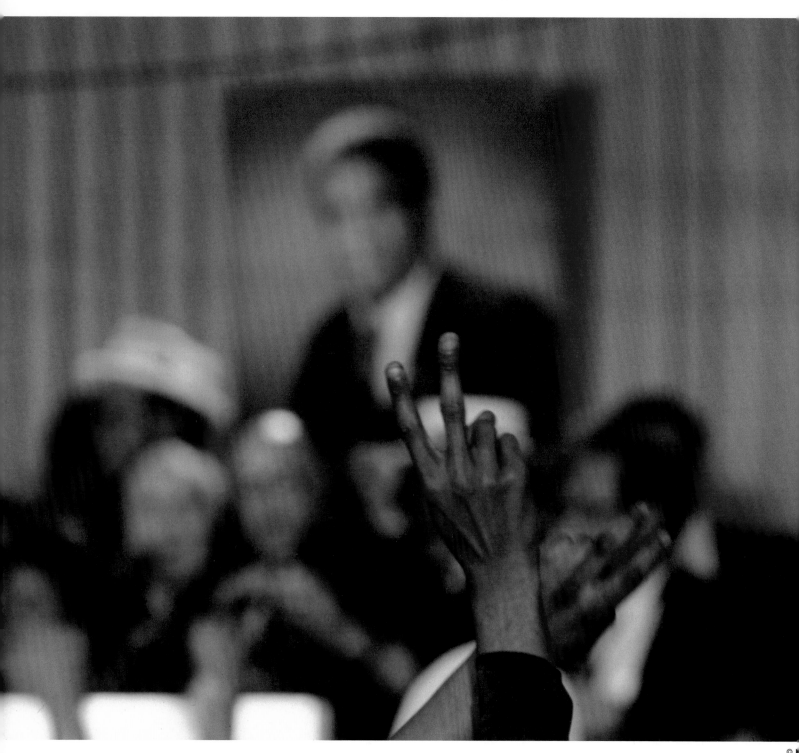

© N

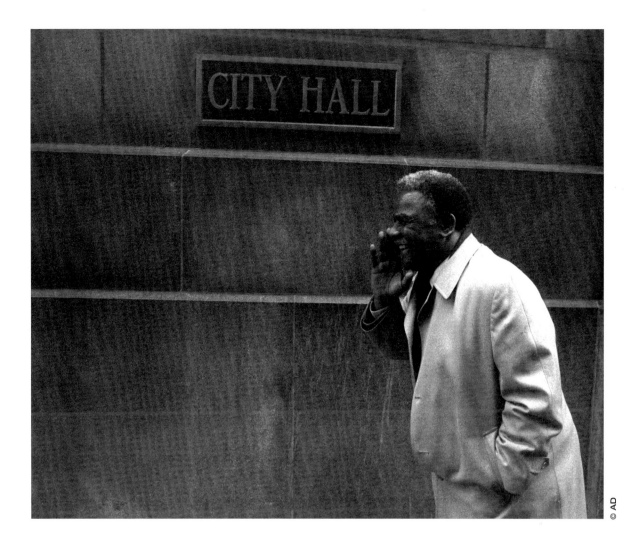

The stupefied reaction of the press and most of the white public to Washington's primary victory presaged the ugly racial politics of the general election campaign. That fray drew international attention, due largely to the expressions of bigotry that blighted the campaign. Chicago's white electorate, which had become famous (even infamous) for its rock-solid support of Democrats, began to change political parties. Even party chairman Vrdolyak supported the suddenly popular Republican candidate, a formerly obscure state legislator named Bernard Epton. His campaign slogan was "Epton, before it's too late."

Harold Washington stakes out territory in the Loop in the closing days of the 1983 mayoral primary campaign.

Every available space was commandeered for the "Punch 9" message, an easily remembered way of locating Washington's line on the 1983 Democratic primary ballot. "Punch 9" was also repeated frequently on local African American talk radio.

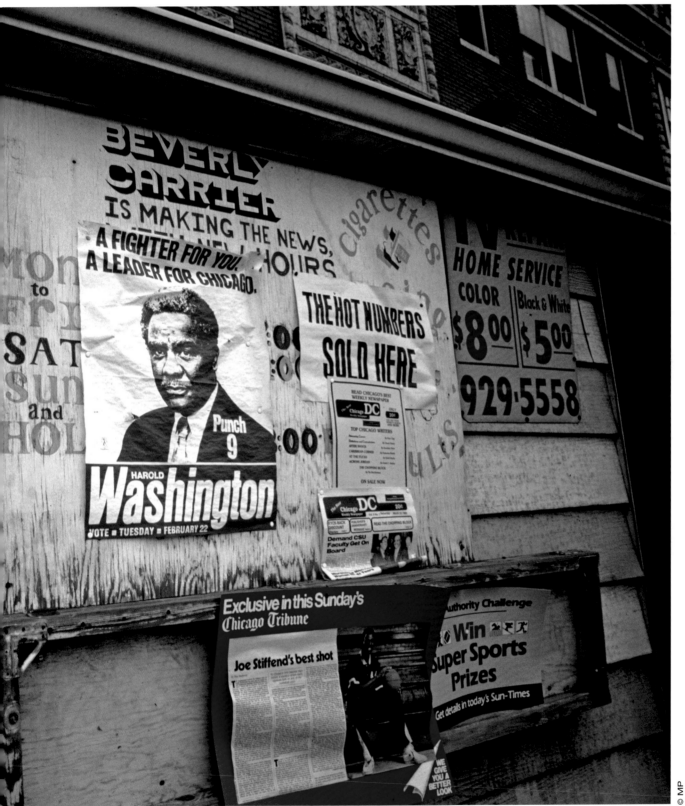

Washington reached out to local communities (*below*) and to national audiences, with appearances such as his 1985 speech to the U.S. Conference of Mayors (*overleaf*).

Virtually every black voter chose Washington in that historic general election. With more than half of the Latino vote and about 12 percent of the white vote, he slipped by to become Chicago's first black mayor. Mayor Washington outlined an ambitious agenda, listing public housing, affirmative action, and the destruction of patronage as his highest priorities.

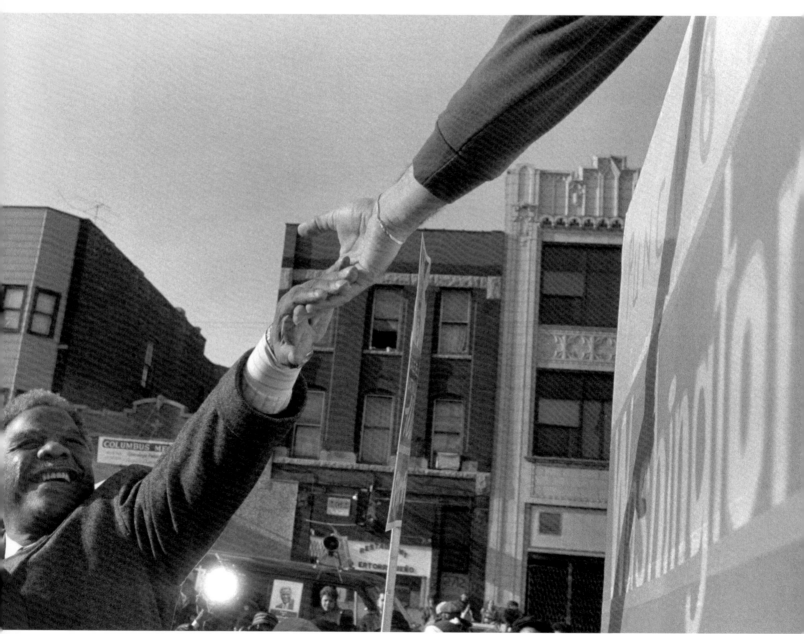

But many of his reform policies were blocked by what became known as Council Wars. On one side of this conflict were twenty-nine aldermen (one Latino and the rest white) loyal to remnants of the political machine, and on the other side was a multiracial group of twenty-one, known as the Washington reformers. This raucous political rivalry earned Chicago the moniker "Beirut on the Lake." But through it all, the charismatic Washington continued pushing for progressive changes, gaining converts as he demonstrated commitment to fair and transparent government. A special aldermanic election in 1986 changed the composition of the city council and allowed Washington to fully engage his agenda just a year before the end of his first term.

Mayor Washington outlined an ambitious agenda, listing public housing, affirmative action, and the destruction of patronage as his highest priorities.

Washington's reelection effort focused on his progress in the face of a determined and flagrantly obstructionist opposition. Although the racist attacks on Washington subsided a bit in the 1987 campaign, there was a racial subtext nonetheless. After solidly defeating former mayor Byrne in the primary, Washington had to confront two former Democratic officials who had formed entirely new parties just to challenge the African American incumbent. Even the Republican candidate was a former Democrat. The city's first black mayor won reelection with just a bit more of the white vote than he got the first time, but he solidified his hold on black voters and the Latino electorate.

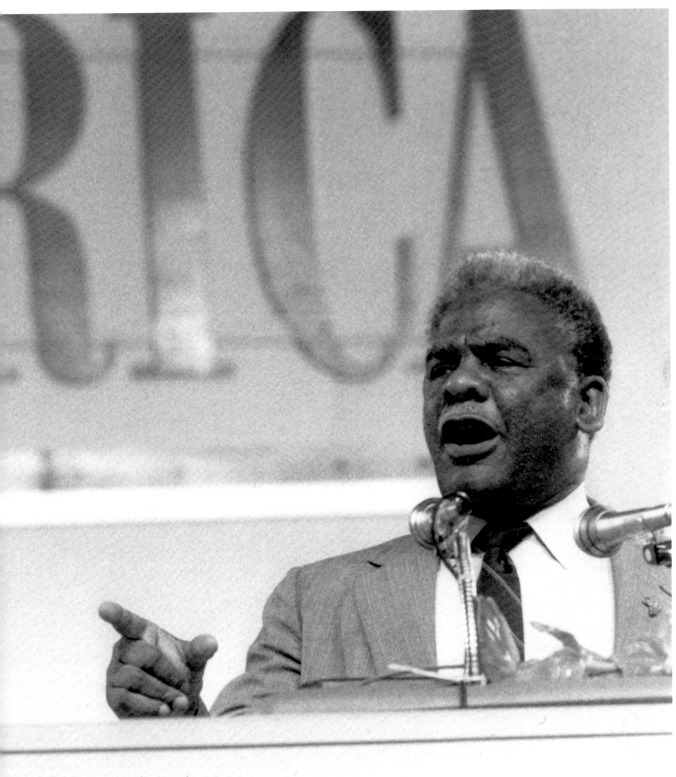

Following Washington's death, the coalition he constructed collapsed and has not been seen since.

Political momentum was moving in Washington's direction, and his second term seemed promising. He had broadened his electoral coalition and gained the city council majority. The Daley machine finally seemed to lose its grip on municipal power, and Harold Washington was poised to pick up the reins and steer a new progressive course. Then a massive heart attack felled Washington the day before Thanksgiving 1987, just seven months into his second term. His sudden death traumatized black Chicagoans, many of whom had begun to place Washington in the pantheon of African American luminaries. Soon it became clear that Chicago's first black mayor was not just a local hero. His charismatic presence and widening reputation as a people's intellectual gave him a personal appeal that spanned geography and social class. His principled struggle against racist opposition and machine politics—and his eventual triumph—inspired activists of all stripes and provided hope for successful multiracial alliances.

During his tenure, Washington opened city government to those previously excluded, he unified the black electorate into a powerful and influential political force, and he unleashed the forces of reform on many aspects of municipal government. But Washington's coalition was a collection of disparate interests brought together only by his unique appeal; he harmonized a cacophony of political voices.

Twenty years have passed since his death, and several books have chronicled the Washington years, but something about Harold—which is how nearly everyone refers to him still— remains mysterious. A certain quality of his voice, the range of his rhetoric, a particular hand gesture, a peculiar tilt of the head, all connoted an intangible something that distinguished him from other leaders.

Following his death, the coalition he constructed collapsed and has not been seen since. Many aspects of Washington's brief shining moment are reflected in *Harold!* When you close this book, ask yourself if Carlyle's theory of great men sounds a bit more reasonable.

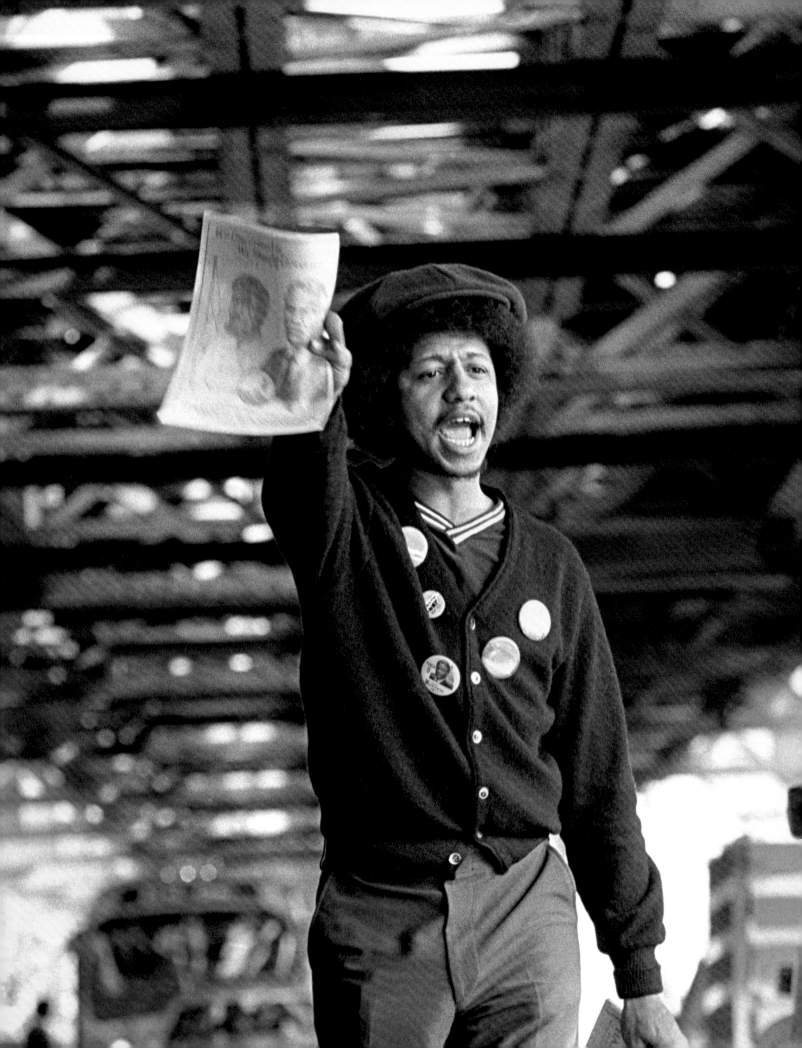

1!

Black Chicago Awakens

Black people have lived in Chicago since 1779, the year Jean Baptiste Pointe DuSable, a Haitian-born fur trader, established the first permanent non–Native American settlement at the mouth of the Chicago River. DuSable had observed the Potawatomi people using the area as a staging point for water trade with other groups and concluded it was a good spot to settle. The United States government later concurred with DuSable when it set up Fort Dearborn near his settlement in 1803. The Potawatomi called the region Chicago (meaning "stinking wild onions"). Settlers seized both the area and its name from the Native Americans, chartering Chicago as a city in 1837. According to the census, the population was nearly 4,200 people by that time—seventy-seven of whom were black.

Like the Potawatomi, Chicago's new inhabitants used the area as a conduit for fur, grain, and lumber, and the busy young city grew rapidly. Antebellum laws restricting black migration to Illinois limited the black population. The number of black residents was probably much higher than the official count, however; as one of the major stops on the Underground Railroad, Chicago attracted many fugitive slaves. The Illinois and Michigan Canal opened in 1848, and later that year the first real railway began operation. By the mid-1850s, Chicago's commercial vitality and new rail links to eastern cities sparked a remarkable spurt of growth in population from the 4,200 of 1837 to about 110,000 in 1860. The city supplied horses, food, and other goods to the Union army during the American Civil War, which led to the opening of the Union Stock Yards in 1865, another robust industry that helped define Chicago

Opposite: Young people long estranged from the political process were energized by the Washington movement. Under the El tracks on Sixty-third Street, this young man passes out campaign literature bracketing Chicago history between Jean Baptiste Pointe DuSable and Harold Washington.

for many years. Several steel mills sprang up on the city's southeast border to manufacture the era's most popular building material. The founding of the Chicago Board of Trade in 1848 transformed the city into a major center for stock and commodities trading as well.

Chicago's industrial bustle attracted many more people than the city could comfortably accommodate. That forced city leaders to build thousands of flimsy, balloon-frame homes that became ready kindling for the Great Chicago Fire of October 8, 1871. The fire knocked out about a third of the city, including much of the commercial downtown. Because of the widespread destruction, the city adopted a freewheeling attitude and encouraged architectural innovation in its reconstruction. Chicago rebuilt quickly, and by 1890, the population had reached more than a million and grew rapidly during the next several decades.

Chicago gained a reputation as the "can-do" city, a gritty, smoke-belching metropolis where resilient people made things and made things work. The city's industrial vitality also nurtured a sense of labor militancy. Frequent worker strikes disrupted operations of many local industries; the strikes were enthusiastic and sometimes violent. Notably, Chicago was the site of the 1886 Haymarket Riot, during which a bomb exploded during a labor rally for the eight-hour workday. This industrial metropolis nurtured and honed notions of worker solidarity that crystallized the nation's labor movement. But Chicago wasn't all brawn and no brain.

Opposite: **Even as late as the early 1970s, residential segregation, overcrowding, and poverty in the Black Belt left some areas, like this one on the Near South Side, looking like the Deep South during the Great Depression.**

More than half a million southern blacks made the journey north in just the years 1916 to 1919, beginning what is now routinely referred to as the Great Migration.

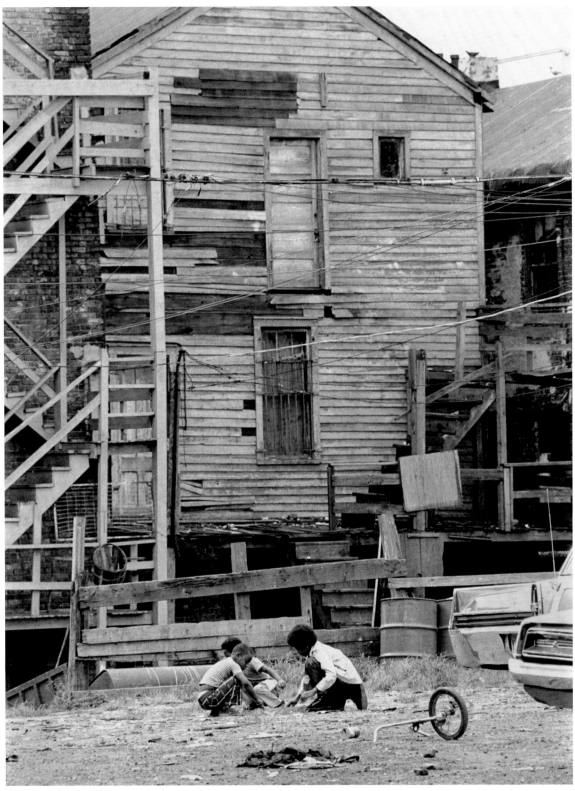

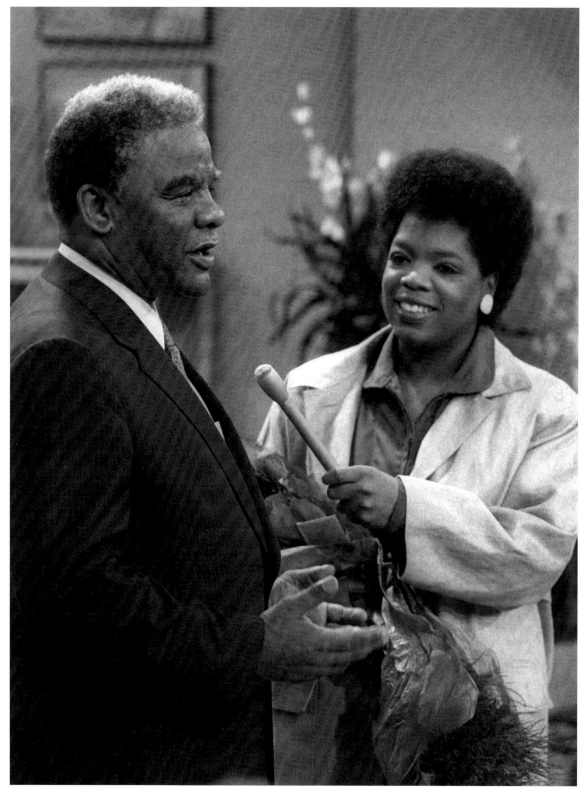

24 **Harold!**

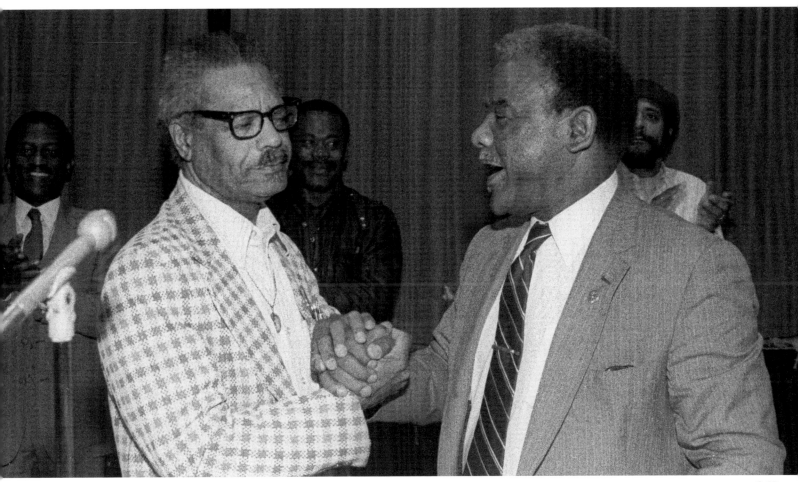

Black migration from the South tapered off, but there were always new arrivals contributing
to the vibrancy of Chicago's black community. Harold Washington was a native Chicagoan
raised in a middle-class black community, whereas Oprah Winfrey (*opposite*) escaped
poverty in Kosciusko, Mississippi, to become the embodiment of "beyond race" celebrity,
while Lu Palmer (*above*), a native of Newport News, Virginia, was progressively radicalized
until, in the 1980s, he became a leading Chicago exponent of black nationalism.

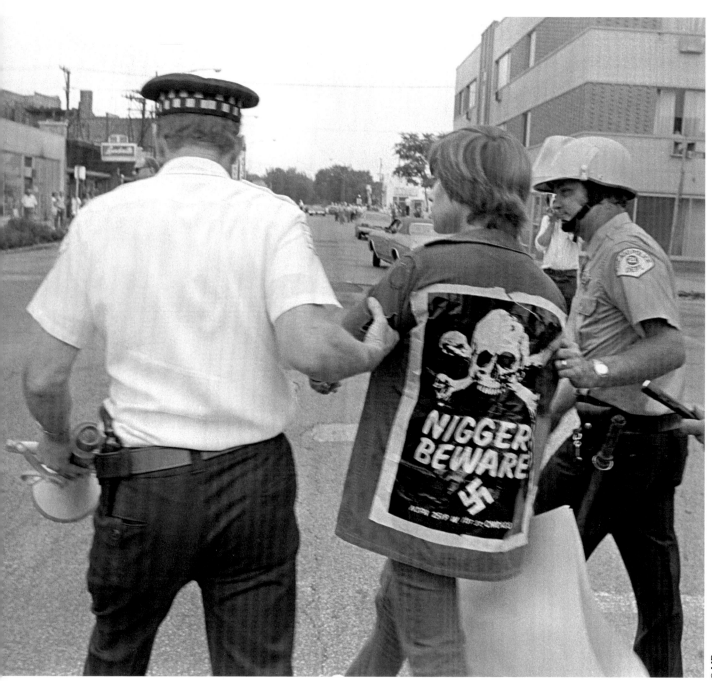

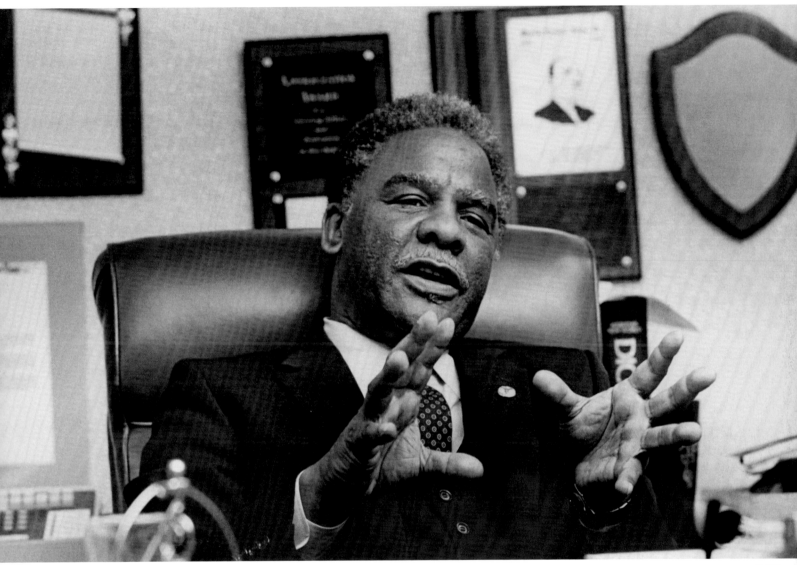

Above: Harold Washington in his congressional office in 1981, framed by numerous awards from grateful civic organizations and with a dictionary always close at hand. *Opposite:* The black South Side was sharply divided from white neighborhoods like Marquette Park, where this neo-Nazi youth was arrested after a disturbance at a 1976 demonstration.

Religious groups founded Northwestern University (the Methodist Episcopal Church) and the University of Chicago (the Baptist Church) in the 1850s. The Chicago Conservatory of Music, the Chicago Academy of Music, and the Academy of Design came along about twenty years later to bolster Chicago's cultural credentials. Innovative reconstruction efforts after the disastrous fire transformed Chicago into a global leader in architecture; it became known as the city of skyscrapers. This new industrial behemoth also turned out to be an audacious technical innovator—city engineers actually reversed the flow of the turbid Chicago River to divert sewage from Lake Michigan, from which Chicago drew its drinking water.

Following the Civil War, African Americans began dribbling into the city in incremental numbers. By the turn of the century, there were about thirty thousand blacks out of a total population of more than one million. World War I produced an economic boom and a severe labor shortage because the war cut off the flow of European immigrants. The shrinking labor pool forced many firms to turn to the rural South, recruiting black workers made increasingly irrelevant there by agricultural automation. More than half a million southern blacks made the journey north in just the years 1916 to 1919, beginning what is now routinely referred to as the Great Migration. From southern cities, towns, and farms they came pouring into any northern city where jobs were available. Many northern cities competed for these southern workers, and the black populations of Chicago, New York City, Detroit, and Philadelphia skyrocketed during this period. Because of its wide array of industries, especially meatpacking and steelworking, Chicago was foremost in the minds of many southern migrants seeking new employment opportunities. Glowing tales of prosperity and partying, spread far and wide by the black-owned *Chicago Defender,* burnished the city's allure. Between fifty and seventy thousand black southerners relocated to Chicago from 1916 to 1919.

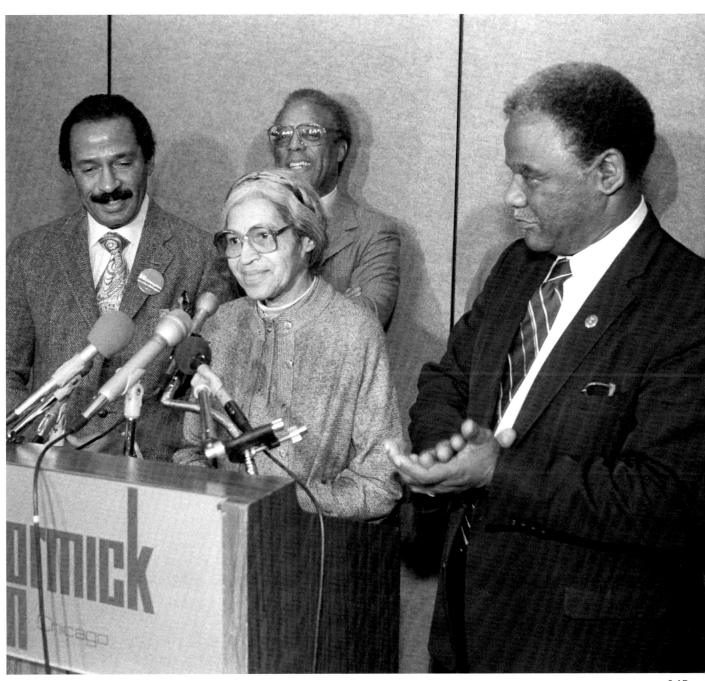

Candidate Washington gets a boost in the 1983 primary
from Michigan congressman John Conyers Jr. (*left*),
Illinois state senator Richard Newhouse (*rear*), and,
at the microphone, civil rights heroine Rosa Parks.

As the black population increased, migrants were channeled into one distinct residential area—the South Side Black Belt, now romanticized as "Bronzeville." The city already had been carved up into bitterly divided ethnic enclaves; Irish, Serbian, German, Polish, and Scandinavian neighborhoods were starkly partitioned, and ethnic encroachment was resisted, sometimes violently. And though divisions were intense, competing European immigrants found a consensus in their dislike of African Americans. This was codified in 1917, when the Chicago Real Estate Board appointed the Special Committee on Negro Housing to officially restrict blacks' encroachment into white neighborhoods. By 1920, about 85 percent of the city's burgeoning black community was confined to the small Black Belt area.

Rigid residential segregation served to create a self-reliant black community.

But this rigid residential segregation also served to create a largely self-reliant black community. Lawyers, teachers, doctors, accountants, and other black professionals shared residential space with blue-collar and service workers. The Black Belt's business districts were filled with black-owned businesses and the offices of black doctors, lawyers, and dentists. The entertainment venues throbbed with people attracted by the talents of black musical and comedic giants. Sidney Bechet and Jelly Roll Morton were two of the many musical geniuses who regularly played clubs along "The Stroll," the South Side's storied entertainment district. This cultural and economic vibrancy gave credence to the notion of an alternative black community, deliberately distinct from white Chicago. That sense of autonomy helped elect real-estate developer Oscar DePriest as the city's first black alderman in 1915. Thirteen years later, DePriest had expanded his political base enough to become the first black congressman ever elected from the North.

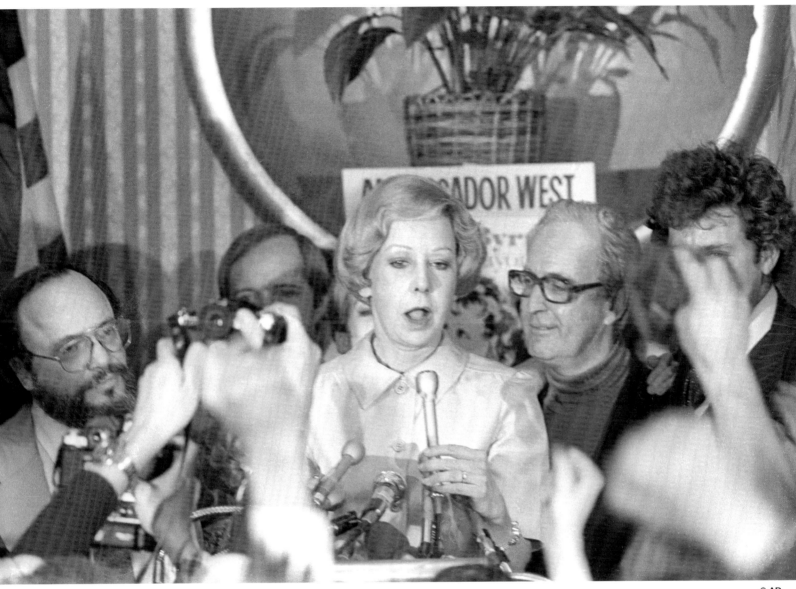

Here Jane Byrne claims victory during her 1979 Ambassador
West election-night party with campaign manager Don Rose
(*at left*) and Byrne's husband, Jay McMullen, the former
Chicago Daily News City Hall reporter (*at right*). Byrne's
victory was secured with an outpouring of votes from a
black electorate angered by the machine's neglect.

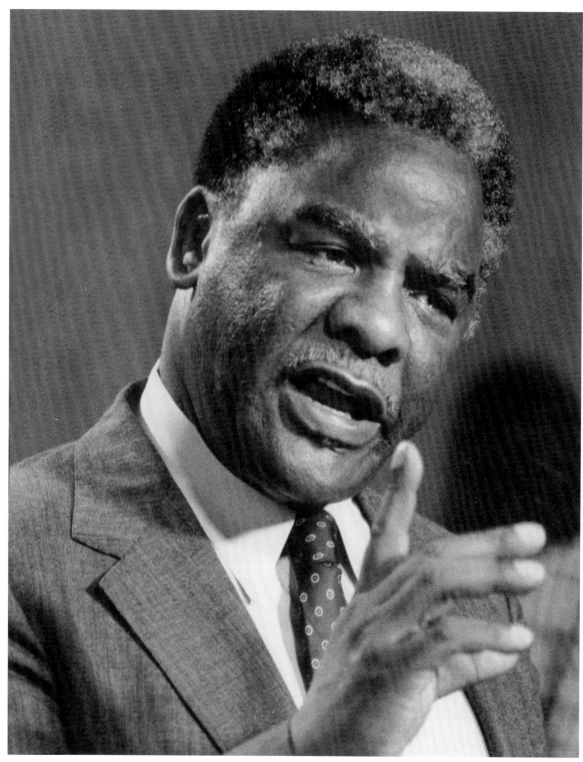

But the racial divisions for which Chicago later became famous were already festering. Many black migrants were first recruited by "labor agents" to work as scabs replacing striking white workers. The black southerners who surged into the city during World War I were still there when the white servicemen they had replaced came home. Fierce economic competition added hostility to the tense relationship between African Americans and European immigrants and exacerbated the antiblack biases already embedded in America. Chicago began spawning militant African American leaders and attracting others. By 1878, Ferdinand L. Barnett had founded the *Conservator,* the city's first black newspaper, a publication that proudly championed racial solidarity and militant protest. Barnett later married Ida B. Wells, the well-known antilynching activist who left the South to write and crusade from Chicago against mob violence and for women's suffrage. The couple's militant campaign became the *Conservator*'s primary mission. Barnett's example helped motivate Georgia-born Robert S. Abbott to launch the *Chicago Defender* in 1905. The *Defender* took up Barnett's banner by boldly challenging racist violence and other obstacles to black progress, eventually becoming the most widely circulated black newspaper in the country. Other African American entrepreneurs caught the spirit and started their own newspapers, providing black Chicago with several vibrant publications. The *Chicago Whip,* for example, sparked a successful "Spend your money where you can work" campaign in 1929, targeting chain stores that wouldn't hire blacks; the campaign caught on with African Americans across the country.

African Americans in the "city on the lake" were gaining a national reputation for forthrightly challenging the racist status quo.

African Americans in the "city on the lake" were gaining a national reputation for forthrightly challenging the racist status quo. Their assertive spirit provoked some racial tensions that occasionally led to physical confrontations. In July of 1919, the city's seething racial cauldron exploded into an orgy of violence. The proximate cause was the death of a black youth who drowned after being attacked while swimming in a designated white area of Lake Michigan. This triggered five days of rioting, took the lives of twenty-three blacks and fifteen whites, and injured 537 more, mostly blacks. Although the outbreak was hardest on their community, African Americans took a measure of pride in the fact that they fought back. That reputation bolstered the image of Chicago's black community as one of the most self-confident and self-sufficient in America. Similar fights broke out in other parts of the country as well, causing some historians to characterize the summer of 1919 as the "red summer."

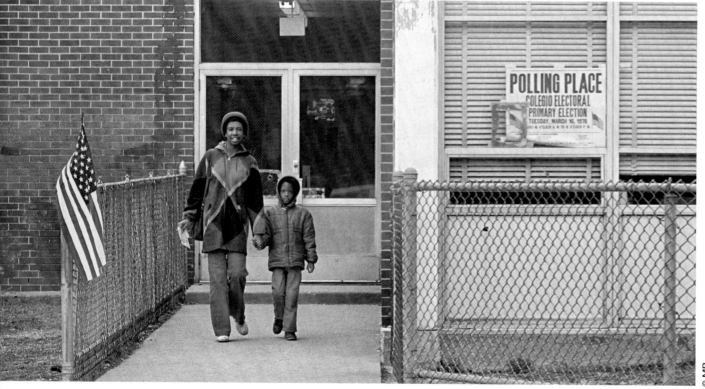

© MP

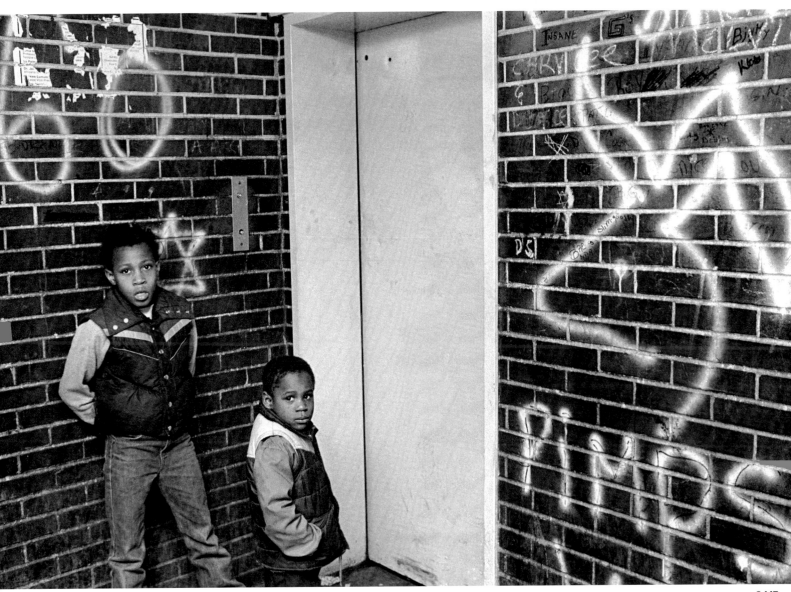

The deteriorating condition of much of Chicago's public housing was a major reason for the black community's resistance to the Democratic machine, toppling first Bilandic and then Byrne. Elevators like this one at the Robert Taylor Homes frequently malfunctioned.

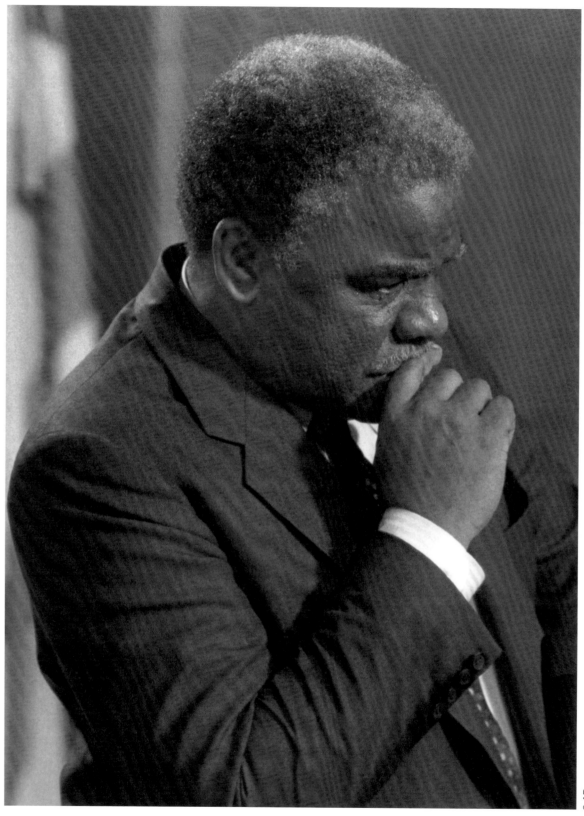

36 **Harold!**

Harold Washington was born amid this tumult in 1922, the last of Roy and Bertha Washington's four children. Roy Washington was a lawyer, a Methodist minister, and an active precinct captain. He instilled in his son a love of education, reading, and public service; he also modeled a way of speaking to both secular and church audiences—a talent that would come in handy in Harold's later political career. Harold Washington seldom discussed his personal history, but close friends knew that his parents divorced when he was very young, and he lived with his father afterward. He often spoke admiringly of his father. "I was very fortunate. My father was my role model," he told one audience during a political campaign. "He was a real man, he was a good man. For many years he was not only my father, he was my mother . . . He came home every night, put his feet under the table, and had dinner with me."

"I was very fortunate. My father was my role model."

Washington briefly attended a boarding school in Milwaukee and then Forestville Elementary School in Chicago's Third Ward. He then went to DuSable High School, where he gained fame as a high hurdler and middleweight boxer. Washington didn't graduate from DuSable but joined the Army Air Corps, where he earned a high school equivalency diploma and reached the rank of first sergeant during his four-year tenure. He used the GI Bill to pay his tuition at the newly opened Roosevelt College in downtown Chicago. It was during his time at Roosevelt that Washington's leadership qualities became too apparent to ignore. He started an independent fraternity because the others discriminated against blacks. Despite his willingness to confront racial exclusion and his assertive sense of racial identity, Washington was popular with white students.

Overleaf: A South Side stage set for a Democratic precinct captains' rally in the 1976 primary campaign. Erwin France was the Daley machine's challenger against the rebellious incumbent from the First Congressional District, Ralph Metcalfe. (Photograph © MP)

Hartigan ♥
DEMOCRAT
YOUR LT. GOVERNOR

HOWLETT

VOTE FOR
NELLIE JONES
Commissioner

Hartigan ♥
DEMOCRAT
YOUR LT. GOVERNOR

PARTEE
ATTORNEY GENERAL - DEMOCRAT

He Works For People
Erwin A.
FRANCE
For Congress

HOWLETT

Hartiga ♥
DEMOCRAT
YOUR LT. GOVER

e Works For People
Erwin A.
FRANCE
For Congress
First Congressional District

VOTE FOR
NELLIE JONES
Commissioner
Metropolitan Sanitary District
Primary Election Day
MARCH 16, 1976

Hartigan ♥
DEMOCRAT
YOUR LT. GOVERNOR

He Works For People
Erwin A.
FRANCE
For Congress
First Congressional District

VOTE
FOR
R. EUGENE
PINCHA
DEMOCRATIC ENDORSED CAND
JUDGE OF THE CIRCUIT C
OF COOK COUNTY ILLINO
PRIMARY ELECTION MARCH 1

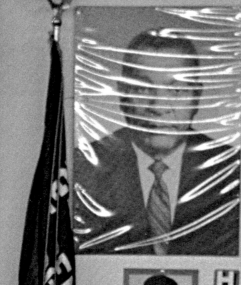

HOWLETT

He Works For People
Erwin A.
FRANCE
For Congress

HOWLETT

He Works For People
Erwin A.
France
For Congress

HOWLETT

VOTE FOR
NELLIE JONES

PARTEE
ATTORNEY GENERAL DEMOCRAT

HOWLETT

Illinois, you
can trust
Mike Bakalis.

State Comptroller
Vote Democratic

PARTEE
FOR YOUR
PROTECTION

ORNEY
NERAL
OCRAT

He Works For People
Erwin A.
FRANCE
For Congress

First Congressional District
Vote Democratic, March 16 · Full Level 6A

Hartigan ♥
DEMOCRAT
YOUR LT. GOVERNOR

VOTE FOR

NELLIE JONES
Commissioner
Metropolitan Sanitary District
Primary Election Day
MARCH 16, 1976

Illinois, y
can trust
Mike Ba

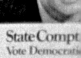

State Compt
Vote Democratic

He was elected president of the senior class and the student council. This son of a minister was a voracious reader whose erudition, vocabulary, and charisma made him an effective spokesman for whatever needed to be heard, such as his advocacy in the National Student Association to promote integration of American colleges.

He took those talents to Northwestern University School of Law and graduated in 1952. His father died the next year, and Washington took over the family law firm; he also succeeded his father as an assistant corporation counsel for the city. That was his first job in government; he later worked for the Illinois Industrial Commission. At the same time, he was learning the intricacies of precinct politics by serving as an aide and campaign manager for Third Ward alderman Ralph Metcalfe. In 1964, Metcalfe sponsored Washington for a seat in the state legislature, which he won. After the 1970 death of William L. Dawson, the unofficial political boss of black Chicago who served as congressman for the First District for nearly thirty years, Washington managed Metcalfe's successful campaigns to succeed him. These came at the height of the civil rights movement and the beginning of a turbulent period of black militancy.

Washington learned the intricacies of precinct politics by serving as an aide and campaign manager for Ralph Metcalfe.

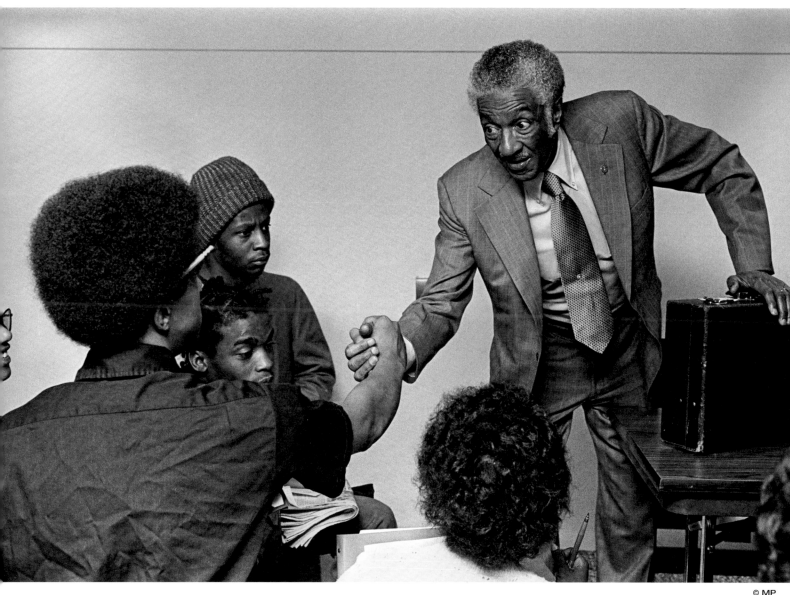

Ralph Metcalfe, a hero in the black community since winning silver and gold medals with Jesse Owens in the 1936 Berlin Olympics, broke with the Democratic machine and successfully defended his congressional seat against a machine challenge in 1976.

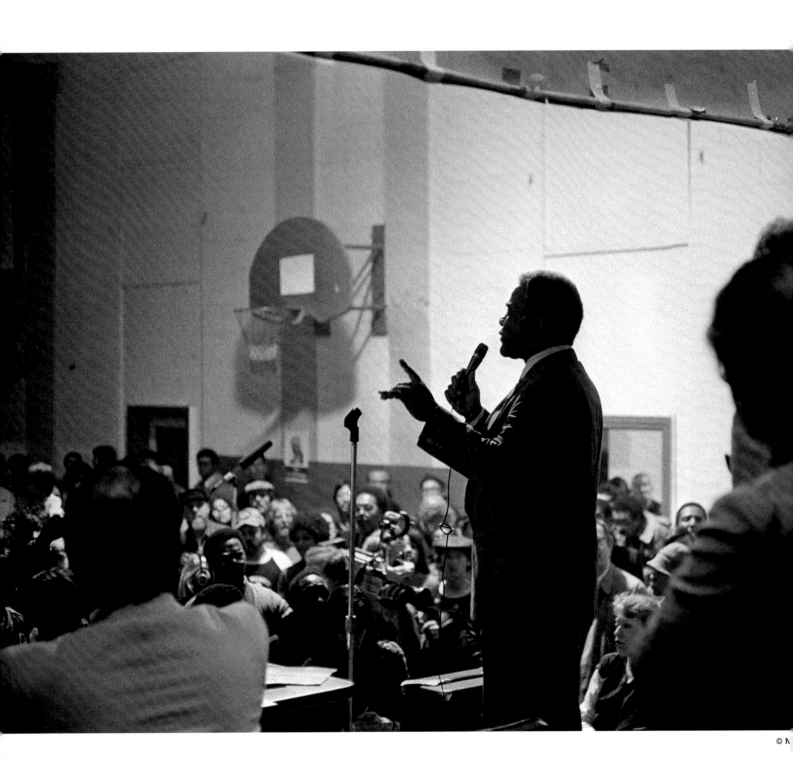

Urban violence, later characterized as "long hot summer" riots, was breaking out in New York's Harlem, Los Angeles (the Watts riots), and several other cities. In 1966, Dr. Martin Luther King Jr. brought the forces of the Southern Christian Leadership Conference north to initiate the Chicago Freedom Movement. King launched a series of marches and demonstrations to focus national attention on persistent housing discrimination in the city. Hit with a rock during one of these marches, King famously said that white resistance to open housing was worse in Chicago than in the southern cities he had previously challenged; he said, "I've never seen anything so hostile and so hateful as I've seen here today." In addition to protests against housing discrimination, black Chicagoans increasingly challenged inequities in the schools and incidents of brutality by police officers. Racial tension grew in a context of shifting economic realities: many of the industrial jobs that initially lured far-flung migrants to the city were beginning to disappear—hinting at the dramatic cutbacks that would cripple the black workforce in later decades.

King famously said that white resistance to open housing was worse in Chicago than in the southern cities he had previously challenged.

Opposite: Harold Washington campaigns at the American Indian Center in Uptown during the 1983 primary. Uptown was one of the few North Side neighborhoods where he had significant popular support.

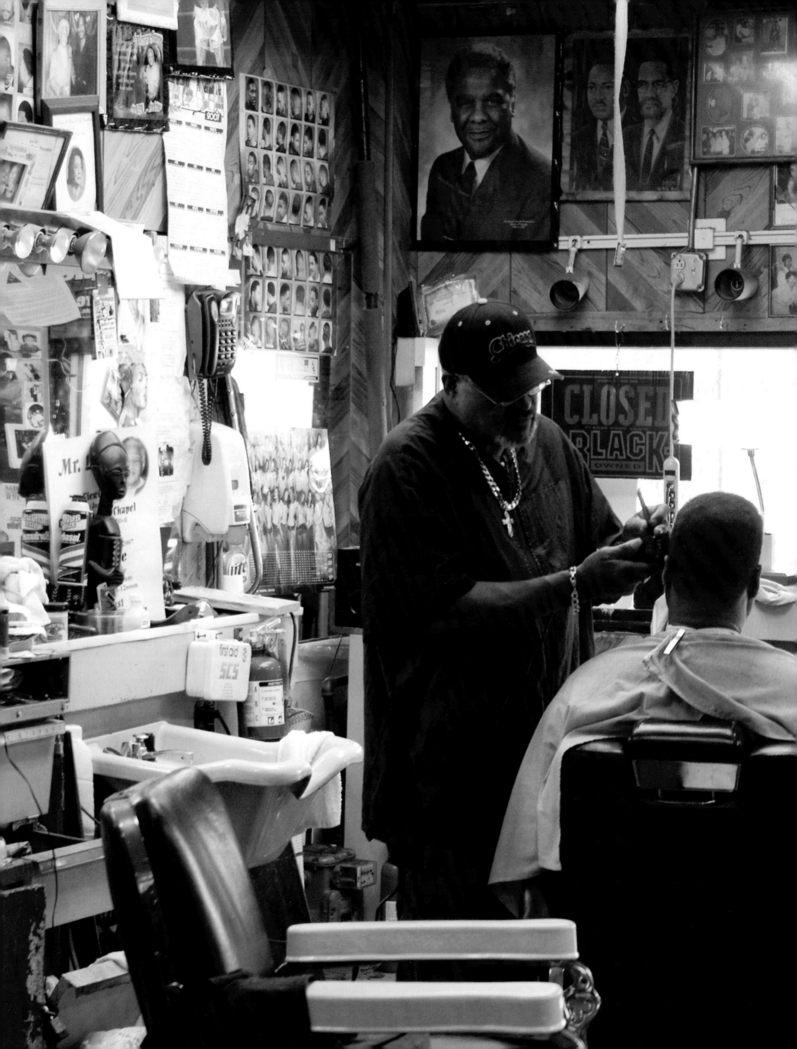

Barack Obama

"

That's how black people talked about Chicago's mayor, with a familiarity and affection normally reserved for a relative. His picture was everywhere: on the walls of shoe repair shops and beauty parlors; still glued to lampposts from the last campaign; even in the windows of the Korean dry cleaners and Arab grocery stores, displayed prominently, like some protective totem. From the barbershop wall, that portrait looked down on me now: the handsome, grizzled face, the bushy eyebrows and mustache, the twinkle in the eyes. Smitty noticed me looking at the picture and asked if I'd been in Chicago during the election. I told him I hadn't. He nodded his head.

"Had to be here before Harold to understand what he means to this city," Smitty said. "Before Harold, seemed like we'd always be second-class citizens."

"Plantation politics," the man with the newspaper said.

"That's just what it was, too," Smitty said. "A plantation. Black people in the worst jobs. The worst housing. Police brutality rampant. But when the so-called black committeemen came around election time, we'd all line up and vote the straight Democratic ticket. Sell our soul for a Christmas turkey. White folks spitting in our faces, and we'd reward 'em with the vote."

"

© M

West Side youths sit on the steps of the house on Monroe Street where Black Panther leaders Fred Hampton and Mark Clark were killed by police in 1969. The Hampton raid catalyzed opposition to machine politicians in the black community, and by 1976, when this photograph was taken, many black independents from Chicago had been elected to city, state, and federal office.

Washington's tenure in the Illinois legislature spanned this period, and his fierce political independence reflected the black community's growing militancy. He became famous for his command of language, deploying words like weapons and winning debates by humiliating opponents. Washington seldom "dummied down" his rich vocabulary, but he did tailor the inflections and cadence of his oratory to the comfort level of his intended audience. His verbal facility became legendary. Washington expertly used alliteration and subtle shifts of tone to get his point across. He was a natural orator. In one memorable instance, in his campaign to arouse public support for a bill making Dr. King's January 15 birthday a state holiday, Washington enthralled a crowd with a speech blasting "white legislators made recalcitrant by racism" but also "complacent blacks who act as compradors." It's doubtful the audience knew the meaning of *comprador,* but it erupted in enthusiastic applause nonetheless.

Washington's fierce political independence reflected the black community's growing militancy.

At the same time, however, he increasingly alienated a party leadership more accustomed to slavish loyalty from black Democrats. Washington beat back several attempts to oust him and served in the Illinois House of Representatives until he ran for the state senate in 1976. His ornery but competent independence, especially on issues of civil rights and civil liberties, won peer respect and media notice.

Overleaf: Public housing residents—organized to improve conditions in their apartment buildings—were at the core of the opposition to an unresponsive political system. Rosalee Cunningham (*foreground*) and her neighbors, shown here in July 1978, formed a tenants' committee at Robert Taylor Homes. (Photograph © MP)

Various groups cited him for his effectiveness as a legislator. Washington not only introduced the bill that made Dr. King's birthday a holiday in Illinois, but he also was instrumental in ensuring that 10 percent of state contracts was set aside for black contractors and that currency exchange fees were equalized in all Illinois communities.

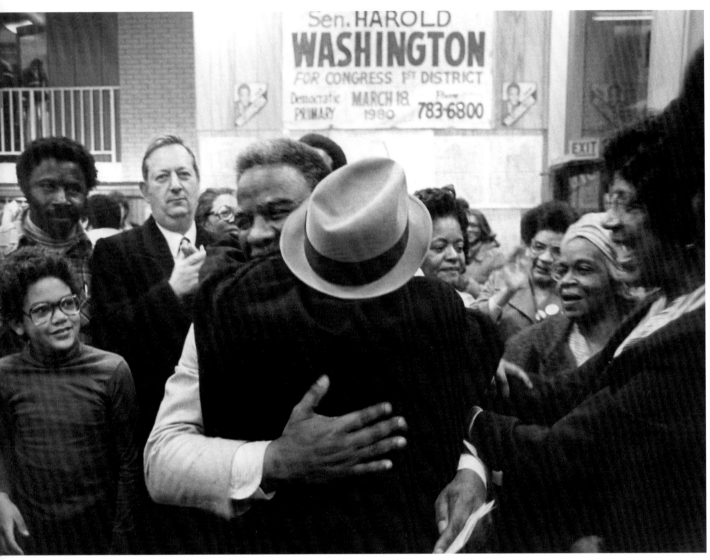

Washington campaigns for the Democratic nomination in the March 1980 primary, aided by State Representative Robert Mann (*in coat and tie at rear*), his Hyde Park colleague in the legislature.

The machine was maneuvering to oust him from the state legislature, so Washington decided to aim for another legislature—in Washington, D.C.

During his tenure in the state legislature, Washington made it clear that he danced to his own rhythms, displeasing party bosses and the black political establishment in equal measure. Angered by machine opposition, Washington grew even more independent and joined with a group that urged Metcalfe to challenge Richard J. Daley in a mayoral bid. When Metcalfe refused, Washington began distancing himself from his former mentor.

After Daley died in 1976, Washington stepped up to run for mayor in the 1977 special election. Despite an underfunded and unfocused campaign, Washington pulled 11 percent of the vote and won five South Side wards. When Metcalfe died in 1978, Washington became a top prospect to replace him as representative from the state's historic First Congressional District. His independence already had alienated his party's leadership, and the machine was maneuvering to oust him from the state legislature, so Washington decided to aim for another legislature—in Washington, D.C. He ran for the seat in 1980 and won easily. Intensely curious, charismatic, and eloquent, and with a wide-ranging liberal message, Washington was a perfect fit for the national spotlight and a favorite of the pundits. He refused to harmonize with the conservative tenor of the times and aggressively challenged the vapid shibboleths of the Reagan administration. He had arrived at the ideal spot for a man of his temper and sensibilities. So it would seem . . .

HAROLD
WASHINGTON
THE QUALIFIED CANDIDATE

Punch
9

The Movement Finds Its Man

"Lord, we thank you, for the man, the moment, and the movement have come together," said Reverend John Porter, pastor of Christ United Methodist Church, on November 10, 1982, at a Hyde Park hotel.

It was indeed a movement moment. Reverend Porter's simple prayer launched a historic campaign that would result in the 1983 election of Chicago's first black mayor. The campaign was a crusade for black political empowerment in Chicago—part of an ongoing process, long ripening. Fortuitously, this black empowerment crusade also stirred the simmering pot of political reform in the infamously machine-run town. Charged with Latino connections and alliances with progressive whites, the movement's power not only elected Harold Washington twice but also forever changed the way the city operates. Some trace the movement's beginnings to the 1969 police murders of Black Panther leaders Fred Hampton and Mark Clark, when outrage against police brutality in the black community was channeled into political activity that ousted the machine-backed state's attorney who had directed the fatal police raid. Some might find the roots buried deeper in history, but the brazen assassinations of the Panthers certainly energized the independent political movement that eventually produced Chicago's first black mayor.

The mayoral movement had begun in earnest in early 1981 with a number of meetings in a few basements on Chicago's South Side. Anger had been percolating in the black community in response to some of Mayor Jane Byrne's

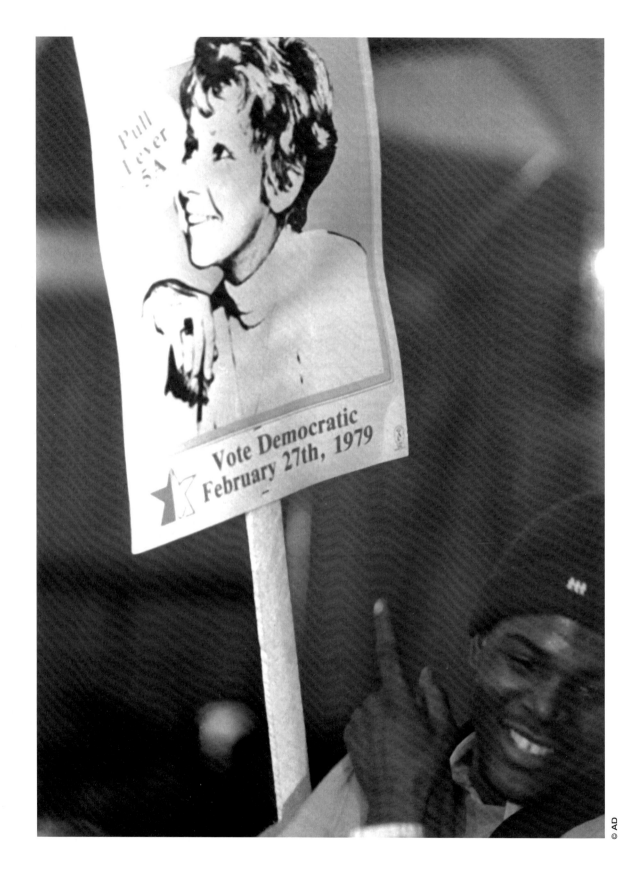

54 **Harold!**

policies and appointments. Byrne had garnered an impressive black vote in her 1979 victory over Michael A. Bilandic, the man the machine chose to replace Richard J. Daley following the death of the Boss in 1976. She'd won the election as a reform candidate, and her victory revealed the vulnerabilities of Chicago's vaunted political machine. But the diminutive Irishwoman, who had been plucked out of obscurity by the late mayor to head the city's Consumer Sales Department, soon turned her back on reform.

Byrne's affronts and the federal government's disinvestment from the inner cities, engineered by conservative president Ronald Reagan, had black Chicagoans wary and restive.

After initially rewarding her African American supporters with a number of high-level appointments, Byrne soon began alienating black voters with several decisions regarding board members of city agencies, leadership of the police department, and city job opportunities for blacks. She flip-flopped on a desegregation busing plan pushed by the U.S. Office for Civil Rights, opposing what she once supported. Many black leaders considered it a betrayal when she named two whites with controversial racial views to the Board of Education, but anger boiled over when she replaced two black members of the beleaguered Chicago Housing Authority with two whites. Byrne's affronts and the federal government's disinvestment from the inner cities, engineered by conservative president Ronald Reagan, had black Chicagoans wary and restive.

Opposite: Black support had been key to Jane Byrne's victory over the machine in the 1979 mayoral primary.

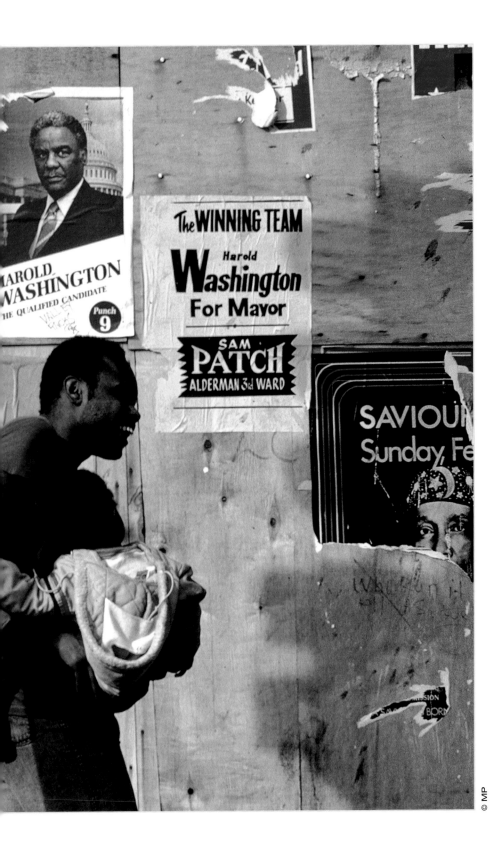

Fences, walls, and lampposts were all fair game for posters as the primary campaign heated up.

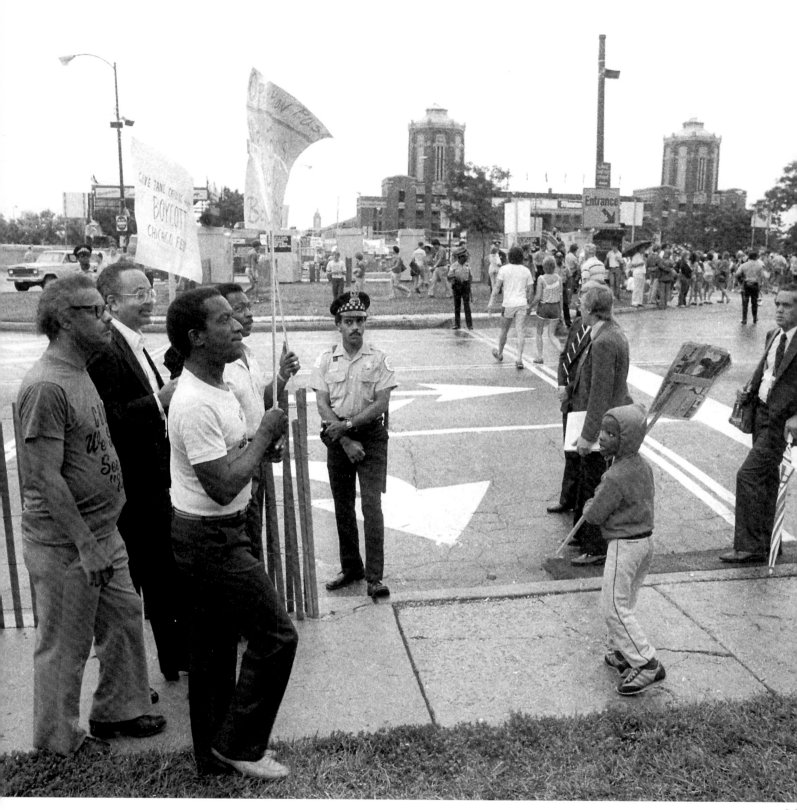

Protesters organized a 1982 boycott of Byrne's popular summer music festival, Chicago Fest, and the boycott triggered an aggressive voter registration program that yielded large numbers of new African American voters. Community leaders, clergy members, and especially black radio hosts urged African Americans to "come alive on October 5," the registration deadline.

Lutrelle "Lu" Palmer, a fiery community activist and former journalist, began organizing meetings he called "plebiscites" to come up with the black candidate best able to exploit that anger. "We shall see in '83" was the slogan Palmer advanced even before a candidate was selected; he founded two groups—the Black Independent Political Organization (BIPO) and Chicago Black United Communities (CBUC)—specifically to push for a black mayor. In 1981, when Palmer coined the slogan, prospects for success seemed remote. Still, Byrne's political mistakes, the disarray of the once formidable Democratic machine, and the entry of State's Attorney Richard M. Daley as a third candidate in the primary made the enterprise seem worth a try. The movement was rolling; all it needed was a candidate.

Opposite: Prominent black activists urge Chicagoans to boycott Mayor Byrne's Chicago Fest summer music festival at Navy Pier in 1982 in retaliation for her backtracking on black community issues. At far left, radio commentator and political organizer Lu Palmer and Alderman Clifford Kelley stand behind community activist Joe Gardner and Alderman Alan Streeter. The boycott touched off a voter registration drive taking aim at the 1983 mayoral election. *Below:* Ed Gardner, president of the Soft Sheen hair products company, was among the principal financial backers of the voter registration drive, the success of which convinced Washington to run.

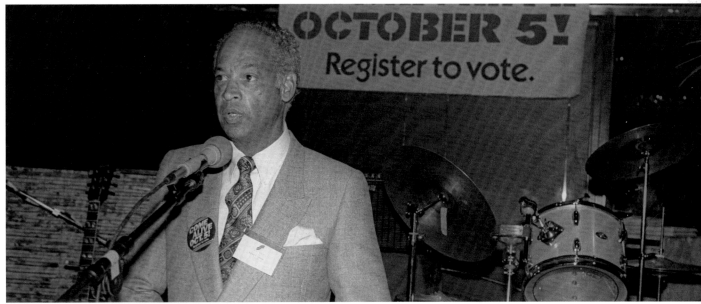

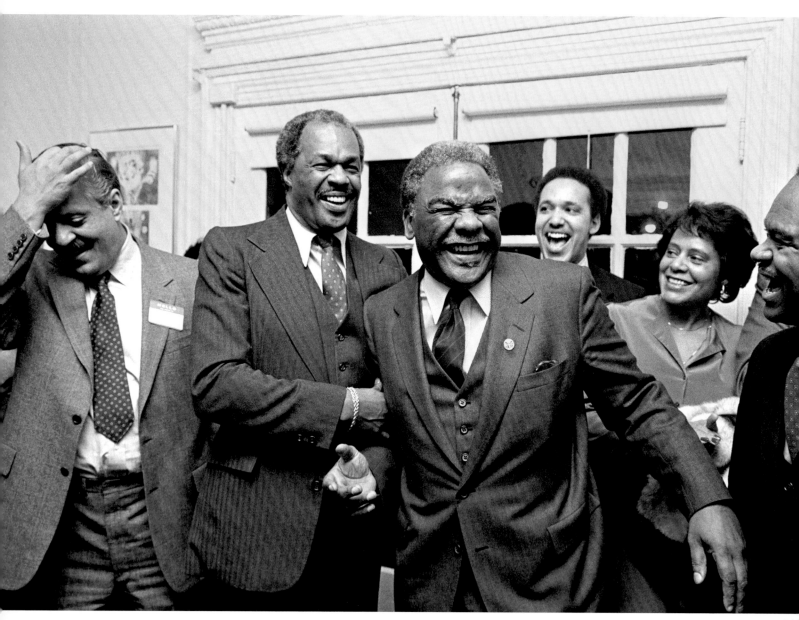

Above: Congressman Washington could call on national Democratic leaders for support in his mayoral bid. Here he appears at a fund-raiser in the nation's capital with District of Columbia mayor Marion Barry. *Overleaf:* The high-rise public housing projects on the South Side produced thousands of Washington voters. (Photograph © MP)

One politician's name repeatedly surfaced as the people's choice: Harold Washington. "Every time we got together to compare notes about the person who could gain the confidence of the community, Harold's name came up," said Robert T. Starks, who was deeply involved in the search for a candidate. Starks headed a group called the Task Force for Black Political Empowerment, which was charged with mobilizing the so-called grassroots. The Task Force's specific task, bolstered by the black nationalist beliefs of its leadership, was to organize residents of the city's housing projects and other low-income communities around issues of racial pride, as well as improved services—issues that had motivated blacks in cities like Detroit and Atlanta to elect African American mayors. Their intent was to create a movement, and they found in Harold Washington the kind of charismatic figure who could inspire the grassroots. Washington already had proven himself as an accomplished politician responsible for several pieces of legislation, including a grant that saved Chicago's historic Provident Hospital. What's more, he had run for mayor in 1977 as the consensus choice of the Committee for a Black Mayor, after Richard J. Daley's sudden death in 1976 opened the way for an independent challenge to the machine. He got 11 percent of the vote and won five black wards in that contest.

They found in Harold Washington the kind of charismatic figure who could inspire the grassroots.

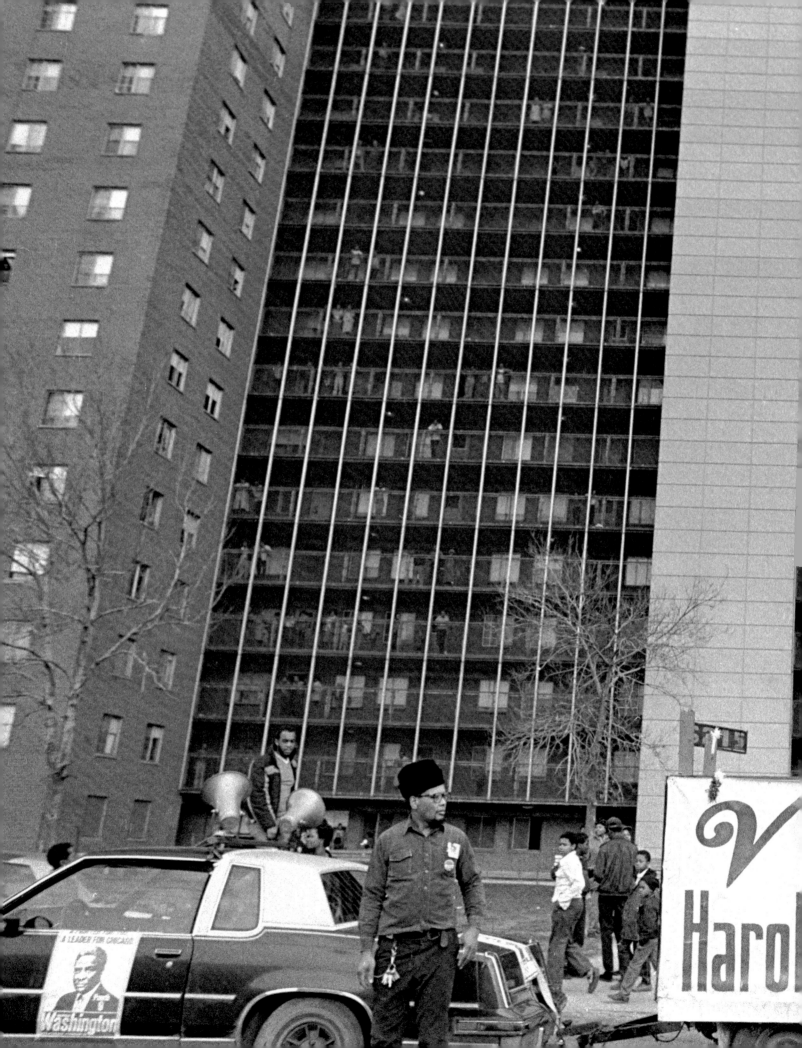

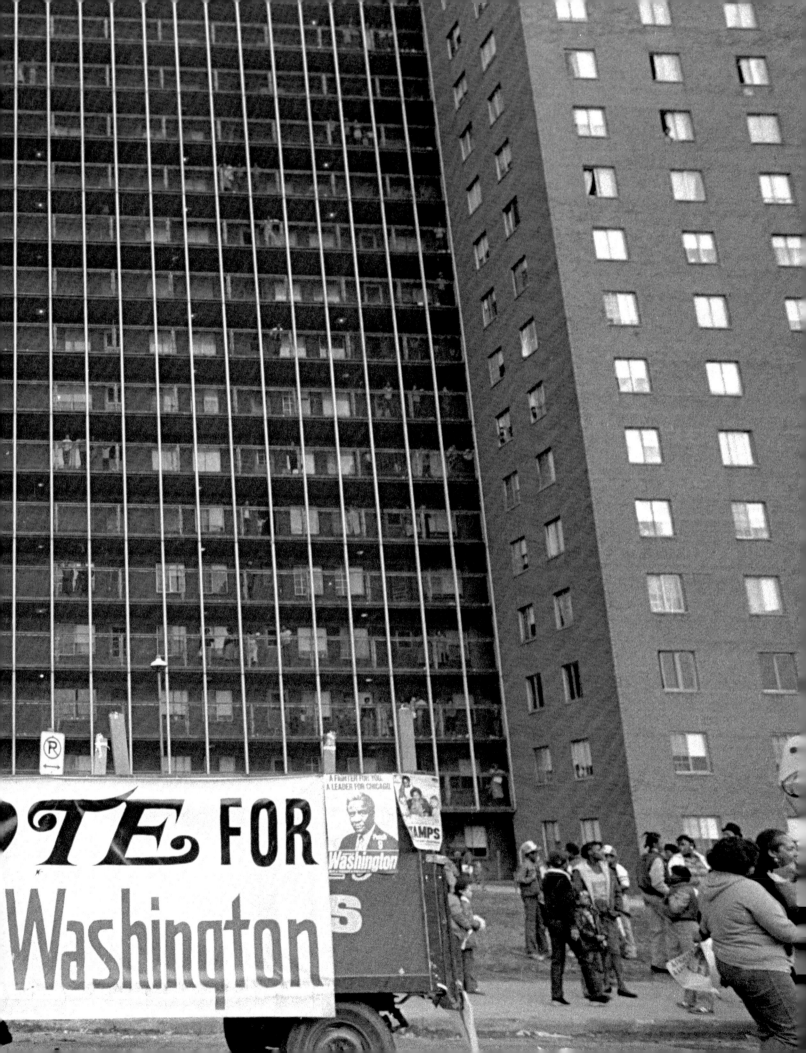

Washington's appeal was wide and deep. Coalitionists in the black community liked him for his ability to work well with other constituencies; businesspeople appreciated his attempts to swing public monies their way; nationalists welcomed his public expressions of racial pride. Congressman Washington was also hosting constituent meetings at the historic "Packinghouse," an old meatpackers' union hall on the South Side, exploring a wide range of issues, including the possibility of a black challenger to Byrne.

Palmer's culminating plebiscite on June 12, 1982, at the South Side's Bethel AME Church, delivered a resounding vote for Washington. But he was reluctant to run. He was winning plaudits for his congressional performance and had established a rather comfortable niche. Why, he asked, should he abandon that hard-won position? He said he would consider running for mayor only if supporters raised at least $250,000 and registered at least fifty thousand new voters. The movement took up the challenge with a collective effort unprecedented in black Chicago.

"Thousands of others flocked to support Harold Washington with no hope for personal reward—he was the right man with the right message for a crusade."—DICK SIMPSON

Opposite: Boys ride in a sound truck rolling through black neighborhoods to distribute lawn signs for the 1983 primary campaign.

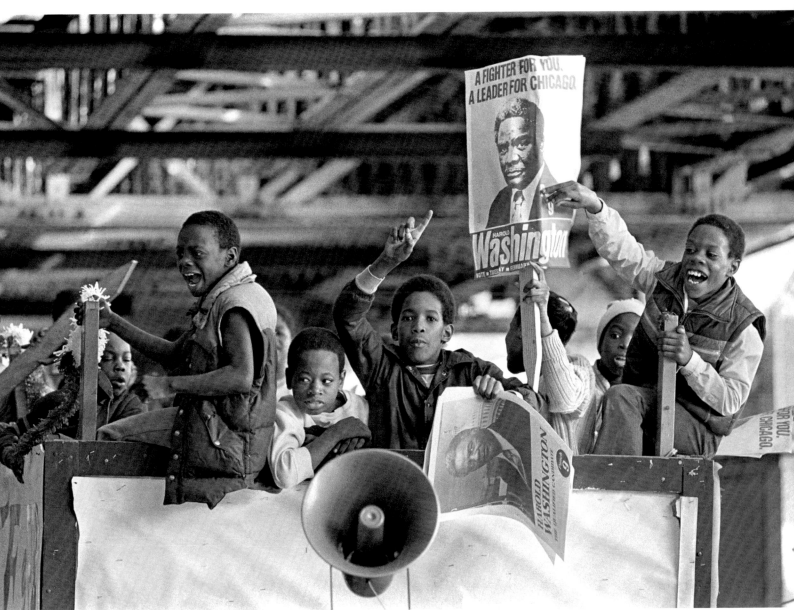

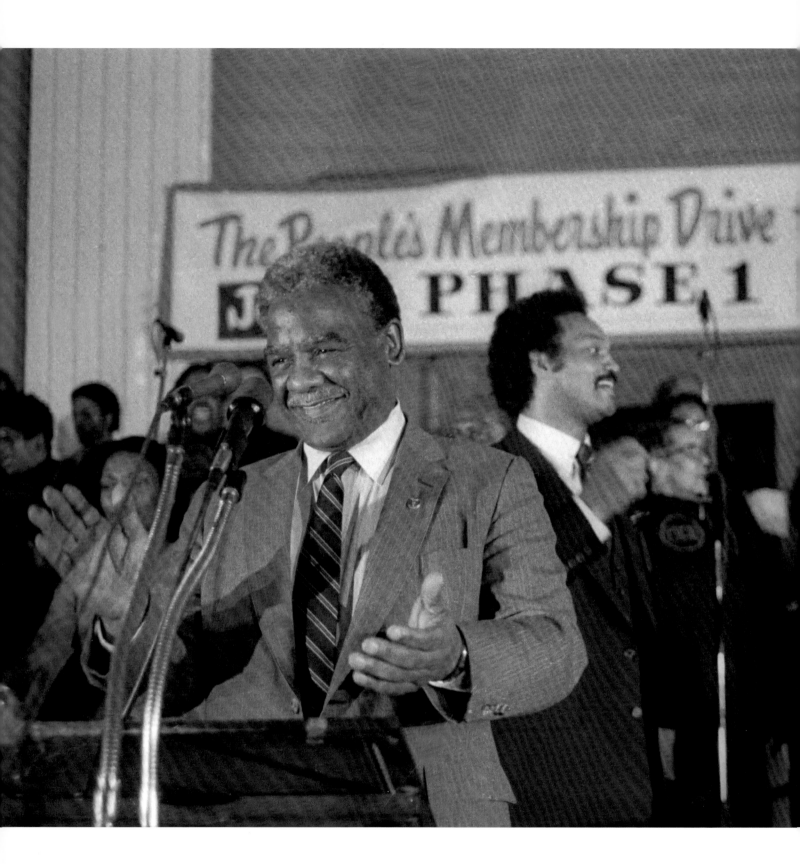

© AD

Washington acknowledges
applause from the
congregation at
Reverend Jesse Jackson's
Operation PUSH in
January 1983, when he
appealed for support in
the February primary.

The incipient Washington campaign became a racial crusade that united black nationalists with integrationists, businesspeople with community activists, church folk with leftist radicals, and machine politicians with political reformers, among other unlikely combinations. Were it not for the economic resources of businesses like Soft Sheen Products and Travis Realty, the army of grassroots workers enlisted by community groups (such as CBUC and BIPO) and civil rights groups (such as Operation PUSH and the Chicago Urban League) would not have had the wherewithal to register the enormous number of voters that convinced Washington to run. This cross-class racial unity is given short shrift in most accounts of the Washington era. But intraracial harmony was the quality that gave Washington's campaign its unique voice.

Still, critics claimed that divisions between the city's black centers of power had become so rancorous that they would paralyze any effort to elect a black mayor. For example, most of the city's black politicians, and even a majority of the black clergy, tied as they were to the Daley machine, had been deeply opposed to Dr. Martin Luther King Jr. when he brought his southern-based civil rights campaign to Chicago in 1966. Those kinds of divisions were more common than rare in Chicago as America moved into the era of black electoral politics, an era when black communities across the country viewed electing black mayors as events in the civil rights movement. During the Washington campaign, these groups submerged long histories of political antagonism.

This cross-class racial unity is given short shrift in most accounts of the Washington era.

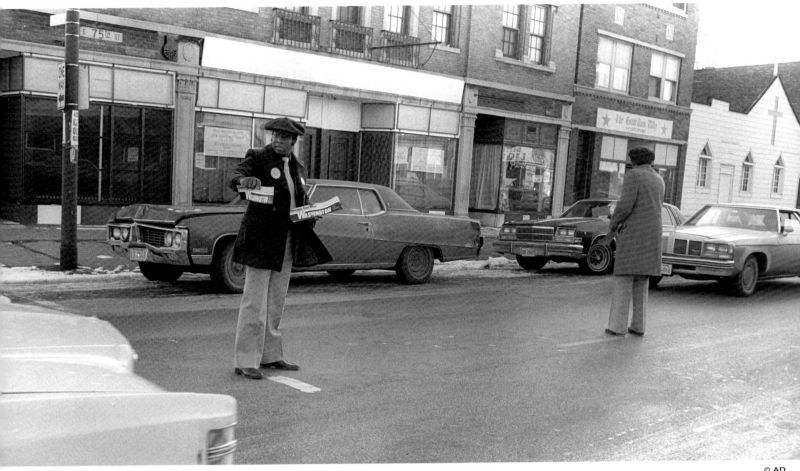

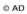

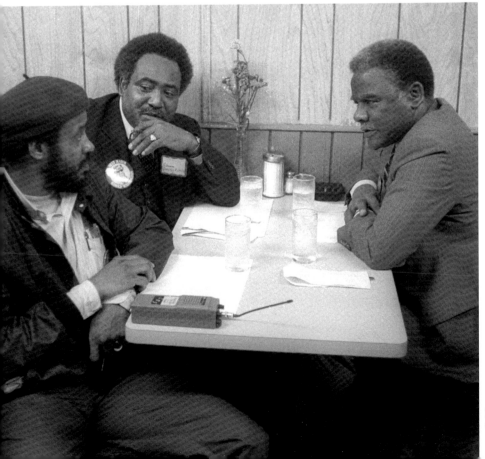

Above: Volunteers hand out bumper stickers to motorists on Seventy-fifth Street.
Left: The candidate meets with community activist Conrad Worrill (*left*) and Twenty-ninth Ward alderman Danny Davis (*center*), now a member of Congress.

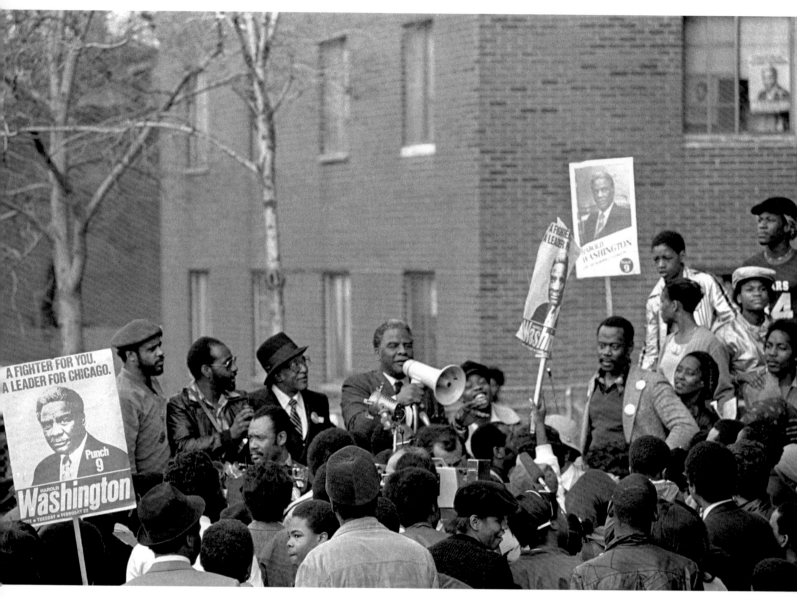

© M

The hectic pace of the primary campaign led to frequent clashes among Washington's advisers about how to divide his time between continued contact with the base and outreach to other constituencies. Here he connects with the base.

During the Washington campaign, groups submerged long histories of political antagonism.

The city's black politicians were deeply enmeshed in the Daley machine and generally were at odds with the reformers, but many eventually joined in the struggle to elect Washington; the rather substantial black business community had interests often contrary to those of the community activists they later financed to pump up voting rolls; politically connected African American clergy members previously shunned the kind of black nationalists they wound up assisting in political organizing for Washington. Chicago was unique in having the strongest black nationalist community of all American cities: it was the headquarters for Louis Farrakhan's Nation of Islam; the National Black United Front, which is the largest secular group of black nationalists; the Moorish Science Temple, another prominent group; and the El Rukns, which was the influential Blackstone Rangers street gang gone nationalist. This nationalist presence presented a particular problem because many of Washington's most fervent supporters were activists like Al Raby and Richard Barnett, who deeply believed in the power of interracial political coalitions. The nationalists envisioned the Washington campaign as a part of the black liberation movement. Cooperation between these disparate groups wasn't completely smooth; there were many disputes, for instance, about where Washington should spend his campaign time or how he should calibrate his message between the themes of black empowerment and reform.

Overleaf: The first of Washington's television ads is previewed at a party at a Lake Shore Drive home. Joining the candidate and a group of his lakefront supporters were the filmmaker Bill Zimmerman, behind monitor, and U.S. senator Alan Cranston (D-California), seated at right.

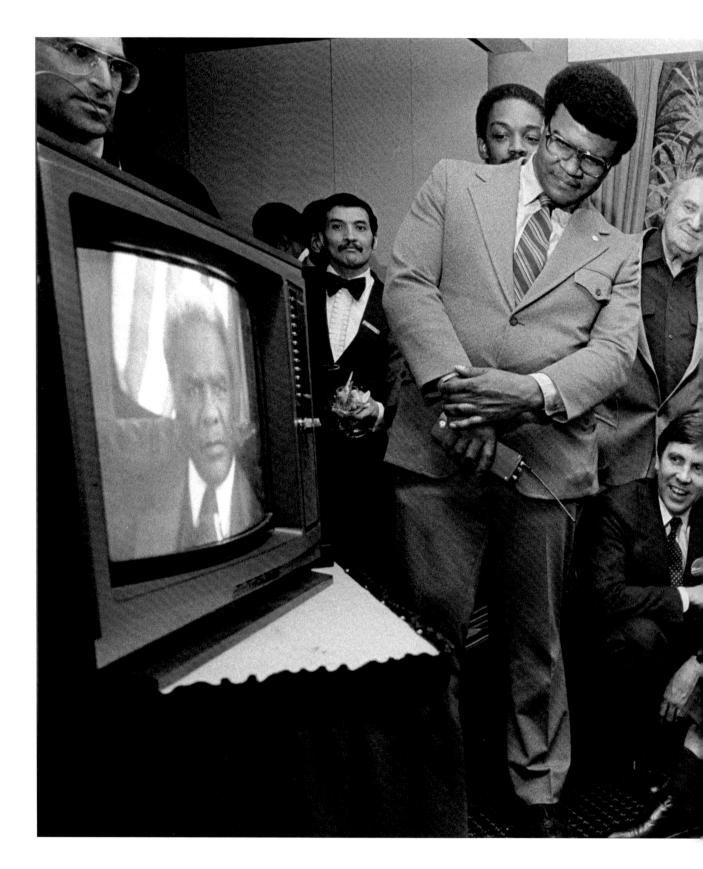

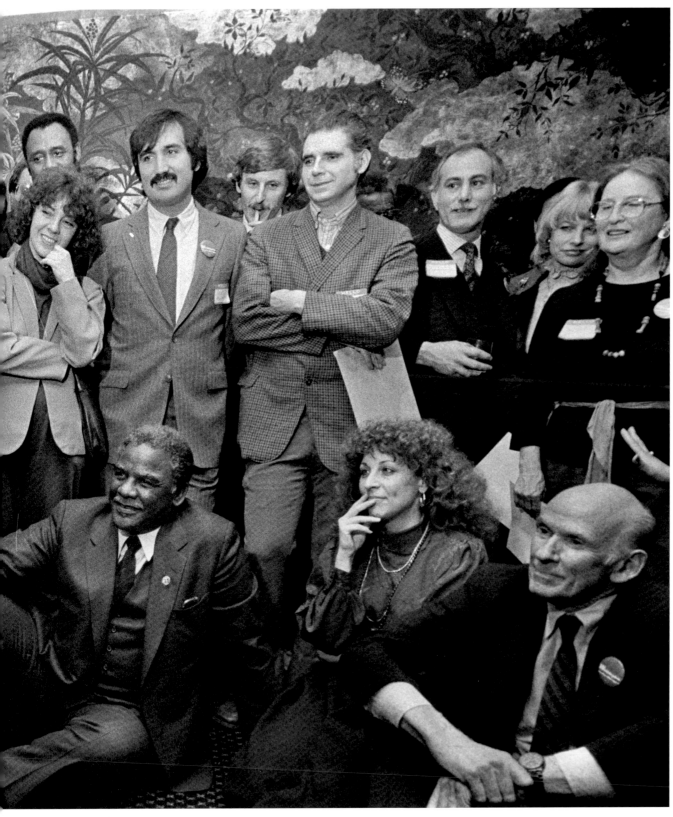

The Movement Finds Its Man 73

Of course, none of that would have mattered had Washington not accepted the candidacy. He announced his entry into the race at that hotel in Hyde Park on November 10 and, as Reverend Porter said, the movement was officially born. Politically savvy and fiercely independent, with a penchant for radical rhetoric, the ruggedly handsome Washington just seemed to be the right candidate for the time. His core supporters were centered in traditional church-based groups and political formations clustered around his seat in the storied First Congressional District—the seat made famous by Oscar DePriest, the first black congressman elected in the twentieth century, and later held by William Dawson and Ralph Metcalfe. Washington's forthright and articulate opposition to the Reagan administration's conservative policies also had attracted new progressive white supporters. He had been a Democratic elected official since 1965 but remained unstained by his past links to the machine. Solidly bicultural, Washington was equally at home in the 'hood and in Congress; his eloquence in the King's English was matched by his facility with Ebonics. His vocabulary was vast, and he often used it to bludgeon political foes, black and white alike.

Politically savvy and fiercely independent, Washington just seemed to be the right candidate for the time.

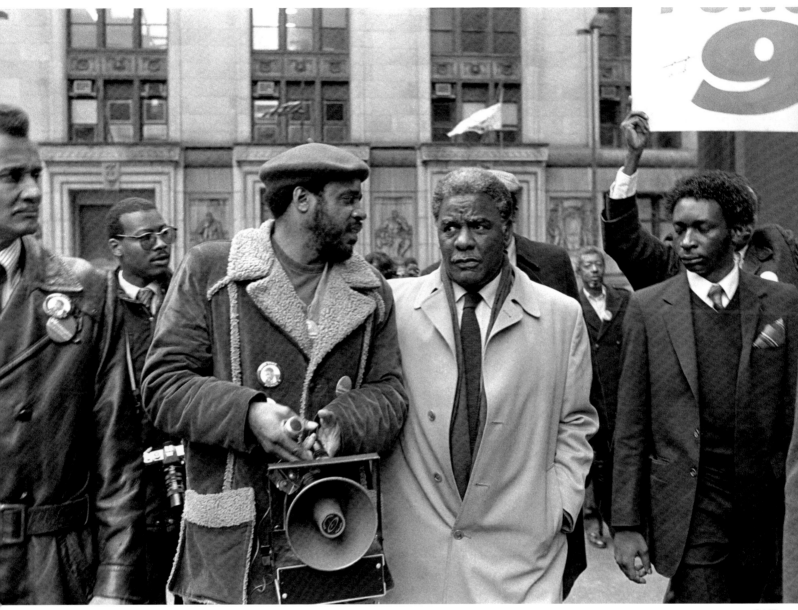

Toward the end of the primary campaign, Washington made several assertive appearances in the Loop to show that downtown was his turf too. Conrad Worrill, shown here walking with Washington across Daley Plaza, was one of the principal figures in the nationalist wing of the coalition supporting Washington's candidacy.

© MP

With Latino connections and alliances with progressive whites, the movement forever changed the way the city operates.

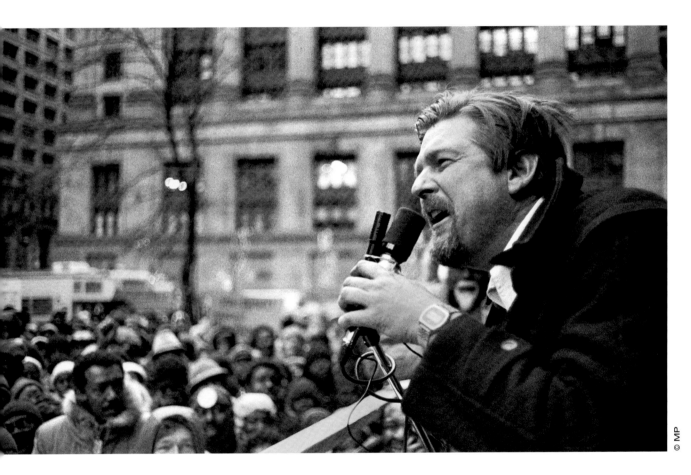

© MP

Shades of the rainbow: Labor leader and community activist Rudy Lozano (*opposite*) appeared at a fund-raiser in the Lill Street Studios on January 29, 1983, and Uptown organizer Slim Coleman (*above*) spoke at a rally for Washington at Daley Plaza on Dr. Martin Luther King Jr.'s birthday, January 15.

> **Byrne agreed to a series of debates that her strategists hoped would expose Daley's startling lack of verbal facility. That part worked.**

Washington campaigned on the issues of balancing the city budget, ending patronage hiring, bringing jobs to the city, and enhancing neighborhood development. His overall theme was fairness in utilizing the talents of all city residents to run and rebuild the city. His critique of explicit racial bias in running Chicago was couched in this message of equality. This was the kind of ambiguity a black candidate needed to reflect in order to win his base and enhance his outreach. The black electorate could read fairness as an empowering message, while other potential supporters would not feel threatened by Washington's call for equity. Washington also had cultivated a significant following in Chicago's diverse, and traditionally fractious, Latino communities; both Puerto Rican and Mexican political activists were drawn into his orbit. When campaigning, he exuded a charisma that attracted admirers across the class spectrum but was particularly effective in low-income communities, where large crowds seemed to resonate with his easy empathy. Oddly enough, his longtime friends say he was a natural introvert who preferred reading to social activity. On the political stage, however, Washington was transformed—and he was at his best during the four televised primary debates with Byrne and Daley.

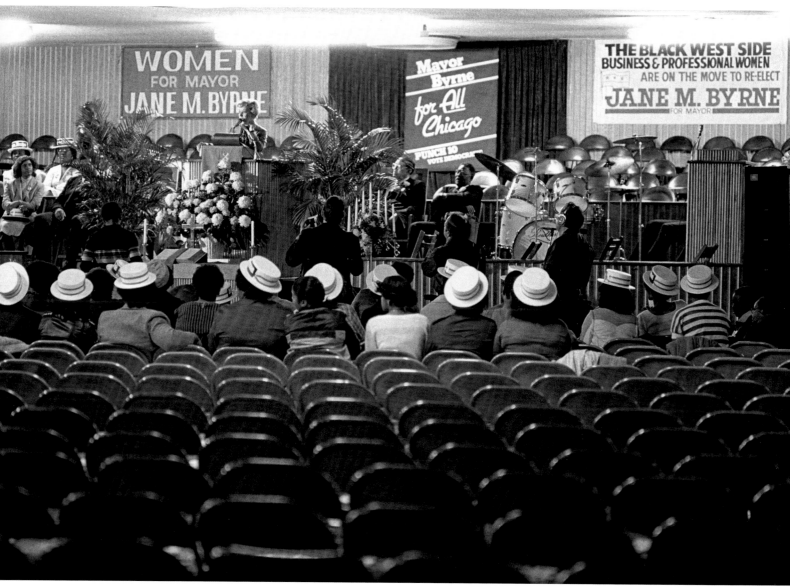

By 1983, Mayor Byrne's black support had melted away.
Here she appears at a nearly empty hall on the West Side.

Grayson Mitchell

[Harold] was going to get a lot of media coverage, and I remember I was very nervous about it because I didn't want there to be any empty sections. Let alone half the place empty. But I always underestimated the extent to which the fire had caught on . . . It ceased being a campaign. It became a movement. We used to think we were running it. We weren't running shit. I mean it had a momentum all of its own . . . And Harold was shot from a cannon just like the rockets being shot from a cannon . . . [Precinct workers] could tell by the signs they were picking up on the street . . . little mini things, [like] when we start getting money in from prisons 'cause the prisoners were passing a hat and sending money. That kind of got our attention. Then we got kids coming to the door with cans of pennies and nickels from public schools on State Street and [in the] projects where they have been collecting money. That kind of stuff comes in . . . It was cold that day, very, very cold. And on very short notice 'cause I didn't advertise, we just didn't [do a big push on] this. Yeah, that's amazing. That's the great shock of it. Harold at his best. He loved that.

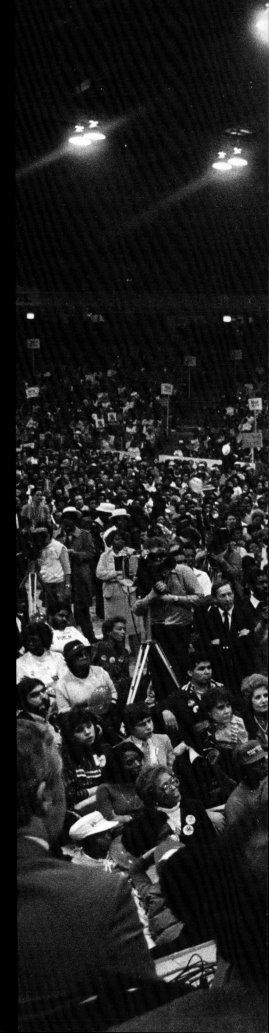

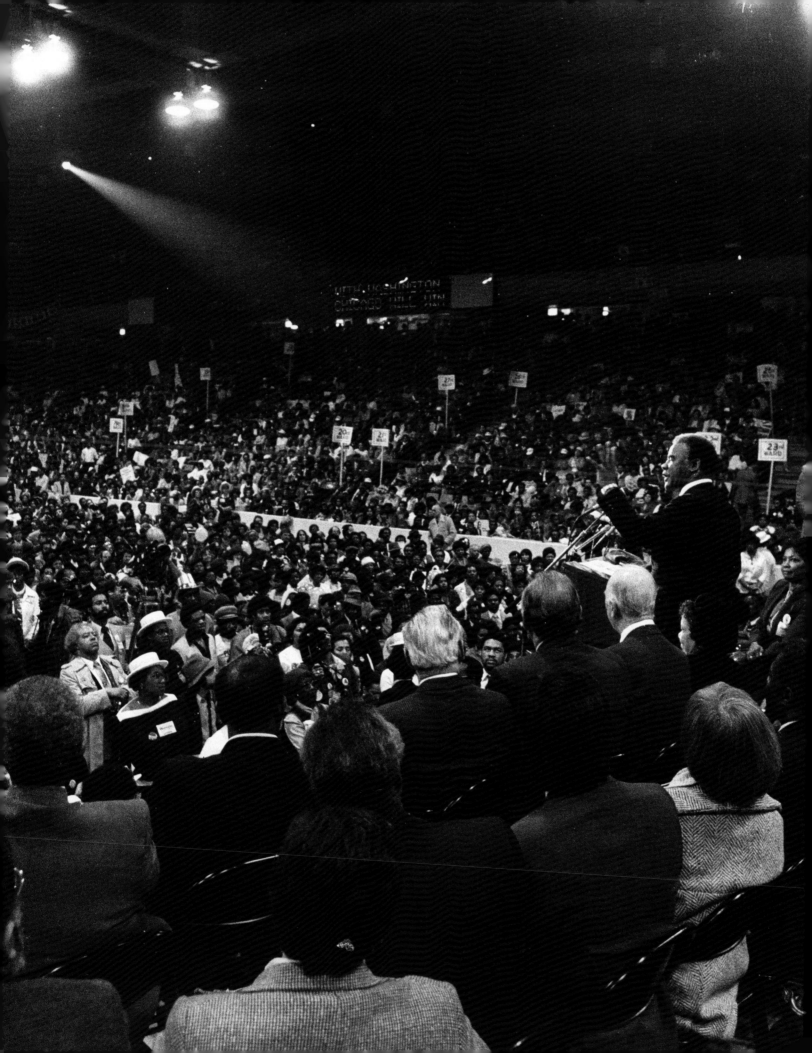

Byrne agreed to a series of debates that her strategists hoped would expose Daley's startling lack of verbal facility. That part worked. But the debates also allowed the underdog Washington to display his verbal virtuosity and thorough knowledge of the issues. In one typical exchange, the candidates were asked what they would do to improve the Police Department's Office of Professional Standards (OPS). Incumbent mayor Byrne answered that the department was doing a good job and took their work with the OPS seriously. Candidate Daley said, "There must be improvement . . . nothing wrong with improvement in the Office of Professional Standards." Washington told the audience, "The precise question is what would I do to improve the Office of Professional Standards, and when I answer it I'll be the only one to answer the question." He immediately distinguished himself from the other candidates by delivering a detailed and thoughtful answer about the failure of the OPS. He said that the police commissioner at the time had "destroyed his credibility" by acting "at the behest of this mayor . . . as a minion of this mayor, as a subaltern of this mayor, as a subordinate." By the time the word *subordinate* left his mouth, black audience members were applauding. *Chicago Sun-Times* columnist Vernon Jarrett said that for many blacks, seeing Washington verbally jousting with Byrne and Daley was like "watching Michael Jordan on the basketball court."

In the black community, Washington's sterling debate performances transformed his candidacy from a symbolic racial crusade into a serious mayoral campaign. The previously unthinkable prospect of a black mayor became a tantalizingly real possibility. Byrne's strategists were so focused on the battle with Daley for white voters that they failed to adequately consider the possibility that Washington could monopolize blacks' votes. And blacks were increasingly well disposed toward Washington: according to a Gallup Poll cited by William J. Grimshaw in his book *Bitter Fruit: Black Politics and the Chicago Machine, 1931–1991*, "Black voters . . . were sizing up Washington against Byrne. This version of the debate cost Byrne six points, Washington gained eight, and Daley lost two."

Above: Byrne, Daley, and Washington during a debate.
Overleaf: Another sign of Washington's growing support
was the February 6 rally at the UIC Pavilion, where twelve
thousand people came to cheer him on. (Photograph © MP)

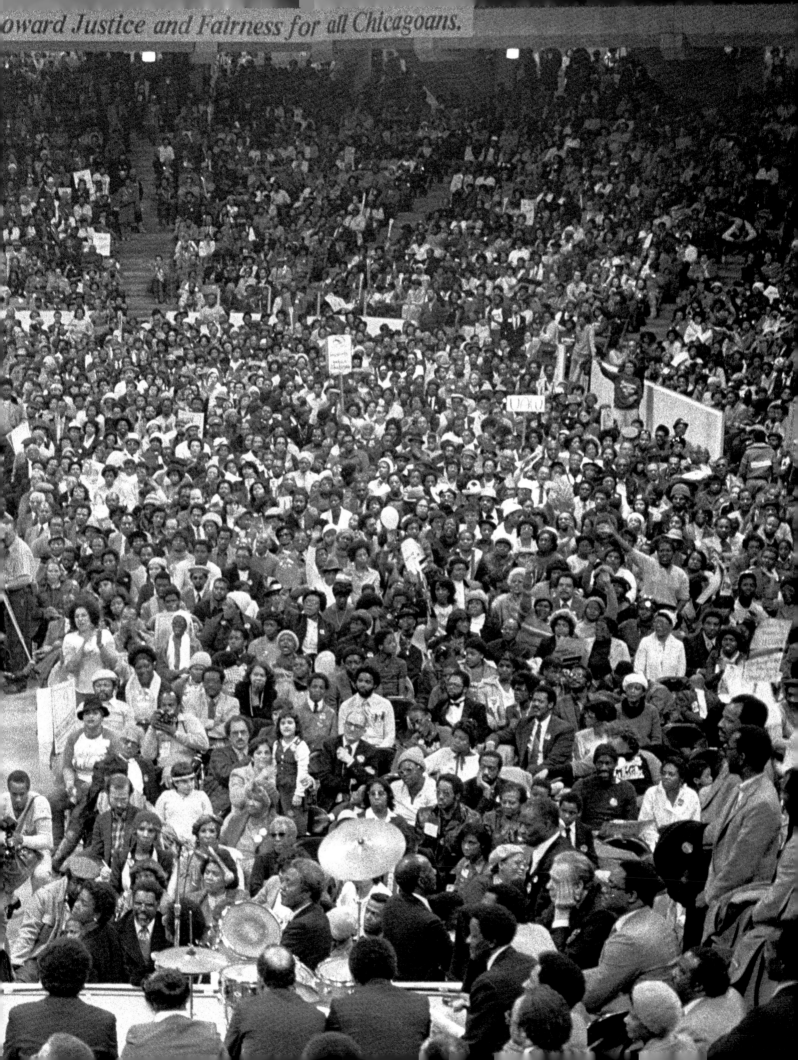

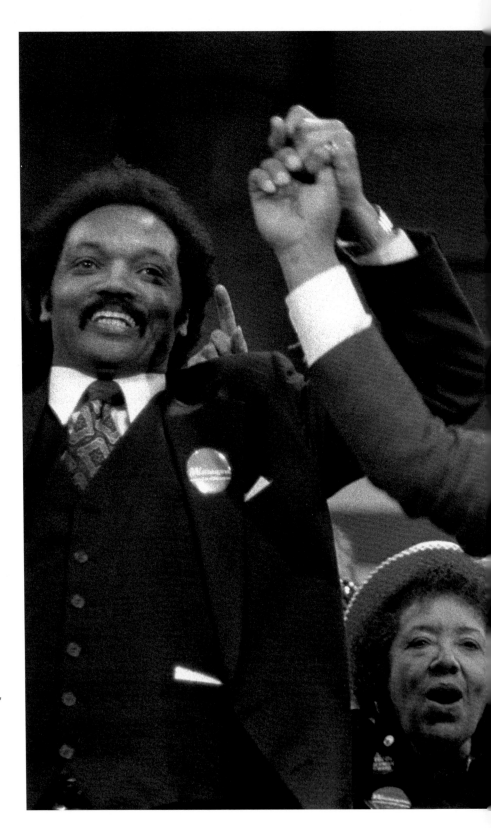

Acknowledging tumultuous cheers from the supporters crowded into the UIC Pavilion, Washington is tethered to Reverend Jesse Jackson and Senator Alan Cranston (D-California). Behind them are Alderman Anna Langford and community activist Bob Starks.

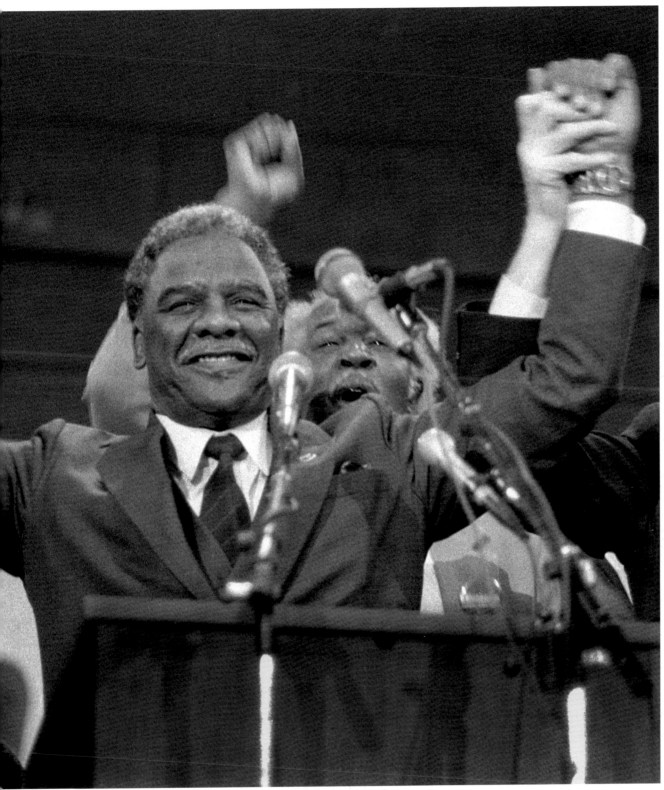

The Movement Finds Its Man 87

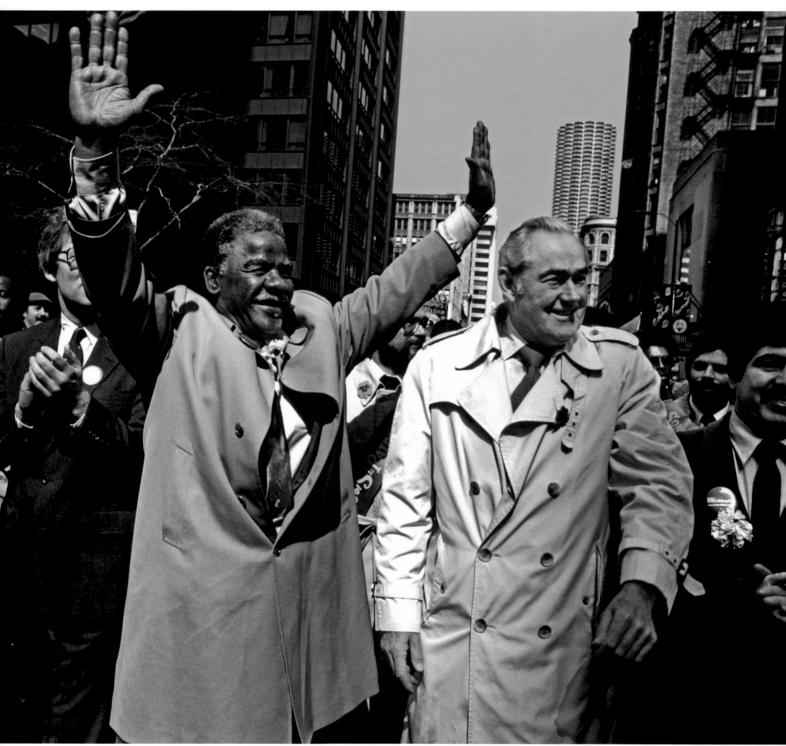

Still, most political pundits were convinced the black candidate couldn't win the Democratic primary, and they spent most of their time analyzing the chances of incumbent mayor Byrne and State's Attorney Daley. It wasn't until Washington drew a huge crowd on a chilly Sunday just two weeks before the primary that the media began to grasp the strength of his support. This February 6 rally at the University of Illinois at Chicago attracted more than twelve thousand exuberant supporters and several national political figures to wish Washington well in the February 22 election. The mainstream media were caught off guard by the enthusiasm and number of Washington supporters. "Most of the reporters and editors in the newsroom were stunned by the big crowds that showed up at the rally," recalls Monroe Anderson, who covered much of the Washington phenomenon as a *Chicago Tribune* reporter. Anderson, who is black, had written a widely ridiculed 1982 column suggesting Washington had a chance of winning in a three-way race that split the white vote. He said the rally also made believers out of black reporters, many of whom had previously shared the view of their white colleagues that Washington's campaign was more symbol than substance. "An exhilarating air of impending victory swept across the black community," wrote Washington adviser Grimshaw.

Meanwhile, as Grimshaw also noted, reporters covering Byrne overheard one of the mayor's strategists exhort campaign workers: "A vote for Daley is a vote for Washington . . . It's a racial thing. Don't kid yourself. I am calling on you to save your city, to save your precinct. We are fighting to keep the city the way it is." The media revelation stripped away Byrne's remaining support in the black community and gave another boost to Washington's chances. As it happens, the strategist caught making that remark was Edward R. Vrdolyak, a political personality who would figure prominently in Chicago's contentious future.

Opposite: Forty-second Ward committeeman George Dunne was the only powerful white machine Democrat to reach out to Harold Washington after he won the primary election. He invited Washington to march with him at the front of the Saint Patrick's Day parade a few weeks before the general election.

Washington won a close primary race with 36 percent of the 1.2 million votes cast. Byrne pulled 34 percent and Daley 30 percent. Eighty-five percent of the black vote went to Washington, with Byrne and Daley approximately splitting the white vote. On the day following the election, black Chicago exploded in a paroxysm of celebration. The joyous possibility of a black mayor combined with the sweet vindication of victory to spark a sense of real jubilation. Black-oriented radio stations played celebratory music, and black motorists blinked their lights and honked their horns in celebration. The blue campaign buttons that had become ubiquitous in the Washington crusade were now proud markers of shared triumph. Bars and lounges all across the South and West sides began posting notices of Washington victory celebrations and fund-raisers. The barbershops, beauty parlors, bookstores, and other street haunts of black Chicago were all abuzz about the prospect of black power in the Windy City.

Below: Reverend Jesse Jackson beams excitedly as Washington's vote total mounts. *Opposite:* Washington and campaign staffers plot last-minute precinct strategy on primary election day. *Overleaf:* The moment of victory: supporters gathered for the election-night party at the McCormick Inn erupt as Washington is declared the winner. "You want Harold?" the nominee asked in response to the crowd calling his name. "Well, you got him!" (Photograph © AD)

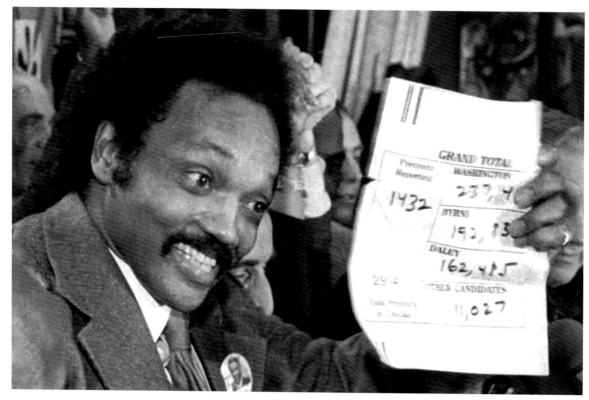

© AD

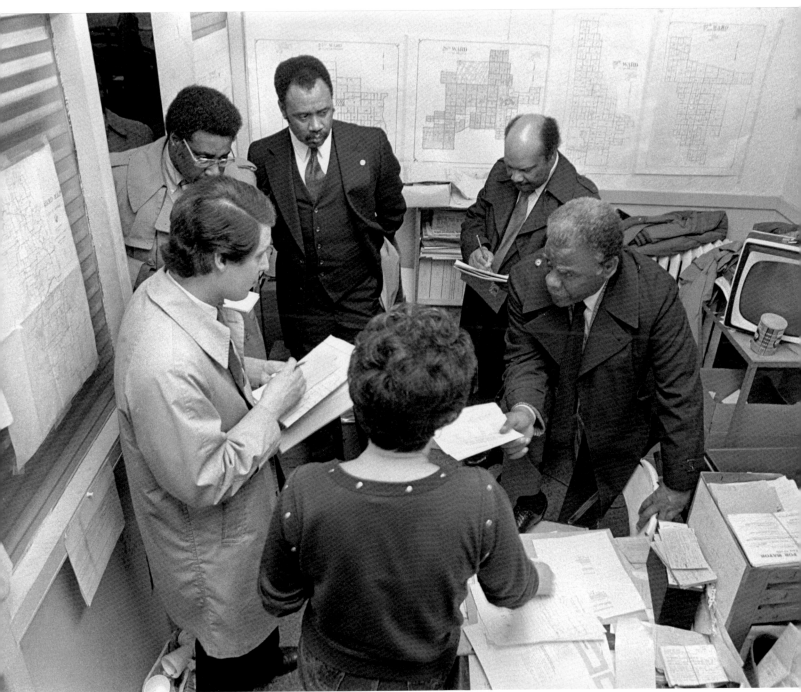

© MP

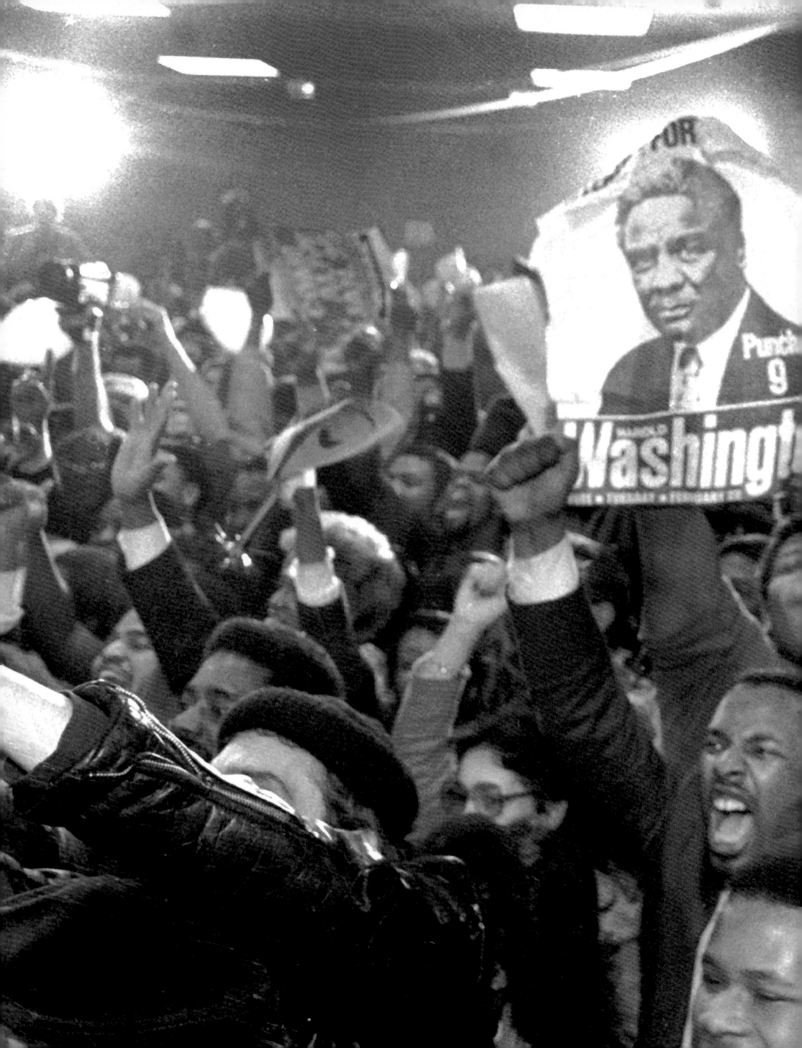

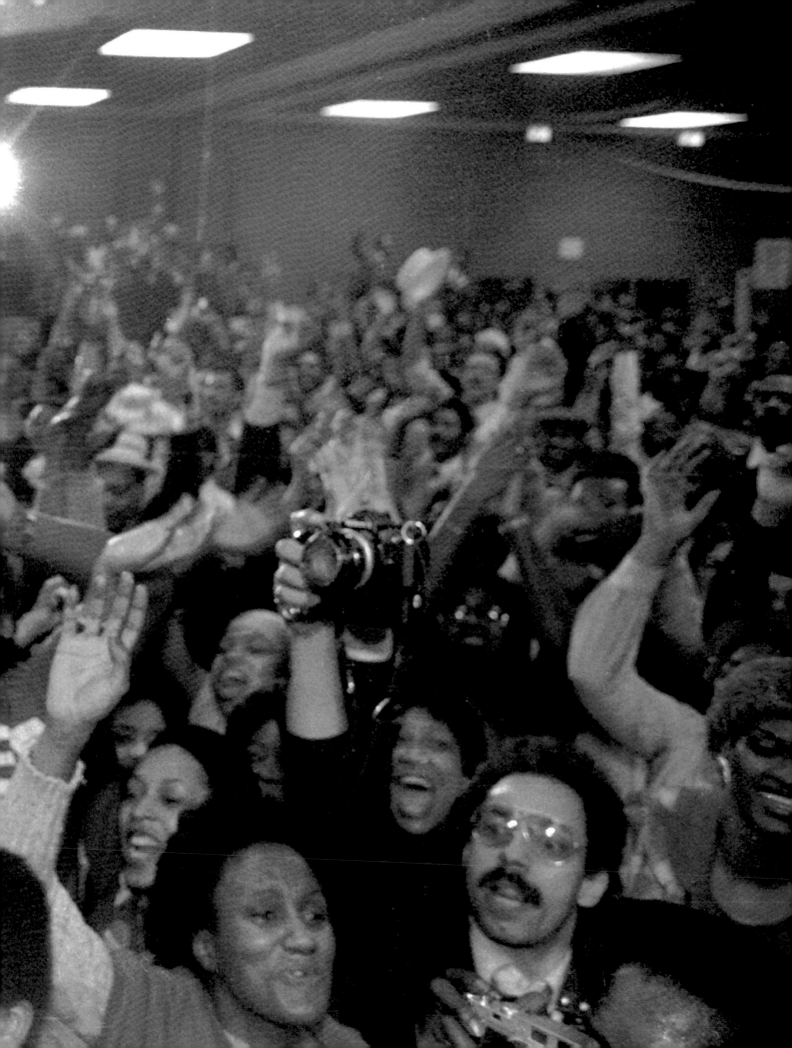

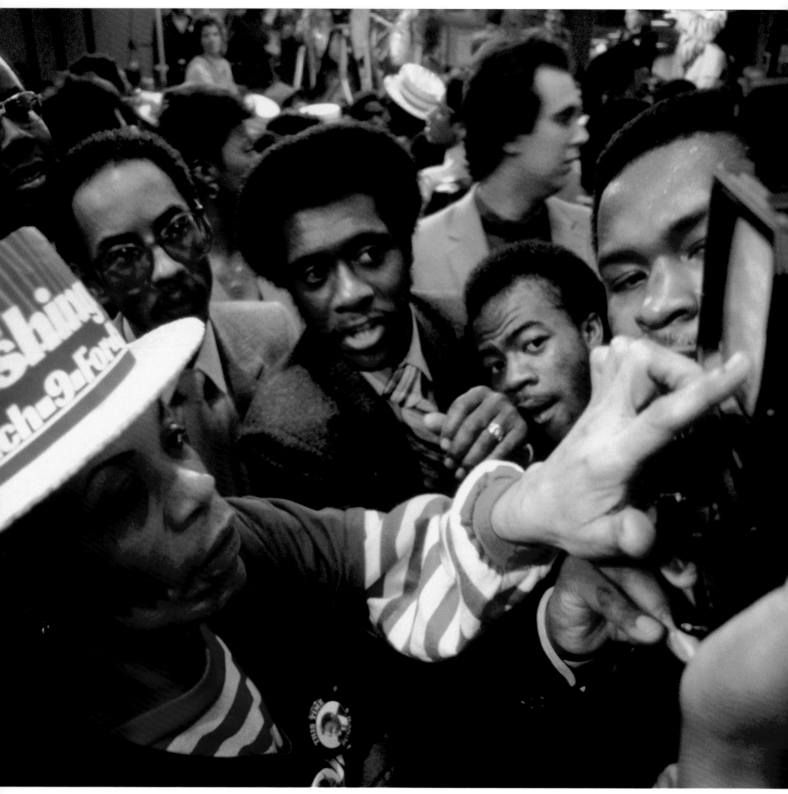

94 Harold!

Media pundits were temporarily humbled by their failure to gauge the power of Washington's electoral juggernaut.

That prospect provoked different reactions on the other side of town. Many of the city's shocked white voters were stunned into a surly silence—seemingly slammed by an electoral hammer. The racially disparate reactions were stark and troubling, prefiguring the tone of the general election campaign. Leanita McClain, a black editorial writer for the *Chicago Tribune,* described the mood in an essay published in the *Washington Post* on July 24, 1983.

> Through 10 years working my way to my present position at the *Tribune,* I have resided in a "gentrified," predominantly white, North Side lakefront liberal neighborhood where high rents are the chief social measure. In neither place have I forgotten the understood but unspoken fact of my "difference"—my blackness. Yet I have been unprepared for the silence with which my white colleagues greeted Washington's nomination. I've been crushed by their inability to share the excitement of one of "us" making it into power.

Media pundits were temporarily humbled by their failure to gauge the power of Washington's electoral juggernaut. Gary Rivlin revealed the scope of the problem in his 1992 book, *Fire on the Prairie: Chicago's Harold Washington and the Politics of Race.*

> Newscasters were speechless. Channel 2's Walter Jacobson shook his head, befuddled. How could all of us have been so wrong? Jacobson asked. He then looked around him and, in a rare moment of candor, offered that the problem was evident right there in the studio. Here they were, five white men, trying to describe a phenomenon occurring in neighborhoods about which they knew next to nothing.

Opposite: Campaign workers check early returns in a television cameraman's monitor at Washington's election-night party at the McCormick Inn. *Overleaf:* In the weeks after Washington's victory in the primary election, mainstream media reporters were still trying to recover from having missed the story. On February 19, the candidate was interviewed on the fly during a campaign stop on the lakefront near the Shedd Aquarium, a spot chosen for its panoramic view of the city. (Photograph © MP)

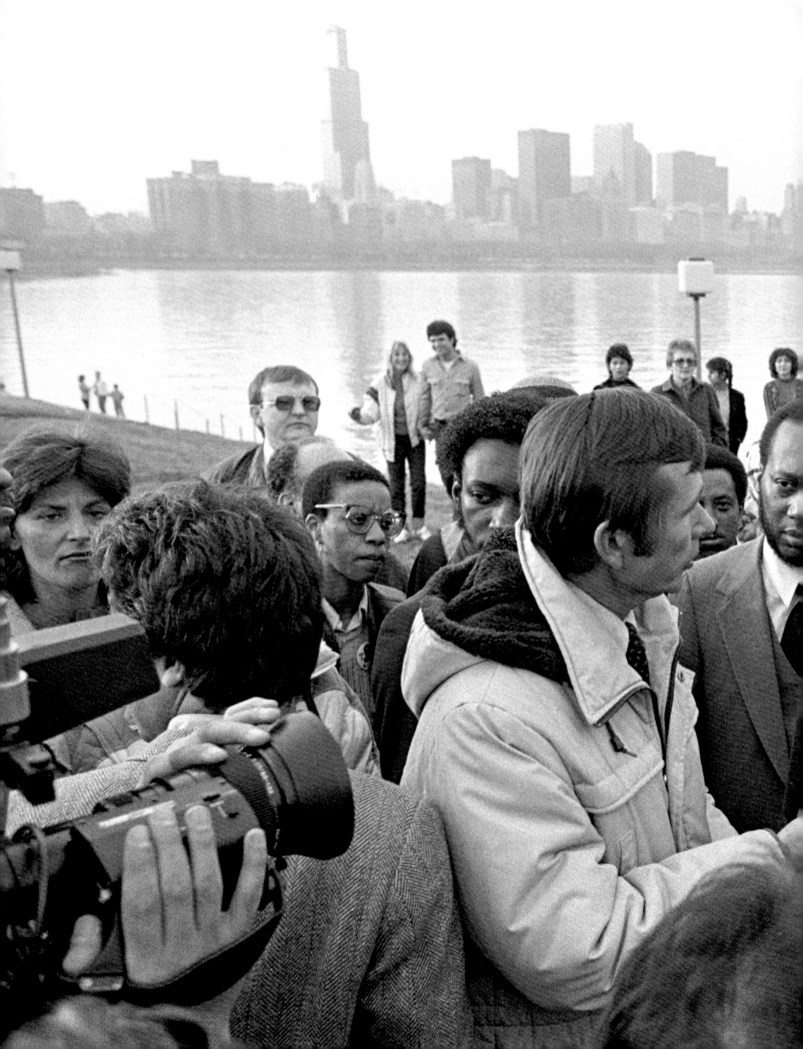

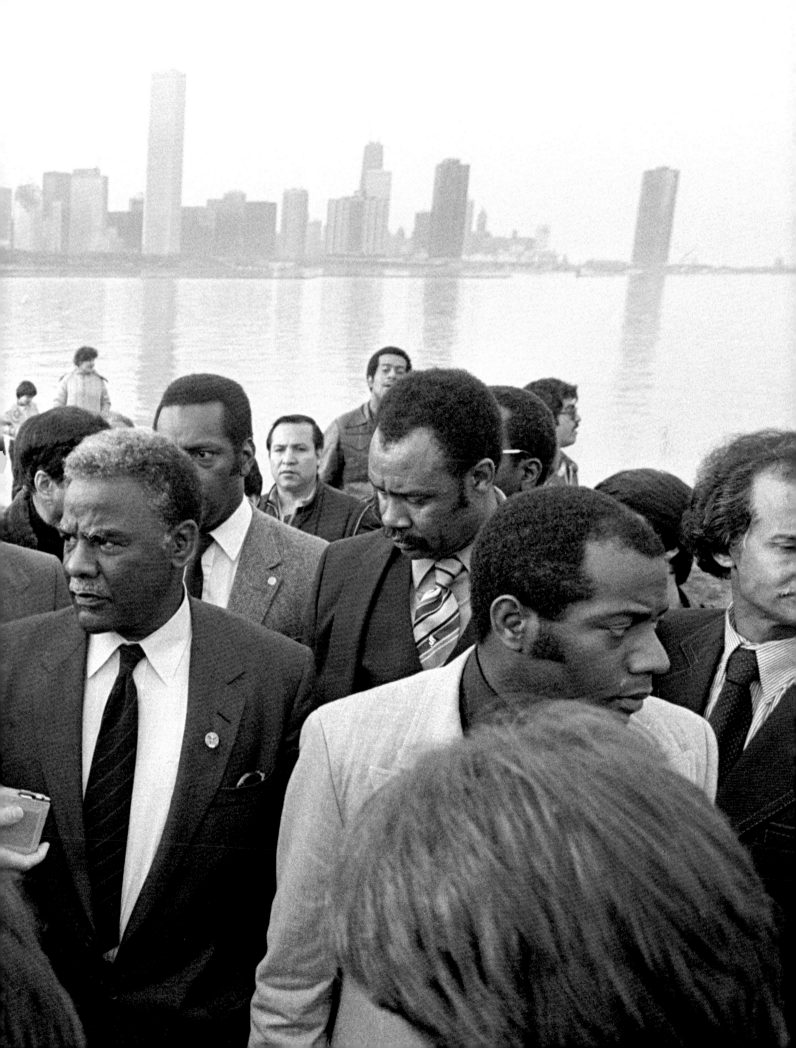

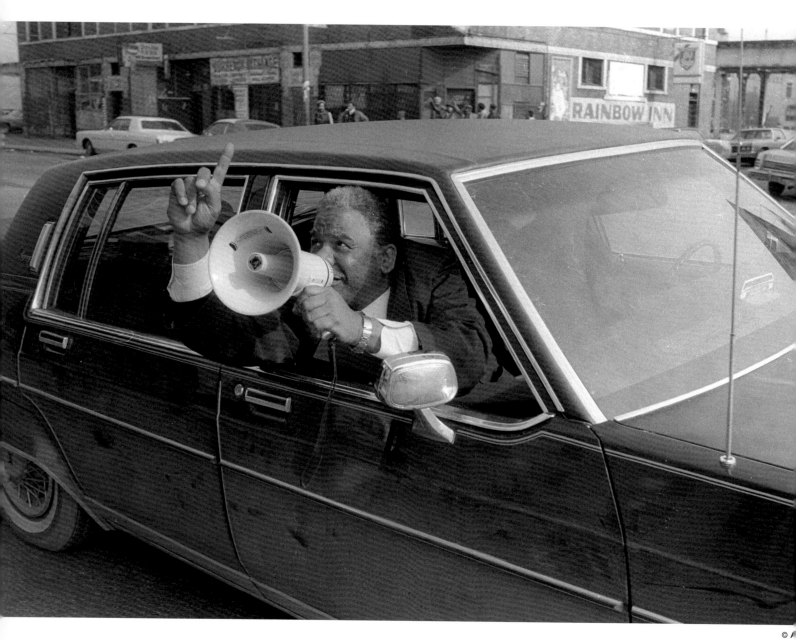

© A

Now the official Democratic nominee, Washington
continued to campaign nonstop. "We're number one" is
his message in this photograph, taken on the South Side.

Washington had some support in white and Latino neighborhoods. Walter "Slim" Coleman, a white activist with longtime links to black groups, had organized a group on the North Side called People Organized for Welfare Economic Reform (POWER), which mobilized blacks, Latinos, and poor whites to register thousands of voters and then get out the vote for the black candidate. Coleman's group had worked cooperatively with the South Side–based Task Force and provided a new model of coalition efforts. Mexican leaders Jesus "Chuy" Garcia, Juan Soliz, and Rudy Lozano joined with Puerto Ricans Luís Gutiérrez, Miguel del Valle, and José López to push their communities in Washington's direction. Although Washington never limited his campaign to a racial appeal, the victory was considered a win for Chicago's black community. And the racial animosity that surfaced just before the primary election soon bloomed in all its perverse glory.

Aldermen and committeemen close to the Democratic machine refused to align themselves with the party's standard-bearer. Washington's uncompromising blackness was one reason for this opposition, but his stated intention to interrupt business as usual was perhaps the more important. Grimshaw, author of *Bitter Fruit,* was also a Washington adviser. He wrote, "Party chairman Edward Vrdolyak conveyed word to Washington that the machine was willing to support him, but only . . . if Washington agreed to abandon his reform platform and work in concert with Vrdolyak to maintain the status quo."

Astute politician that he was, Washington recognized the difficulty of winning without the support of the machine's foot soldiers—but since his insurgent campaign was based on black self-determination as well as political reform, he lost little political currency by rejecting Vrdolyak's demand. And anyway, in a Democratic city like Chicago, winning the primary was supposed to be tantamount to a total electoral victory.

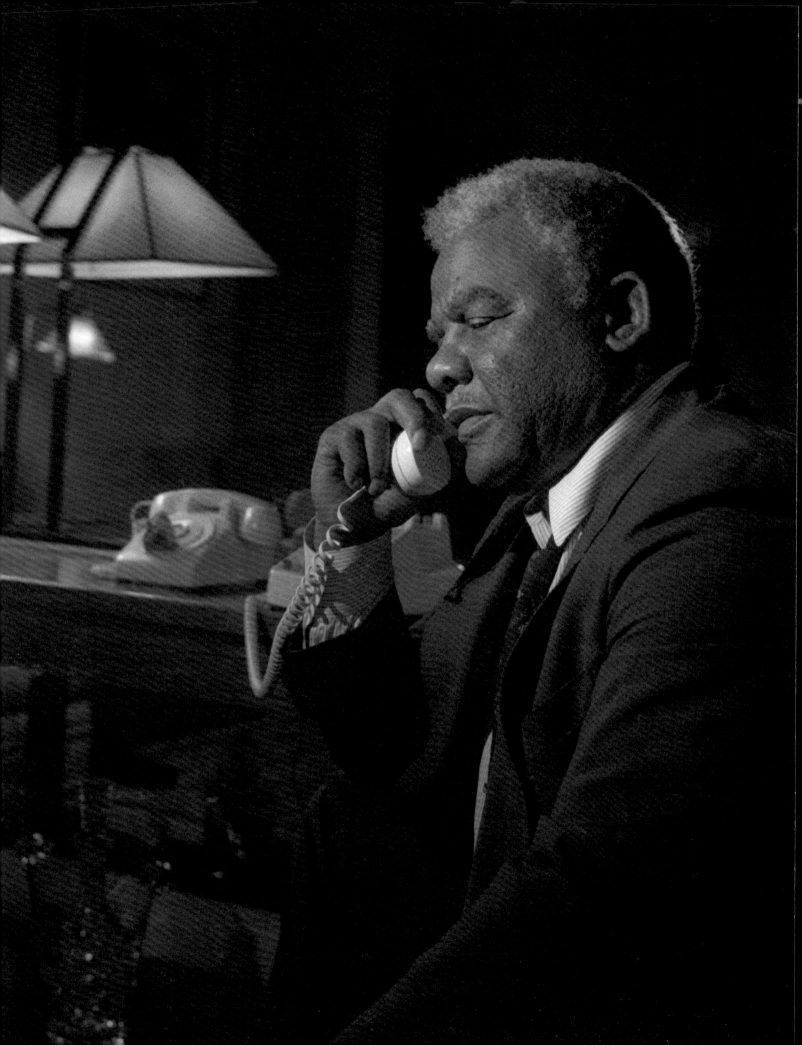

3!

"Before It's Too Late!" The

Republican Party's candidate for mayor in the general election
was Bernard Epton, a previously obscure former state legislator
from liberal Hyde Park, who had won the Republican primary
with just a few thousand votes. Many white Democrats,
dismayed by either Washington's race or his rhetoric,
changed party allegiance easily to become instant Republicans.
Washington's fiercest adversaries used well-worn appeals to
racial prejudice to disparage the black candidate; outrageous
racial caricatures appeared in ads attacking Washington. One
anti-Washington ad featured a watermelon with a black slash
through it; another said a Washington victory would change
the city's name to "Chicongo" with crossed chicken drumsticks
as the city seal.

Byrne, the defeated incumbent, announced in mid-March
that she was reentering the race as a write-in candidate to unify
what she said was a "fragile" city slipping into chaos. Her entry
into the race added to the political and racial polarization that
had taken hold since the primary election. Byrne said she was
compelled to jump in as a unity candidate, implying a sense of
urgency to her motive. Epton's campaign picked up on Byrne's
implication and created the infamous slogan: "Epton, before
it's too late." Byrne soon abandoned her write-in effort when
it became clear that most of the city's white voters had chosen
Epton's candidacy as a rallying point. Even those with deep
generational links to the storied Democratic machine opted
for Epton. Only two white committeemen (the political bosses
of the fifty aldermanic wards) openly pushed Washington's
candidacy, and they represented predominantly black wards.

The vast majority of the city's white committeemen joined the Epton camp. When Edward Vrdolyak, chairman of the Cook County Democratic Party, reportedly offered Washington machine support if he would ditch his reform agenda, Washington not only refused but threw down a political gauntlet of his own: if the party refused to endorse his candidacy, he would reciprocate by withholding support from the county ticket in 1984, potentially threatening thousands of patronage jobs by permitting suburban Republicans to control the Cook County Board. This pugnacious response was vintage Washington, but it diverged dramatically from the conciliatory style of black politics to which the machine was accustomed. Even legendary black politicians like Dawson derived their power from subservience to the machine and the favors it allotted. By abandoning this deeply rooted racial protocol, Washington made it clear he was a different kind of black politician. This audacious black candidate not only challenged the established racial hierarchy, he also sought to rearrange the city's political architecture. For many machine-bred politicians, this realization more starkly defined Washington's threat and added urgency to the mobilization of white opposition. While more progressive machine politicians may have opposed appeals to racial allegiances, they nonetheless understood the utility of such appeals. The gloves were off, so to speak, and Washington had to be defeated by any means necessary.

One question outweighed all others, Epton said: "Will he obey the law?"

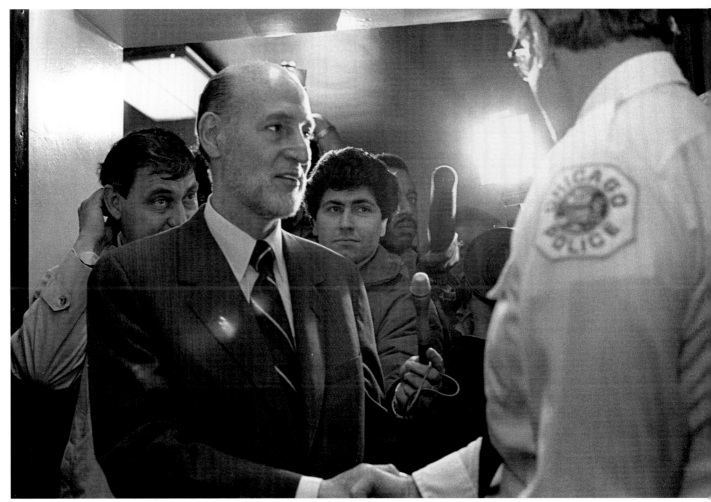

© MP

Republican candidate Bernard Epton made
frequent campaign stops at police stations,
including this one on the Northwest Side.

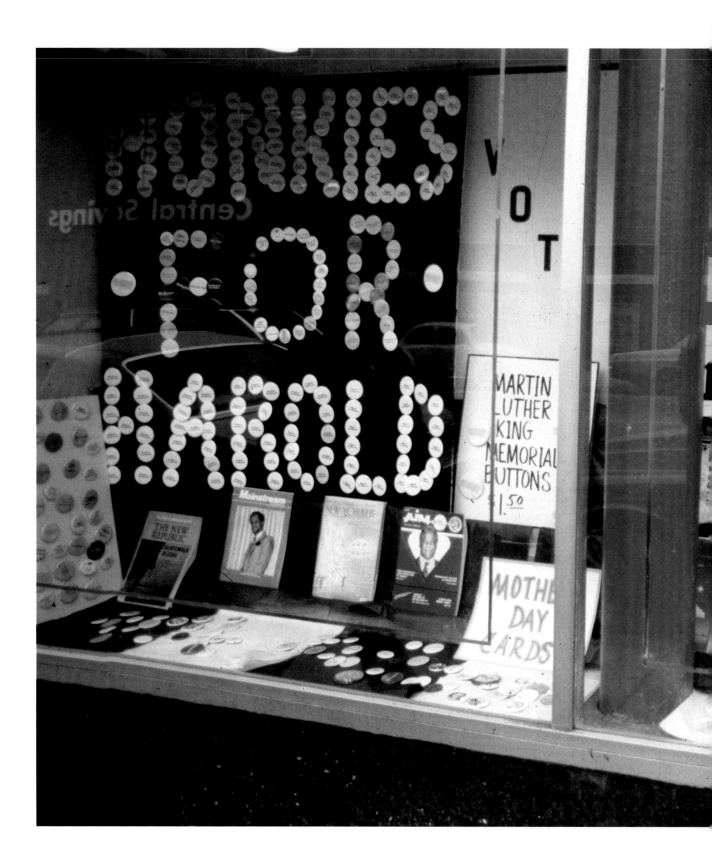

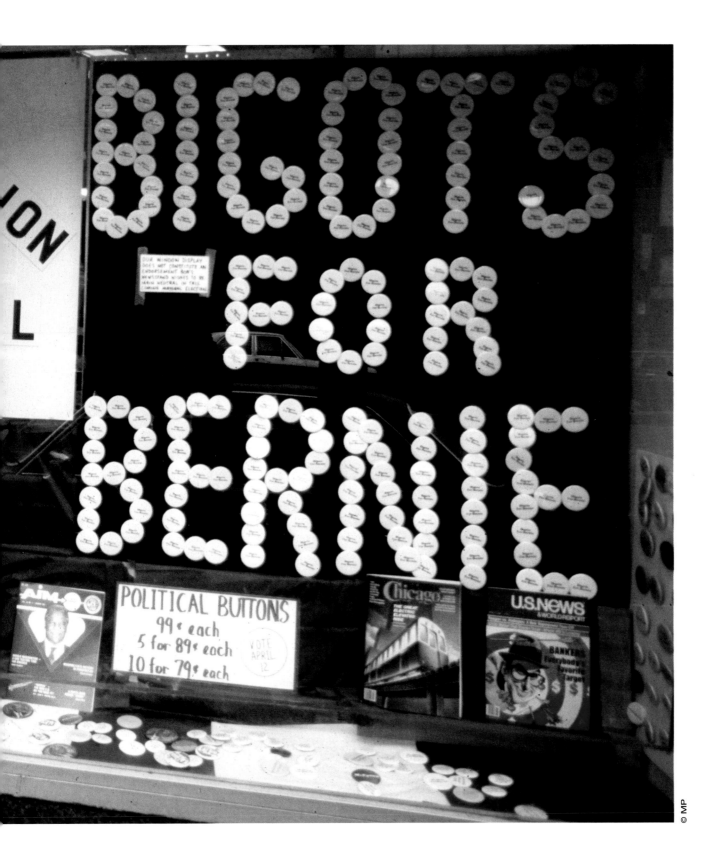

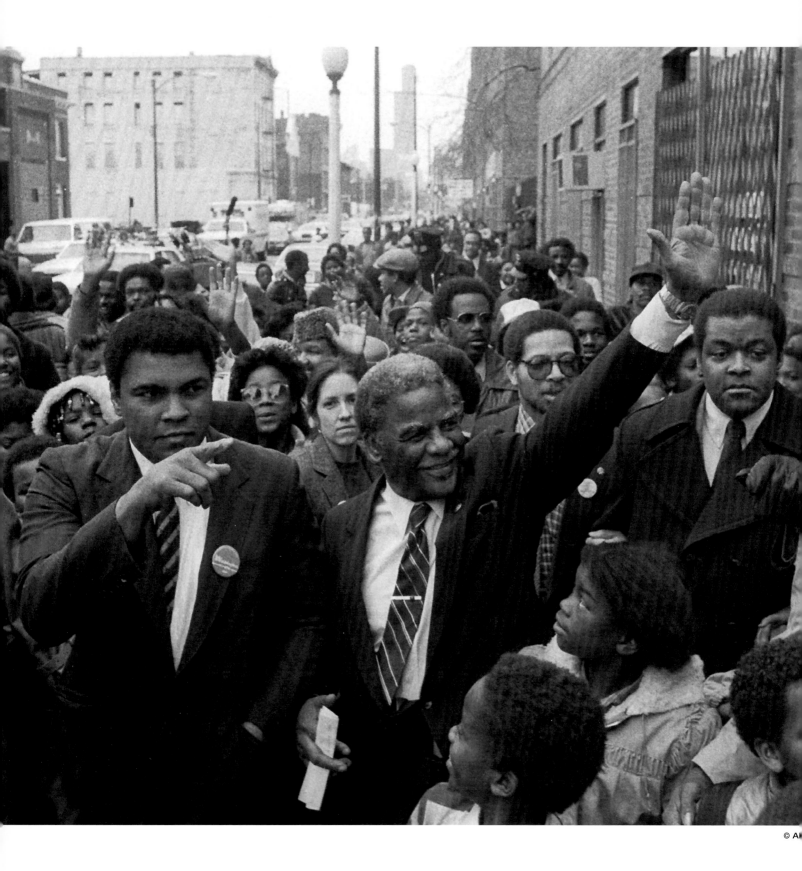

106 **Harold!**

While more progressive machine politicians may have opposed appeals to racial allegiances, they nonetheless understood the utility of such appeals.

While racial animosity was the primary fuel of the Republican campaign, Washington's sloppy handling of his business affairs offered Epton another angle of attack. He repeatedly referred to Washington's conviction for tax evasion (he had served forty days in jail for failing to file tax returns for four years) and the brief suspension of his law license in the early 1970s for "failure to render adequate service" to a client. The Epton campaign focused on these infractions almost to the exclusion of any other campaign issue. The racial aspect could go unmentioned because the cultural linkage of "blackness" and crime was an ever-present subtext. Epton hammered away at Washington's alleged character flaws in his standard stump speech, painting the picture of an arrogant man who was woefully negligent, perhaps even criminal. In his opening statement in the lone debate of the general election campaign, Epton declared that no issue was as important as Washington's background.

Left: Muhammad Ali, campaigning with Washington, admonishes a bystander to remember to vote. In dark glasses behind Washington's outstretched arm is former Black Panther Bobby Rush, a (successful) candidate for the city council who was later elected to Congress.

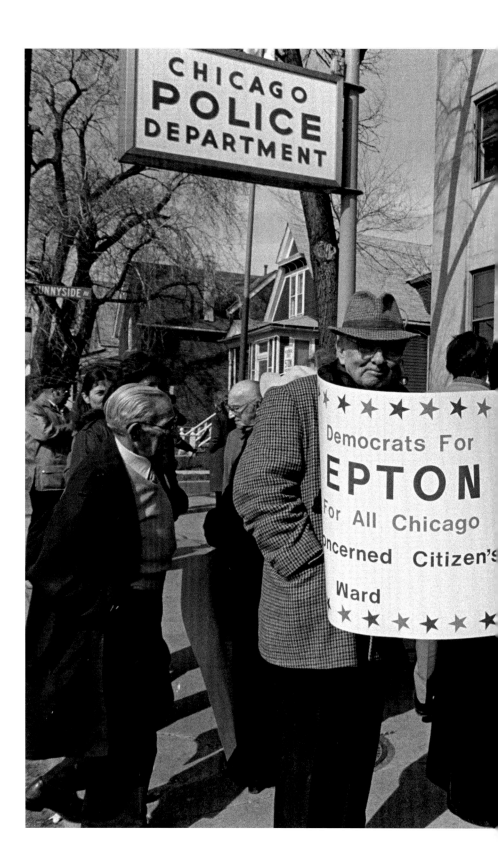

Right: Many lifelong Democrats deserted their party's candidate in favor of Republican Bernard Epton. The woman in the foreground holds a sign proclaiming Epton's Democratic support in the Thirty-ninth Ward on the Northwest Side. *Overleaf:* The button man. "Honkies for Harold" ultimately turned out to be 12 percent of white voters. (Photograph © MP)

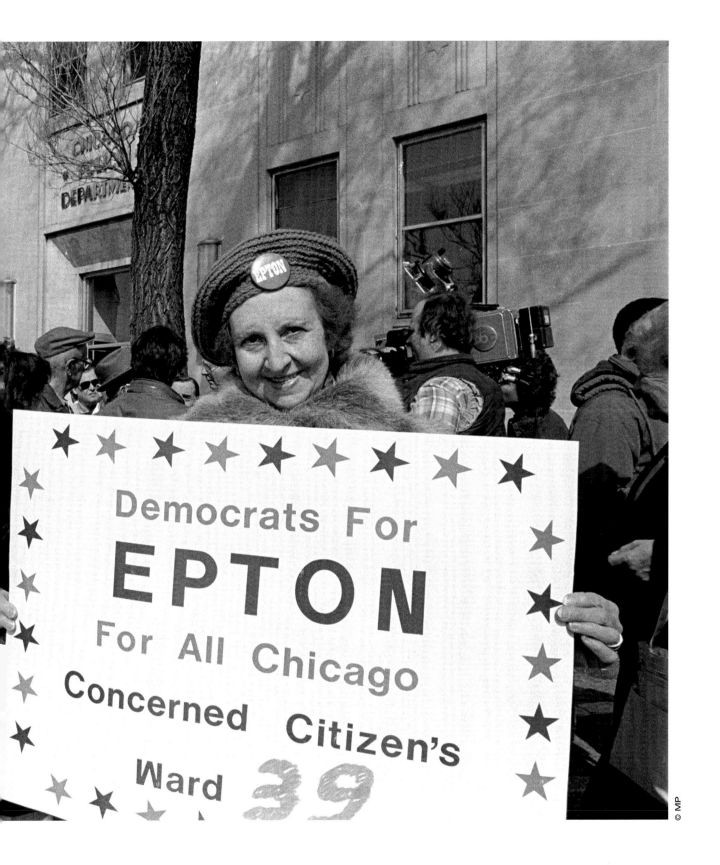

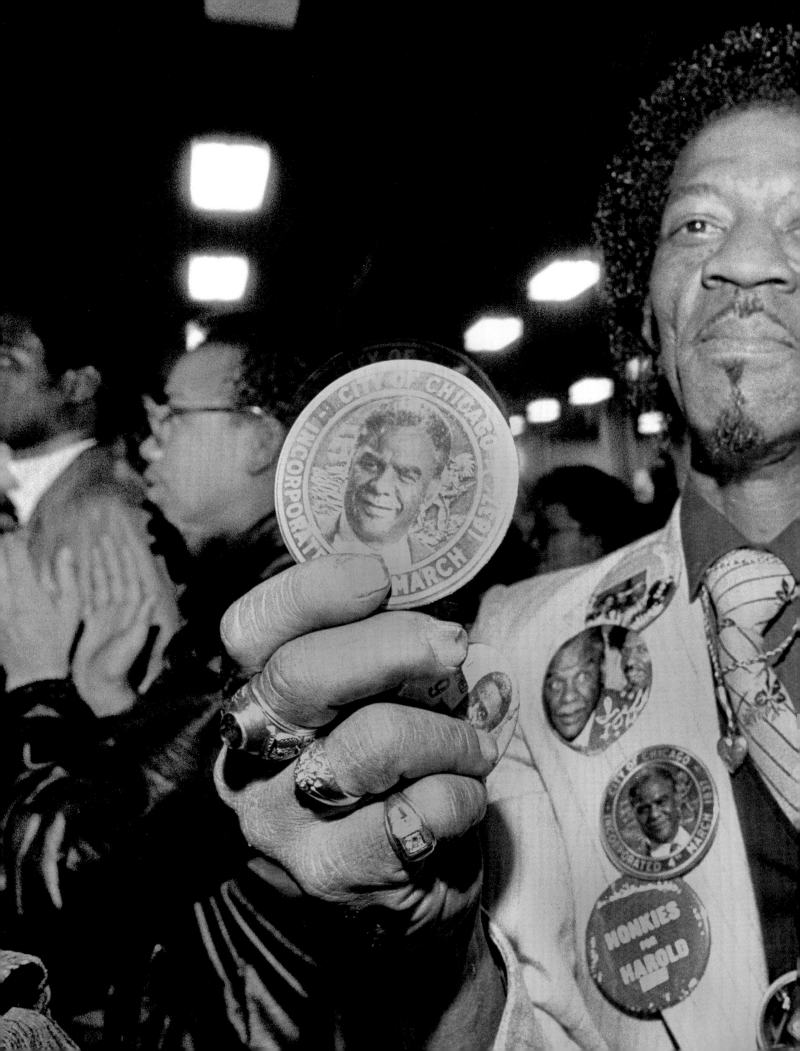

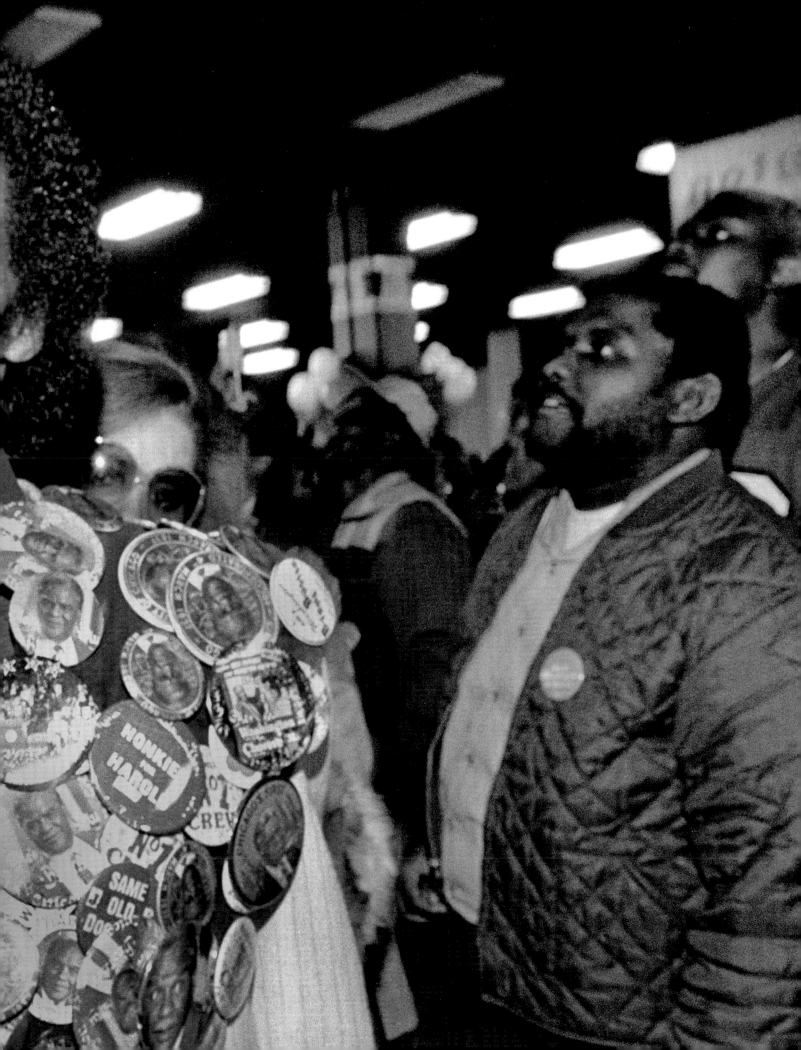

One question outweighed all others, Epton said: "Will he obey the law?" Washington countered that his legal infractions were mere personal indiscretions, and, while the record supports his contention, it did little to dull Epton's attacks. Because of the racial subtext, the Republican candidate could afford to abandon and even disavow racist rhetoric (and soon ditched his apocalyptic campaign slogan). However, his supporters were not as reticent. Many of the city's white residents were openly contemptuous of Washington and let the world know it. During a visit to a Catholic church on the city's Northwest Side, for example, an angry crowd of whites, shouting crude racial epithets, among other things, confronted Washington and former vice president Walter Mondale. Gary Rivlin, rendering the campaign in *Fire on the Prairie,* observed: "Whites attending Epton rallies startled reporters with their frank comments about not wanting a nigger mayor. They held up signs calling Washington a 'crook' and took to wearing a variety of political buttons decidedly racial in appeal: one showed a watermelon with a black slash through it . . . VOTE WHITE, VOTE RIGHT, one popular T-shirt boldly proclaimed." He added, "A white woman wearing a Washington button was told, 'He wins, you'll get raped.'"

Below: An Epton supporter trails Washington's entourage, which on this occasion includes former vice president Walter Mondale at far right in the photograph, at a Northwest Side church. This event made national news. *Opposite:* As Washington campaigns at a church on the Southwest Side, an unidentified protester makes his views known. *Overleaf:* Epton and Washington partisans compete for the attention and allegiance of commuters and passersby in neighborhoods throughout the city.

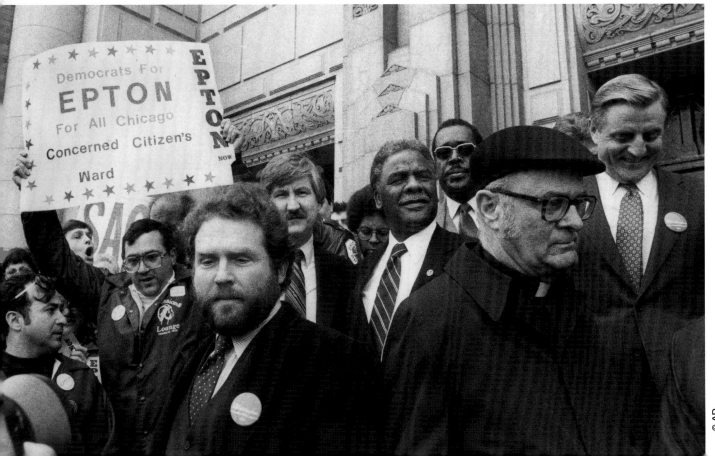

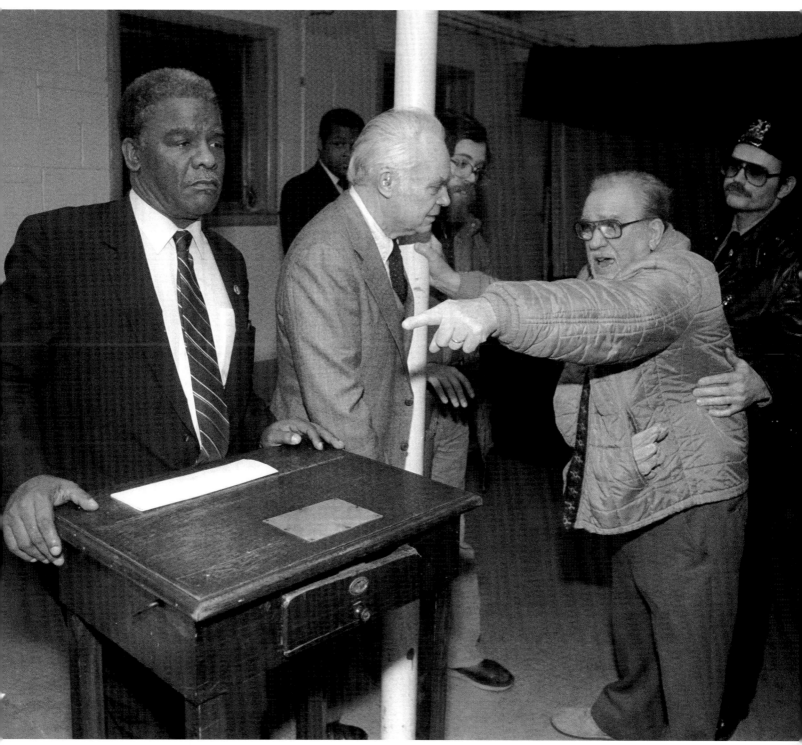

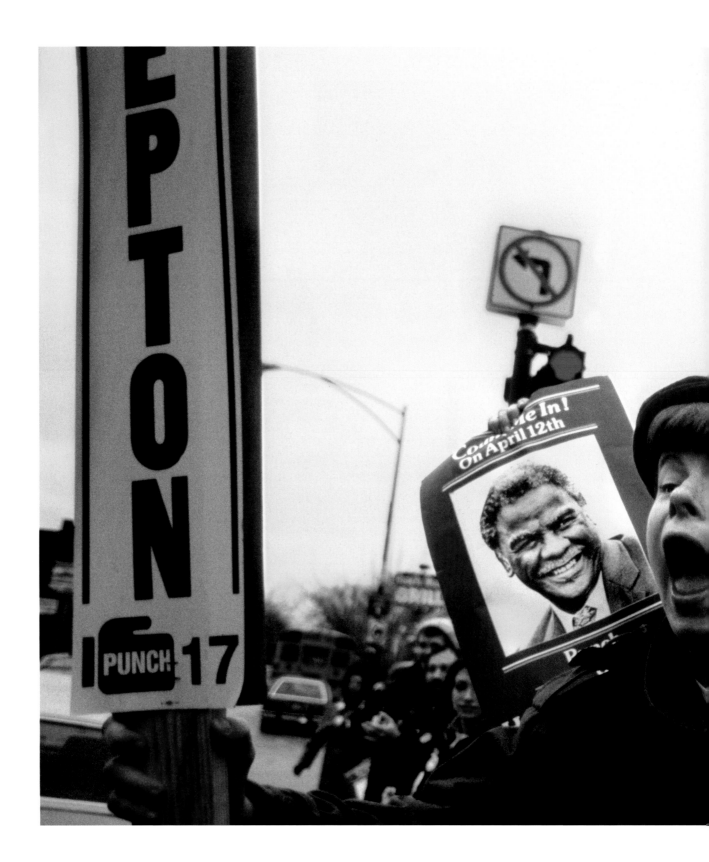

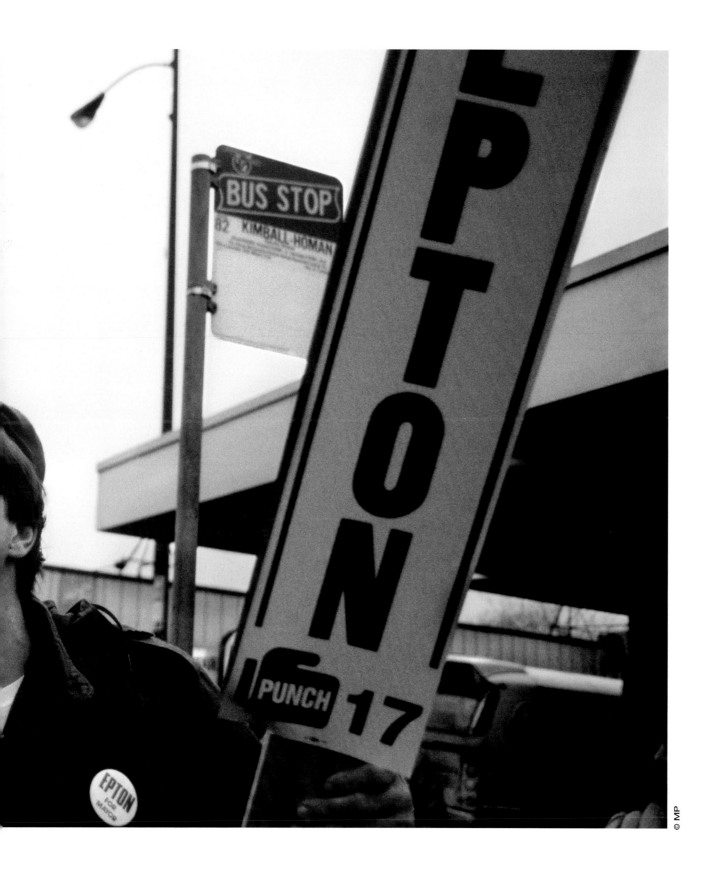

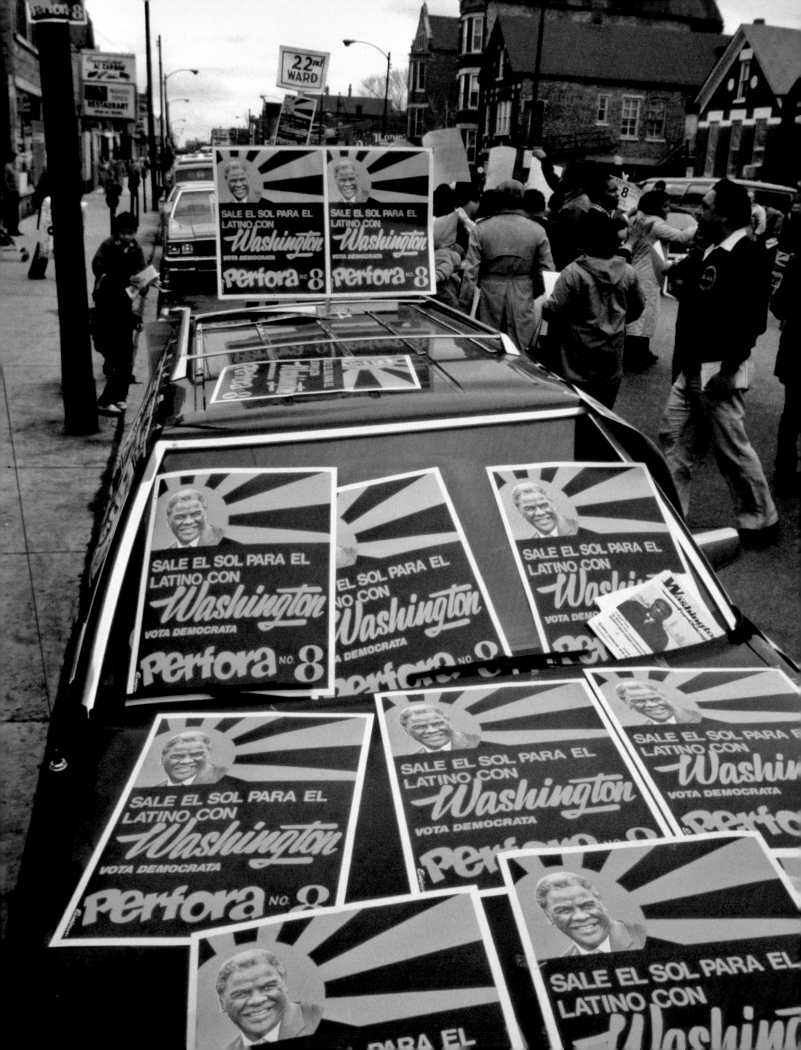

Most whites were voting for Epton, blacks were voting for Washington, and Latinos were a mystery—though most analysts suspected they would join the Democratic candidate.

Epton continued plugging away at past legal problems that called Washington's character into question, seeking to provide progressive white voters reasons other than race to vote against the Democratic candidate. For its part, the Washington campaign seemed caught a bit off guard by Epton's consistent attacks on Washington's integrity. The Republican candidate dug up a number of minor charges, such as an unpaid utility bill from a former campaign, and added them to his litany of accusations. Despite those particulars, the election really boiled down to a racial contest. Most whites were voting for Epton, blacks were voting for Washington, and Latinos were a mystery—though most analysts suspected they would join the Democratic candidate.

Opposite: Latino support for Washington increased after the primary election, as racial lines were drawn more starkly in the political discourse. Washington's familiar sunburst logo took a new form on posters proclaiming "sunrise for the Latino with Washington." *Overleaf:* Crowds became larger and more enthusiastic as Washington became a familiar figure in Mexican and Puerto Rican neighborhoods. (Photograph © MP)

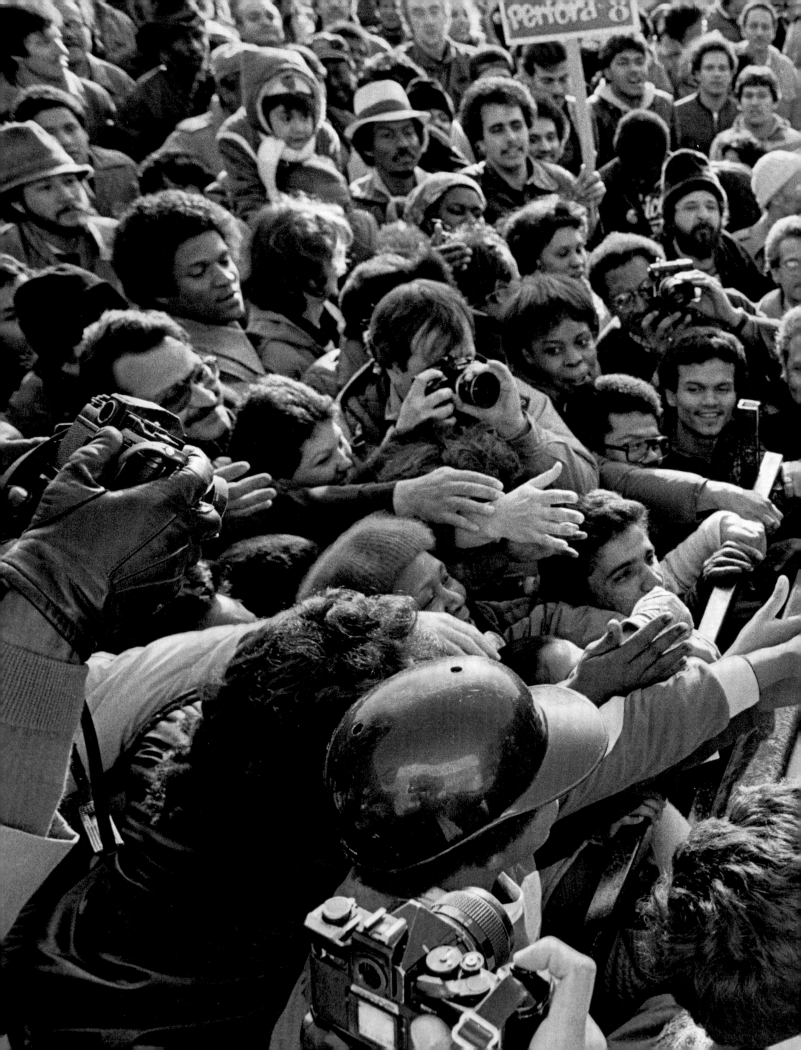

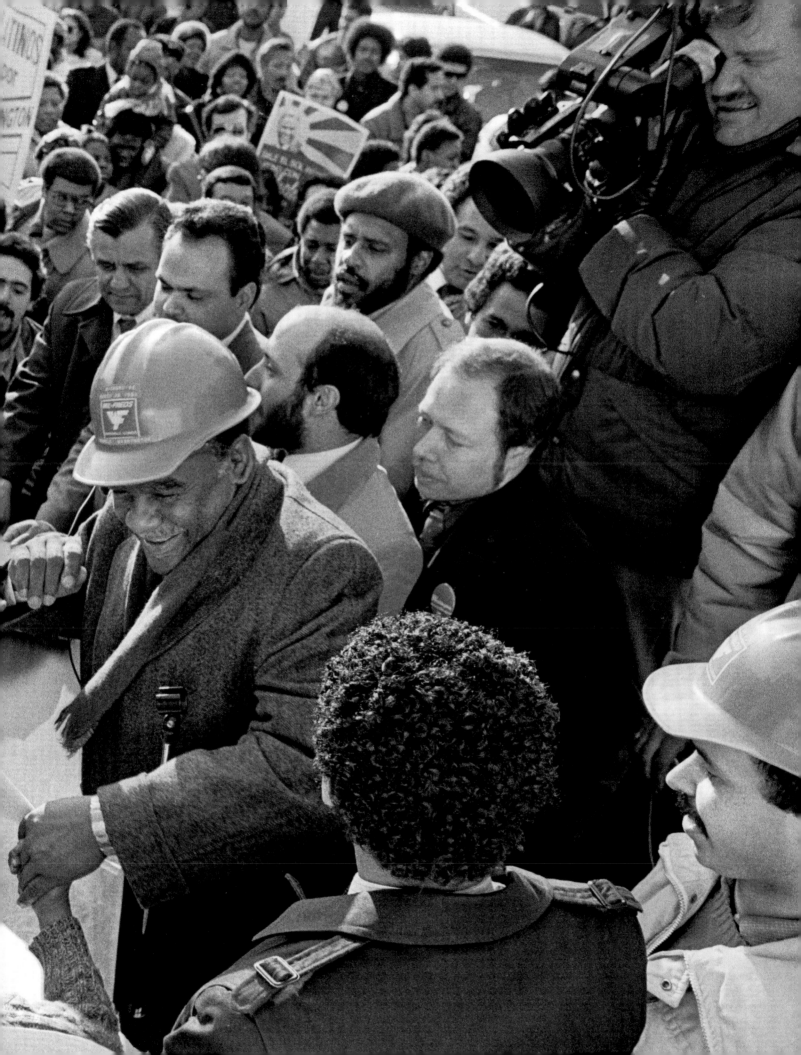

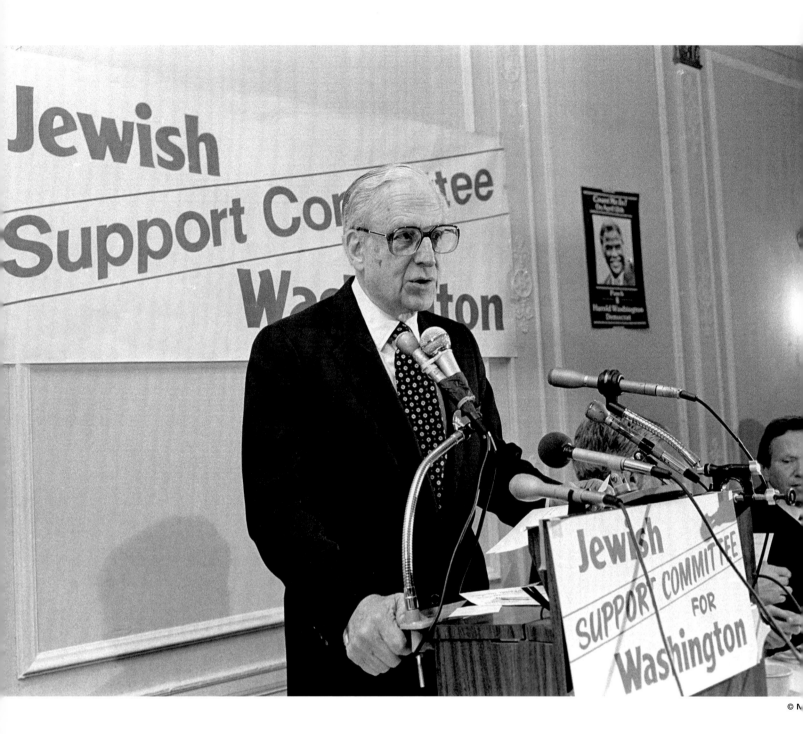

© M

Above: Former Fifth Ward alderman and city council parliamentarian Leon M. Despres addresses a group of Washington's Jewish supporters. *Right:* The racist turn of the campaign stiffened the resolve of black voters, who would turn out in record numbers to "Punch 8" for Harold on election day.

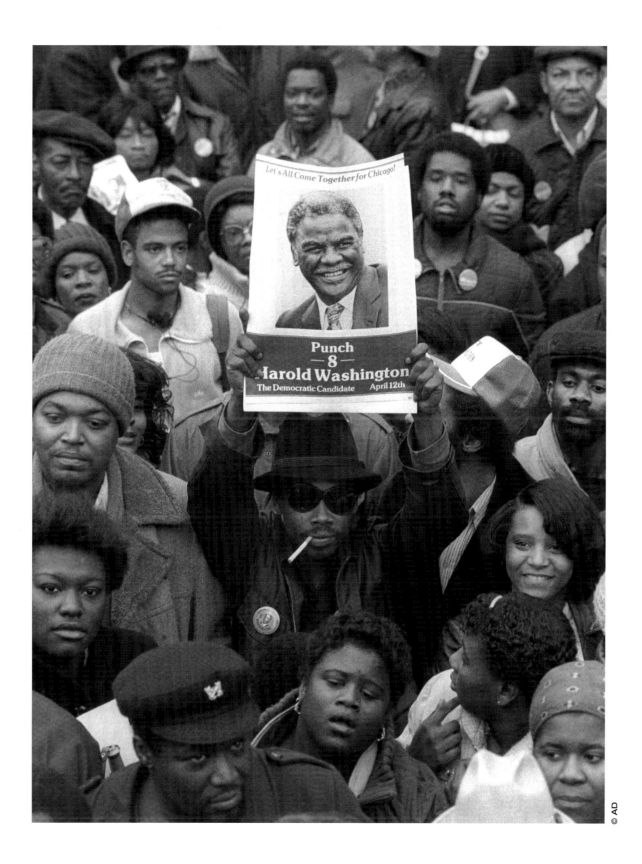

Text on poster: Let's All Come Together for Chicago!

Punch — 8 — Harold Washington The Democratic Candidate April 12th

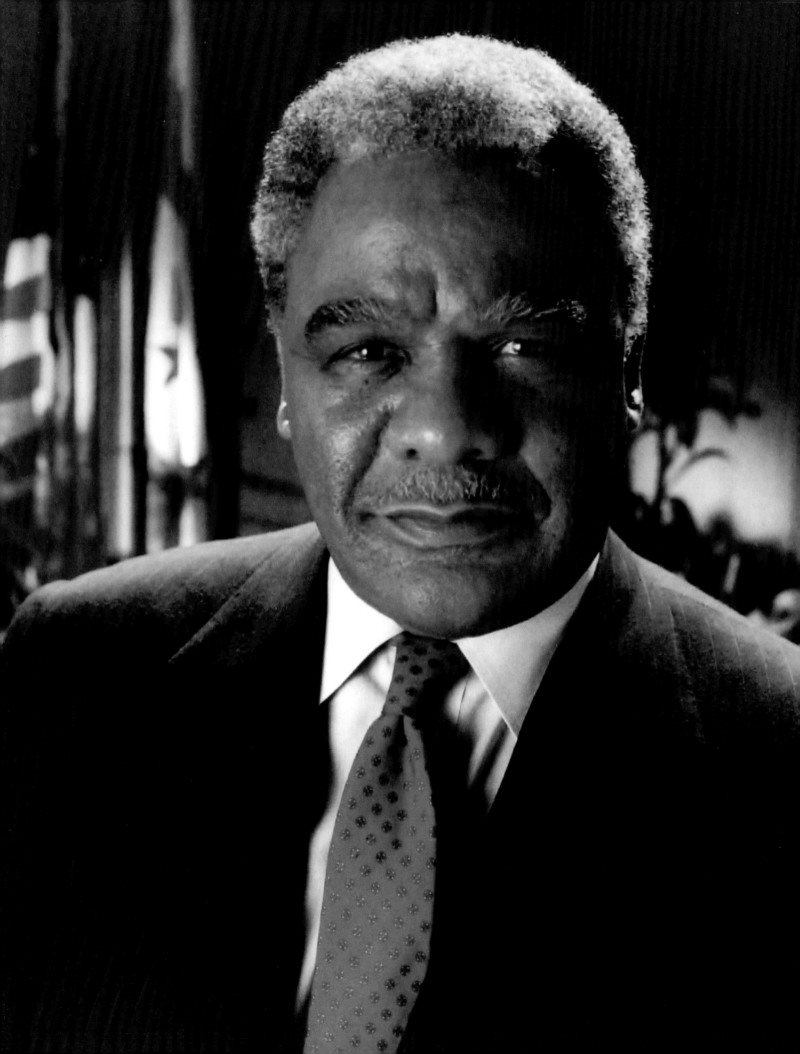

Barack Obama

"

Clumps of hair fell into my lap as I listened to the men [in the barbershop] recall Harold's rise. He had run for mayor once before, shortly after the elder Daley died, but the candidacy had faltered—a source of shame, the men told me, the lack of unity within the black community, the doubts that had to be overcome. But Harold had tried again, and this time the people were ready. They had stuck with him when the press played up the income taxes he'd failed to pay ("Like the white cats don't cheat on every damn thing every minute of their lives"). They had rallied behind him when the white Democratic committeemen, Vrdolyak and others, announced their support for the Republican candidate, saying that the city would go to hell if it had a black mayor. They had turned out in record numbers on election night, ministers and gang-bangers, young and old.

And their faith had been rewarded. Smitty said, "The night Harold won, let me tell you, people just ran the streets. It was like the day Joe Louis knocked out Schmeling. Same feeling. People weren't just proud of Harold. They were proud of themselves. I stayed inside, but my wife and I, we couldn't get to bed until three, we were so excited. When I woke up the next morning, it seemed like the most beautiful day of my life . . ."

"

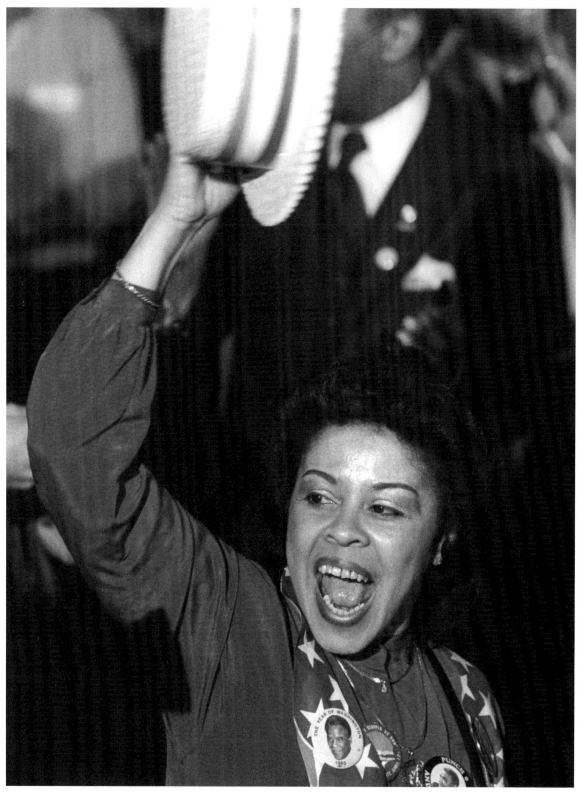

124 **Harold!**

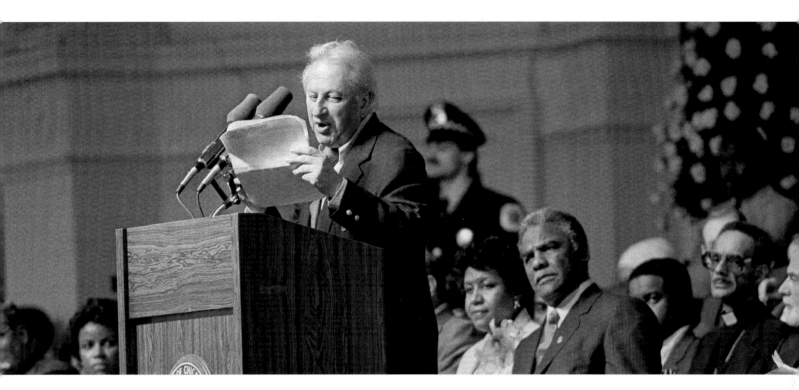

Washington won the April 12 general election with 51 percent of the vote. Black turnout was a remarkable 85 percent, and Washington won more than 99 percent of it. He also won 82 percent of the Latino vote. About 12 percent of white Chicagoans voted for Washington. The white committeemen and aldermen who supported Epton, either openly or covertly (including county Democratic chairman Vrdolyak), began designing other strategies. The struggle had moved to another battlefield.

Opposite: A Washington supporter rejoices as her candidate is proclaimed winner of the mayoral election. *Above:* Author Studs Terkel speaks at the mayor's inauguration on Navy Pier, April 29, 1983. As he remembers it: "I was reading from notes, it was a love letter to Chicago, love and hate, the two aspects of Chicago working together at the same time. The city of 'I will.' But what about those who say, 'I can't'? It was a double city, a double vision of Chicago." *Overleaf:* Judge Charles E. Freeman swears in the new mayor at the inauguration on Navy Pier. Among those looking on are Mayor Washington's fiancée Mary Ella Smith (*at far left*); author Studs Terkel (*fourth from left, holding papers*); Gwendolyn Brooks, the poet laureate of Illinois (*with eyeglasses and headband behind the mayor*); Joseph Cardinal Bernardin, the Roman Catholic archbishop of Chicago; and former mayor Jane Byrne and her husband, Jay McMullen. (Photograph © MP)

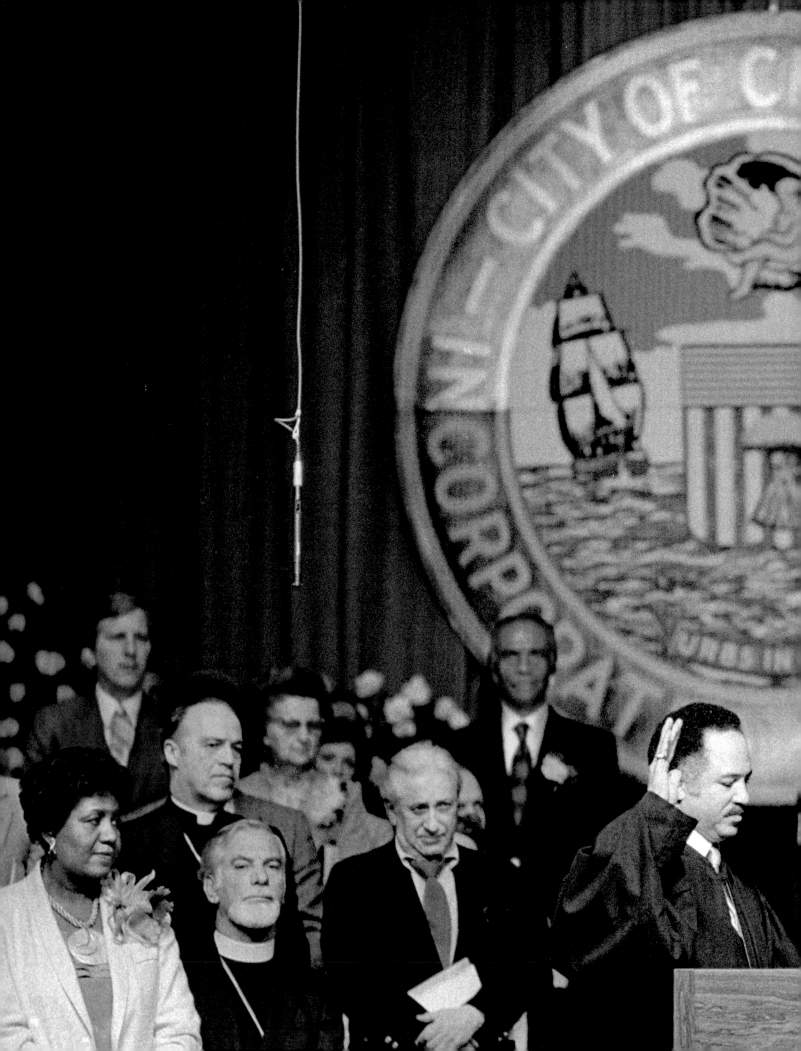

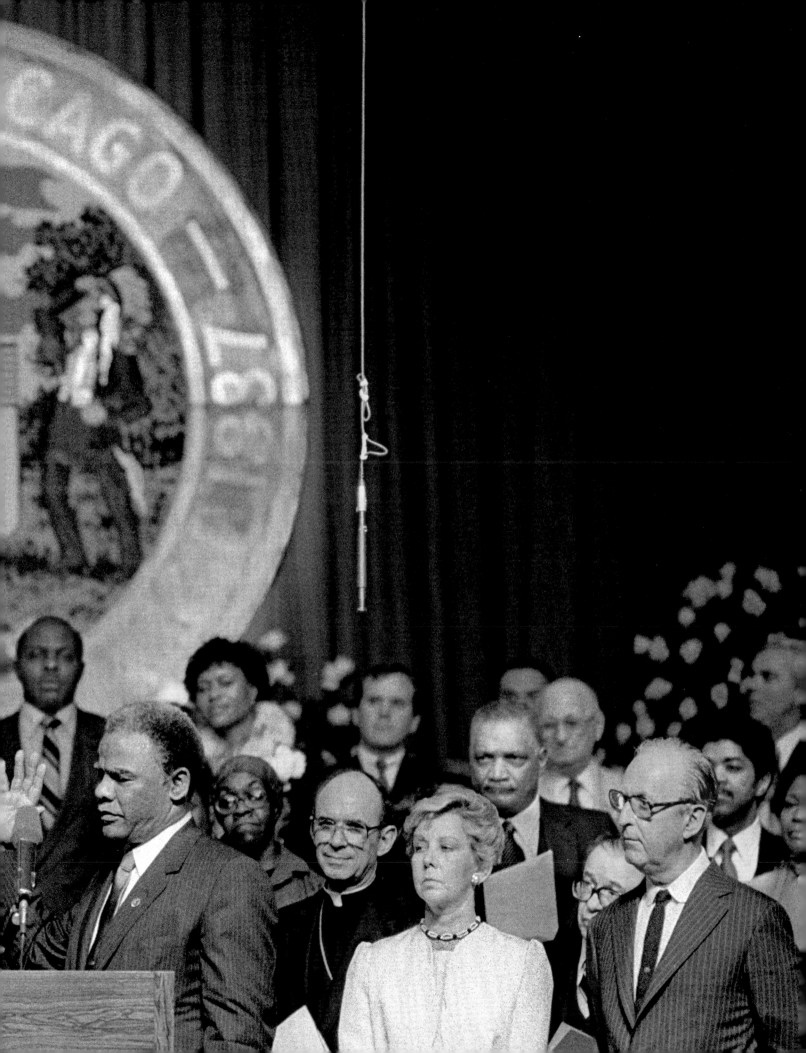

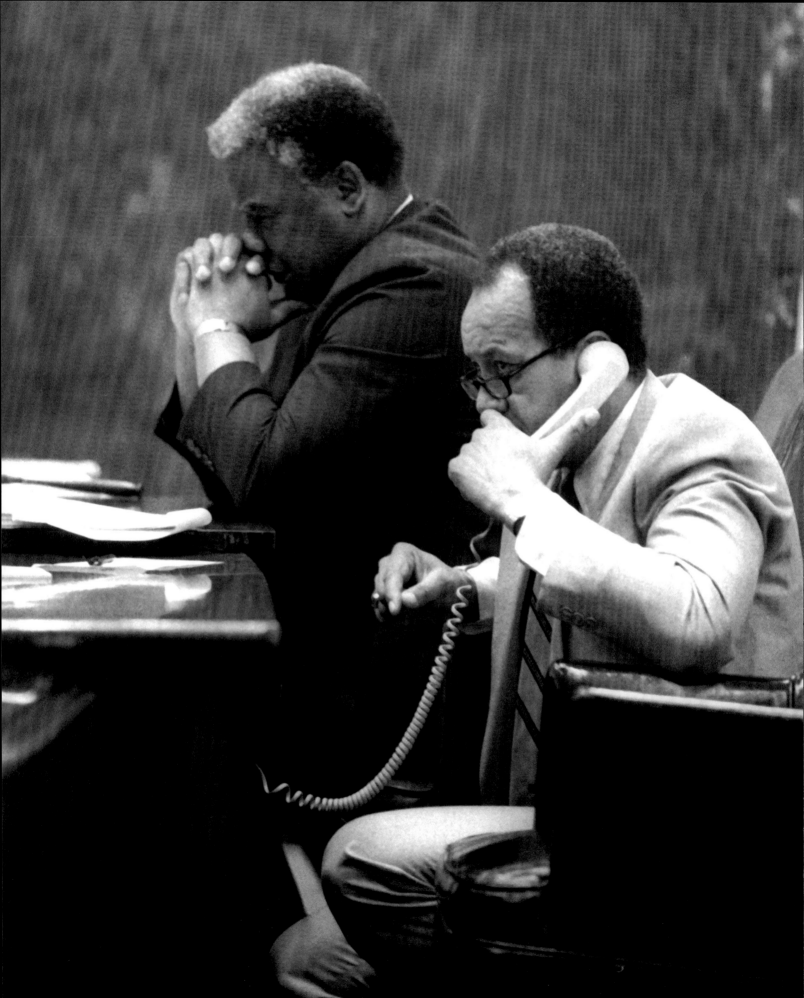

4!

Council Wars

Washington became Chicago's forty-second mayor on April 12, 1983. He won the general election against Republican Bernard Epton by 48,250 votes out of the 1.3 million cast. The black community was ecstatic about his win and expected big changes when he took over City Hall. But the city's first black mayor ran smack into a wall of white political opposition. Edward R. Vrdolyak, alderman of the Tenth Ward and chairman of the Democratic Party, became the mayor's leading opponent and quickly molded twenty-eight white (and one Latino) members of the city council into an opposition bloc. Washington controlled a bloc of twenty-one members, which included all sixteen of the city's black aldermen and a few white liberals. This legislative imbalance made for entertaining televised council meetings and governmental gridlock. The council had acted as a rubber stamp during the tenures of Daley, Bilandic, and Byrne, but now it had become the center of political agitation. The twenty-nine to twenty-one alignment ensured a political stalemate. The Vrdolyak bloc had enough votes to pass any resolution or ordinance it desired but lacked the two-thirds needed to override the mayor's veto. A brilliant local comedian named Aaron Freeman mined the political gridlock for material in a skit he called "Council Wars," a takeoff on the movie *Star Wars*. Vrdolyak was Darth Vader (Darth Vrdolyak) and the mayor was cast as a hulking Luke Skywalker (Harold Skytalker); the skit's title became a convenient label for the political battle between the Vrdolyak 29 and the Washington 21.

Left: With the city council split 29 to 21 against him, the mayor contemplates his next move with Corporation Counsel James Montgomery.

129

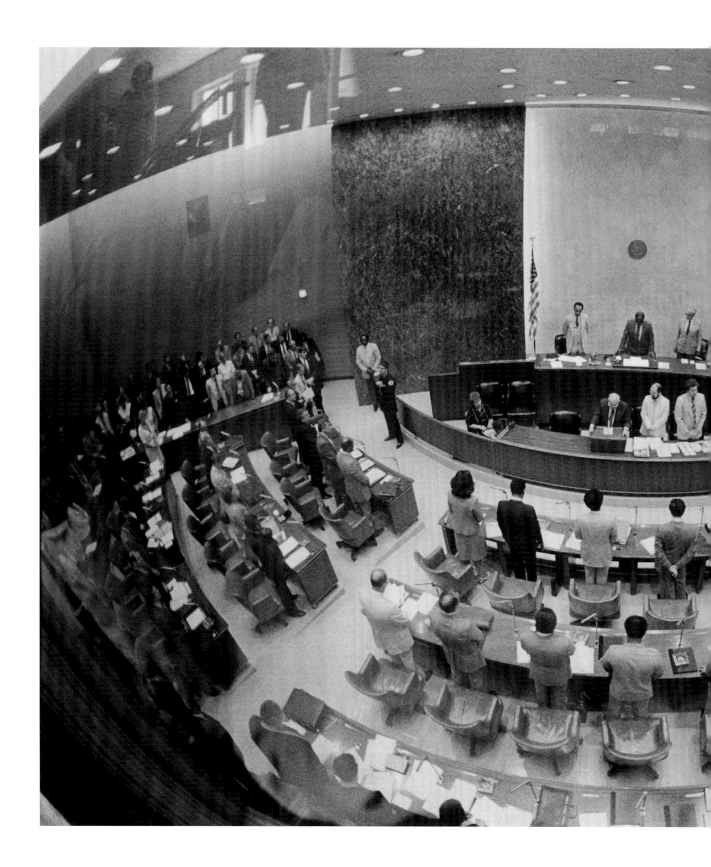

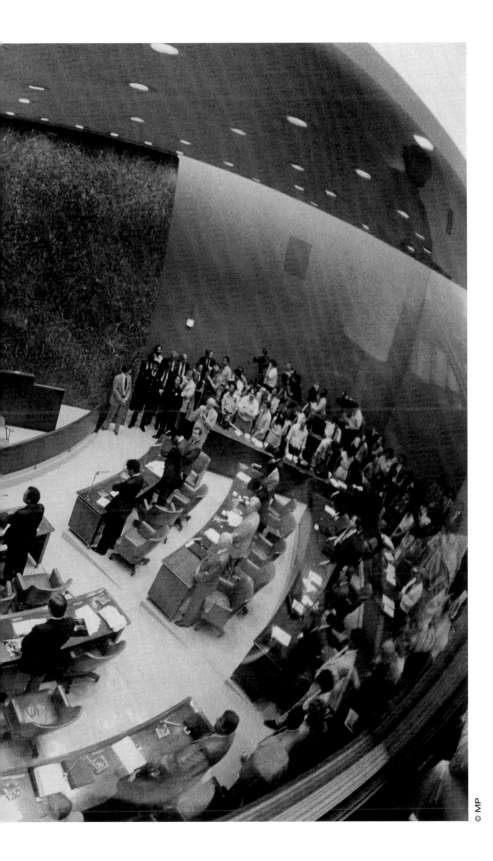

© MP

"Let us pray": A city council meeting opens with a prayer before erupting into Darth versus Luke warfare.

There were struggles over control of key city appointments, funds for city agencies, staffing of the police and fire departments, allocation of park resources, and sites for future public housing. Delay was the main tactic of the Vrdolyak forces. Their media strategy was to impugn Washington's integrity and portray him as a fake reformer out to create a black machine; for example, they characterized his support of affirmative action as just another form of patronage.

The majority bloc also sought to portray the Washington administration as incompetent, slyly exploiting biased assumptions about black people. Additionally, they tried to divide the rickety Washington coalition, seeking to create tension between blacks and Jews, between Latinos and gays, and between black reformers and those linked to the machine. Alderman Vrdolyak was the overall leader, and Edward Burke, who was chairman of the council's Committee on Finance and one of its most competent aldermen, was his chief ally. Burke was an expert parliamentarian, and his powerful position on the council allowed him unique access to restricted documents. The two opposition leaders became known as the Eddies. The labels were media friendly and, in fact, the media seemed much friendlier to the Vrdolyak 29 than to Washington's forces.

Below: Washington's chief of staff Bill Ware is besieged by reporters. *Opposite:* Alderman Edward Burke, chairman of the Committee on Finance.

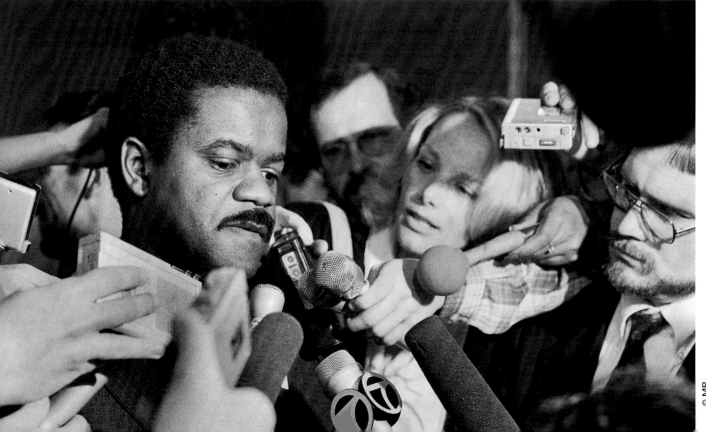

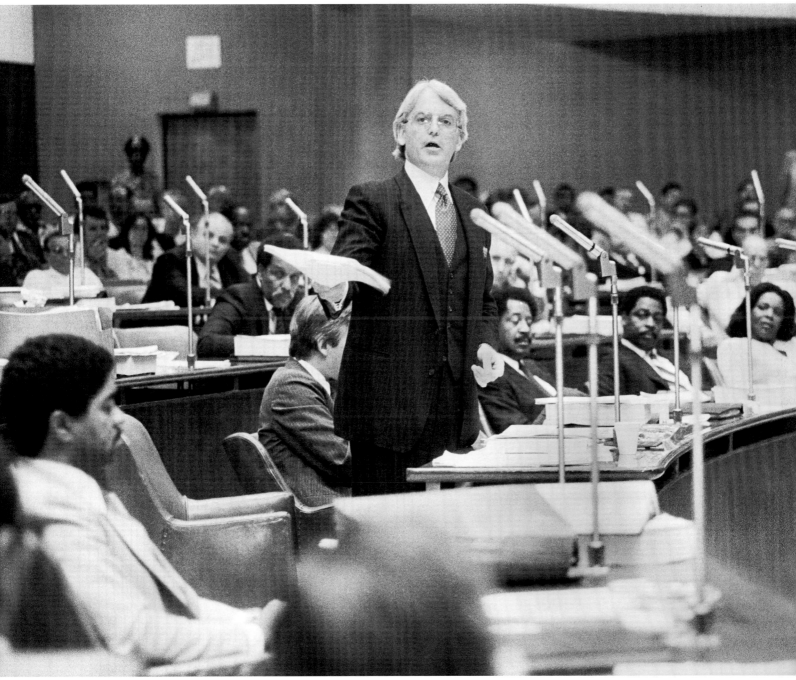

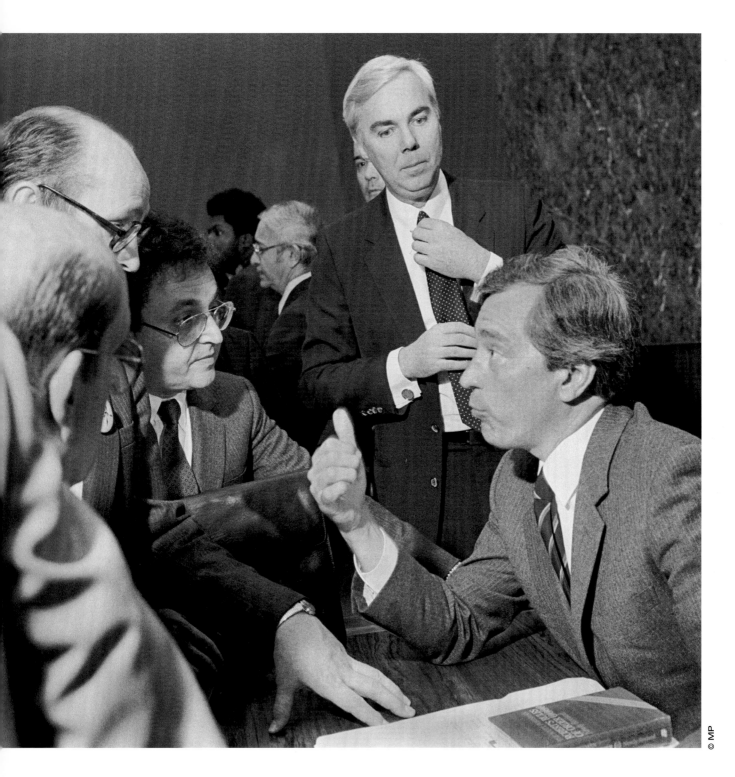

Alderman Edward R. Vrdolyak (*seated at right*) confers with allies and *Robert's Rules of Order* as Council Wars continue.

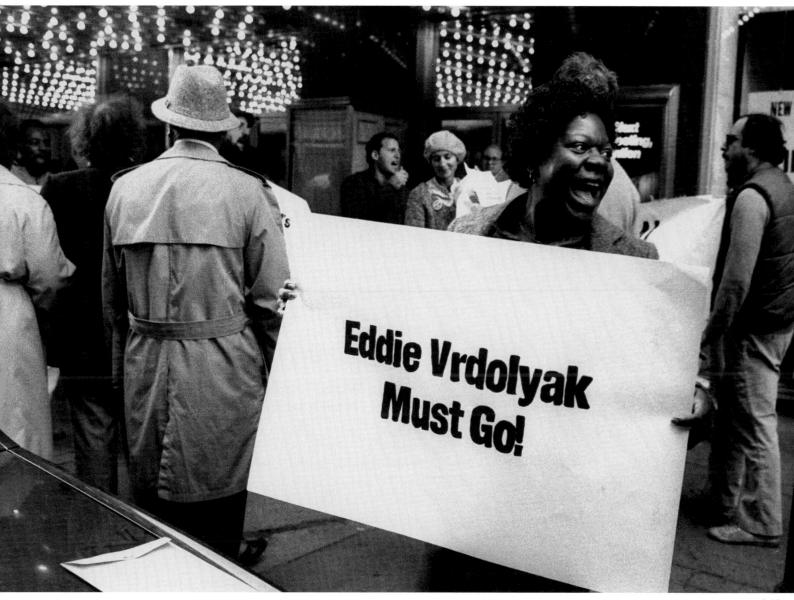

This was not merely a tale of politicians playing politics; there was genuine enmity in this conflict.

Leon M. Despres

"

Well, I look back, I think I should have resigned as
[Byrne's] parliamentarian . . . But I didn't. And I didn't
come to that decision until this afternoon [November
8, 2004] . . . It was my ambiguous position because I
contributed some money to Washington's campaign. And
I gave it to Tom Geoghegan [Despres' law partner] and
asked him to contribute it in his name. So I really was—

Q: So you saw it as a conflict of interest to donate?

. . . Well, I mean that position wasn't anything great. I
loved it because it kept me in touch with the city council
and the city government and what was going on. But I
mean, it wasn't lucrative. Somebody told me to turn in a
bill of eighty dollars an hour and [the city's corporation
counsel] said he never paid a lawyer more than sixty
dollars an hour. And I said OK, if you'd never paid any
lawyer more than sixty dollars an hour, that's all I'll charge.

"

Mayor Washington presides over a council meeting with advice from Chief of Staff Bill Ware (*second frame from left*), and Parliamentarian Leon M. Despres (*fourth frame*).

The administration was stymied by an obstructionism it charged was racist. The opposition claimed that the administration was incompetent.

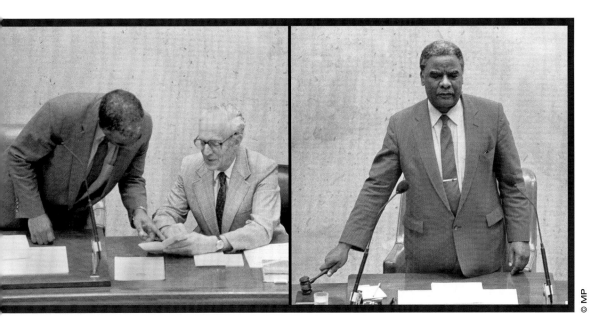

Certainly, the opposition used the media more skillfully than did the mayor's bloc; the opposition would exploit complexities of purchasing and contracting issues to create the impression that the administration was using the rhetoric of reform as a cover for corrupt practices. Burke had access to information unavailable even to the administration, and he became a media conduit for tales purporting to reveal the mayor in various underhanded endeavors. The Vrdolyak forces blocked most of Washington's nominations to city boards and commissions. At one point, they held up sixty nominations (called "hostages" by Washington's allies). The major media accommodated the Vrdolyak 29, dutifully and prominently reporting every little charge the majority bloc made against the mayor.

Washington often urged journalists to take sides and not just report the opposition's charges and the administration's denials. But the opposition skillfully exploited the media's "on the one hand, on the other hand" style of objectivity, evidenced, for example, in reports of Vrdolyak's false charges of laxity in garbage collection. The administration was stymied by an obstructionism it charged was racist. The opposition claimed, on the other hand, that the administration was incompetent and that the Vrdolyak 29 were saving the city by blocking the mayor's initiatives. The local media reveled in portraying this conflict in all its lurid detail. And, in truth, this dramatic story of urban succession and racial competition was a compelling one. What's more, this was not merely a tale of politicians playing politics; there was genuine enmity in this conflict. The leaders on both sides of the dispute were committed to the political extinction of the opposition.

Right: Silver-haired Alderman Roman Pucinski, like Washington a former congressman, was a master of press relations and used his skill effectively to make the case for the Vrdolyak bloc. Here he meets the press on July 27, 1983. *Opposite:* Preston Bradley Hall at the Chicago Cultural Center was the setting for an August 1983 "Town Hall" meeting moderated by radio-TV host and local author Norman Mark. At such events, Mayor Washington could make his case directly to the public without a media filter. *Overleaf:* Council meetings were often televised live in the Council Wars period, and the contempt that some of the opposition aldermen openly expressed for Mayor Washington incensed the black community. Some took to attending council meetings in force in solidarity with the mayor. (Photograph © MP)

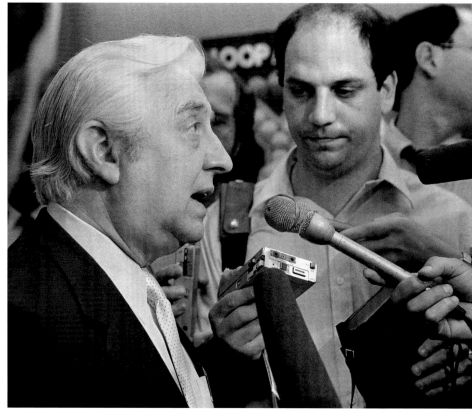

The media seemed much friendlier to the Vrdolyak 29 than to Washington's forces.

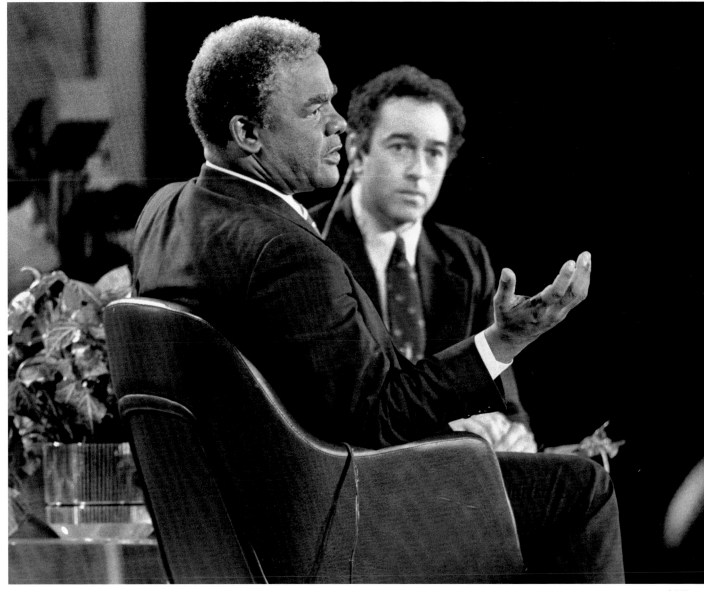

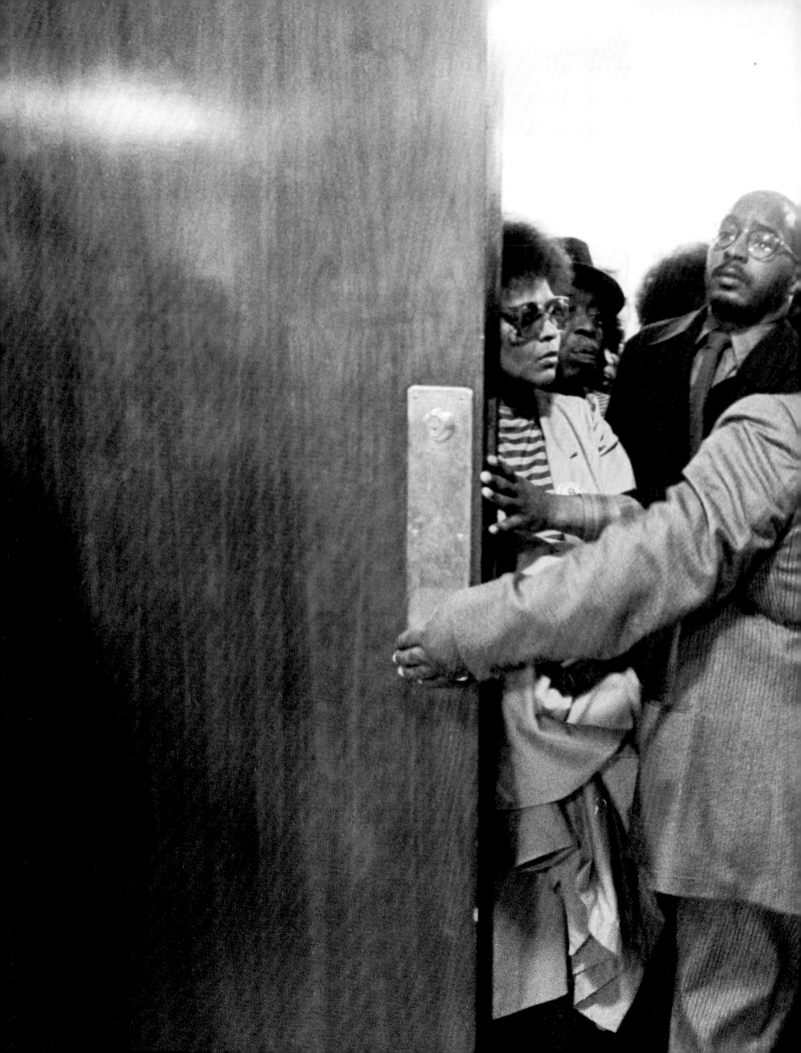

The Eddies' media strategy skillfully put Washington on the spot. The municipal gridlock created frustration, and many commentators began urging the mayor to strike compromises with the Vrdolyak bloc. But Washington was determined to outlast their obstructionism. Despite several tense battles over the budget, job nominations, block grants, bond issues, and other crucial municipal concerns, Washington stayed the course. He suffered some setbacks, but also won a few rounds. He formed a number of commissions that gave a wide range of formerly excluded groups access to city government. Washington opened up the bidding on municipal contracts and established "set-aside" programs to ensure minority participation. He created the Freedom of Information Order, which opened city government to public scrutiny, and he instituted a host of management reforms. His administration was a racial and ethnic rainbow in stark contrast to the monochromatic regimes of the past. Washington opened the municipal workforce to union representation and issued an executive order banning political solicitation of city workers. He did all of this despite relentless opposition from the majority bloc.

The council majority's intransigence served to solidify Washington's black and Latino support.

The acrimony of Council Wars tarnished Chicago's public image. The local media's florid coverage of the conflict fueled that portrayal, and the national media looked on in bemused concern at the city they called "Beirut on the Lake"—drawing a comparison to the civil war then raging in Lebanon's capital city.

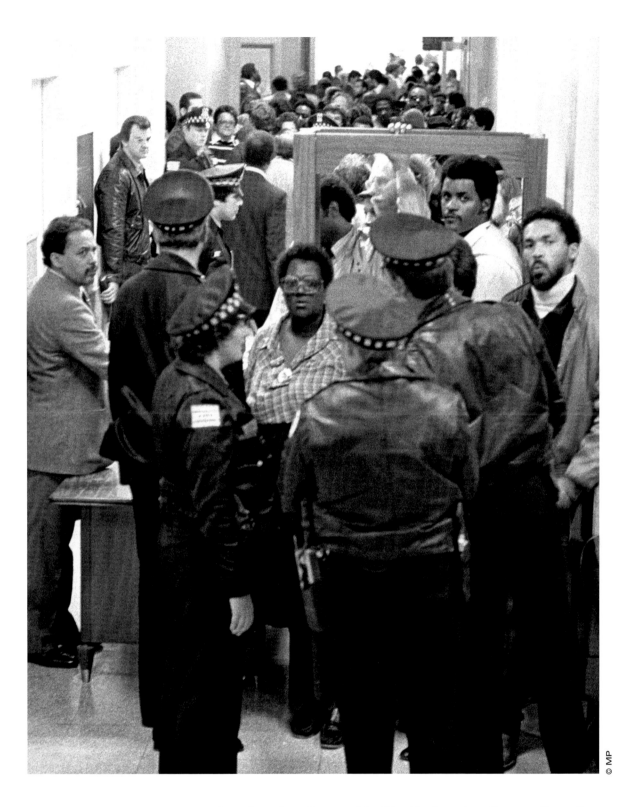

An outpouring of support for Washington at a city council meeting.

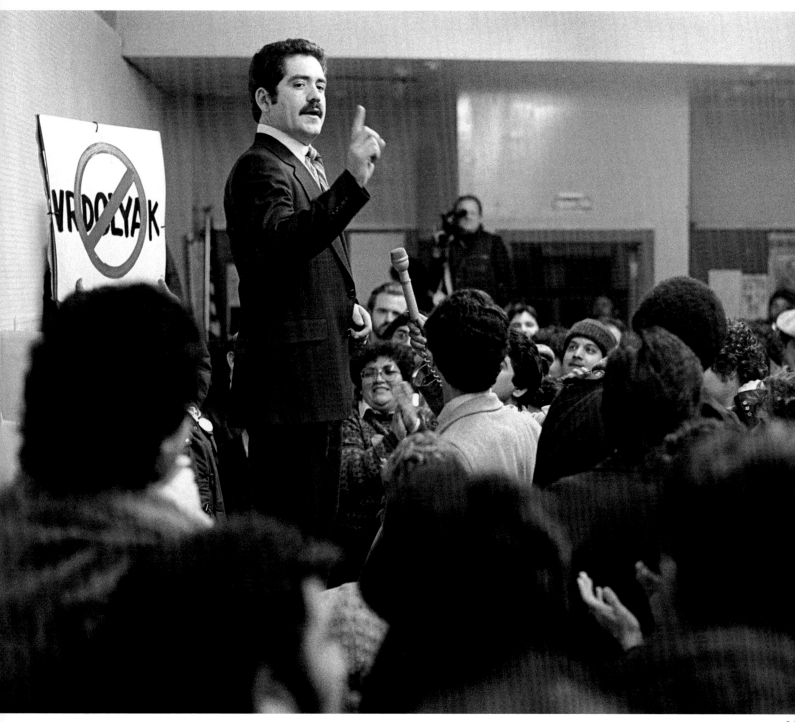

146 **Harold!**

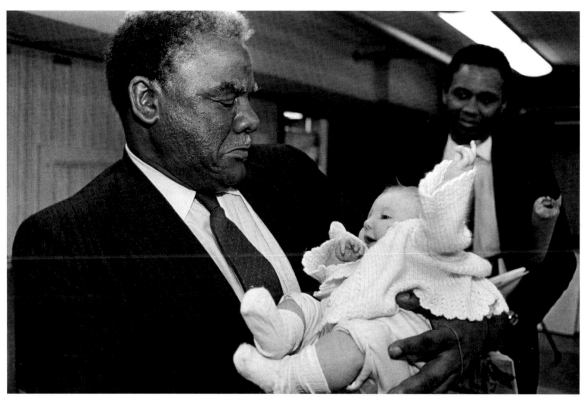

Left: Jesus "Chuy" Garcia was among the black and Latino activists who ran for city council seats with the explicit objective of ending the Vrdolyak era. Garcia won and became part of the new majority. *Above and overleaf:* For all the *sturm und drang* of Council Wars, Washington was still the mayor and did all the mayoral things, like greeting new constituents and addressing a school assembly at Lane Tech High School. (Overleaf photograph © AD)

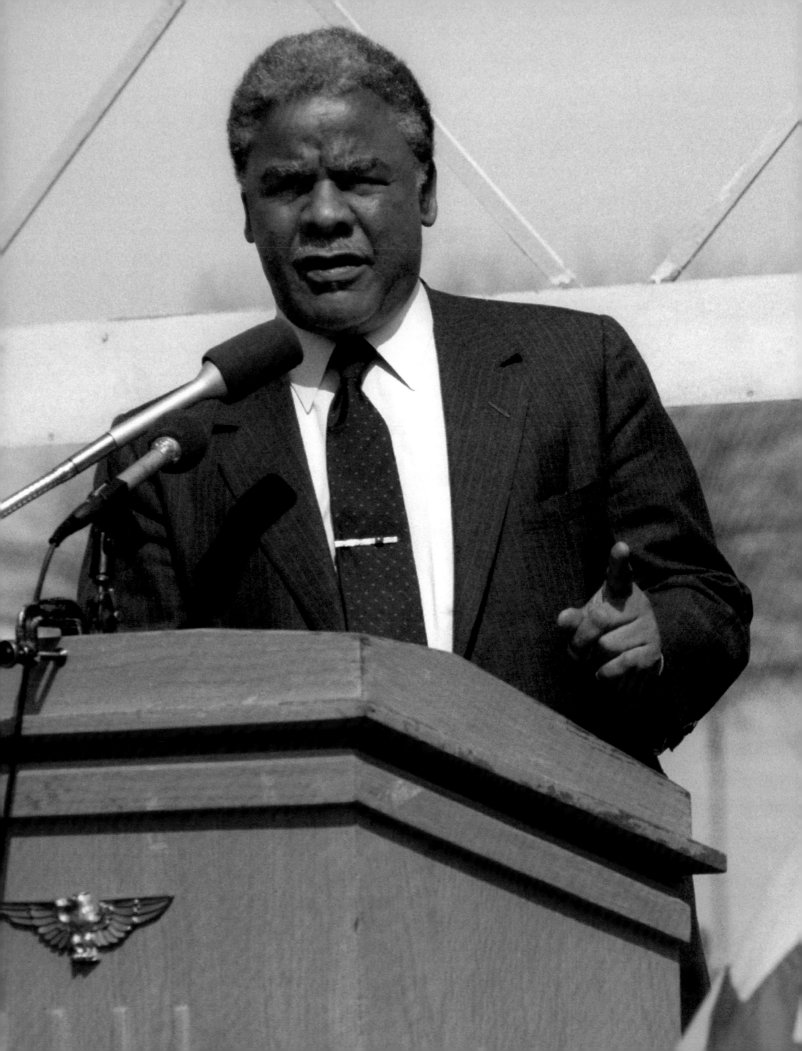

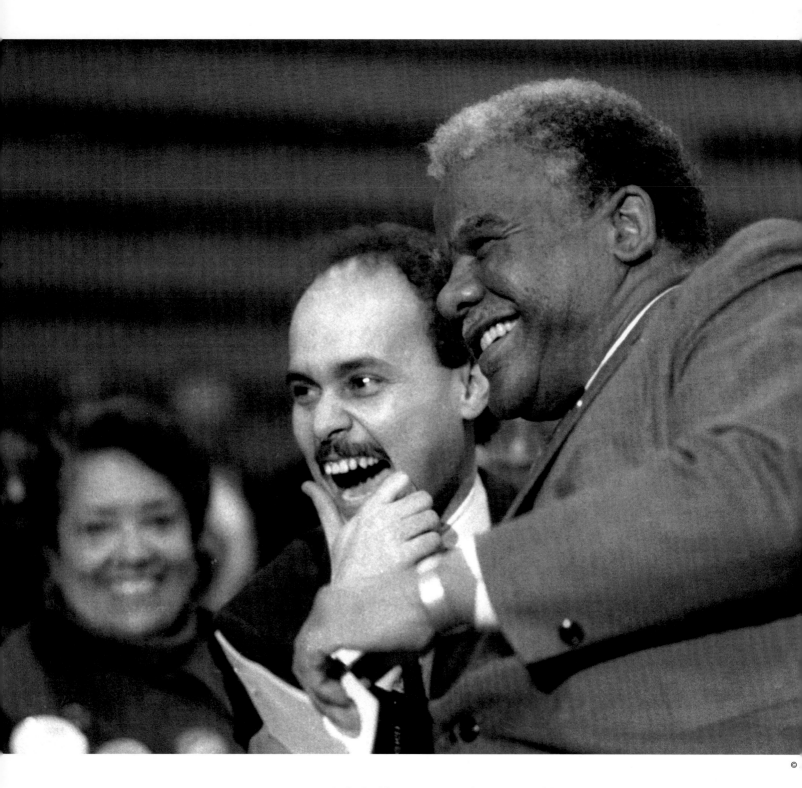

Luís Gutiérrez was another pro-Washington aldermen elected
in the 1986 special election; he was later elected to Congress.

The tit-for-tat hostility that characterized the rivals' political dialogue and the governmental paralysis it produced soon caused even Washington's toughest critics to sour on Council Wars. The majority's intransigence served to solidify Washington's black and Latino support. The mayor also was gaining grudging respect from white wards for his attempts to make city government more transparent. But the Vrdolyak 29 bedeviled the Washington administration for nearly three years before relief finally came in the form of a federal court order for special aldermanic elections in four Latino and three African American wards. The order derived from a suit filed by black activists charging that a council map drawn during the administration of Jane Byrne was racially gerrymandered.

Washington's bloc emerged victorious with a twenty-five to twenty-five council split; the mayor had the tie-breaking vote.

The election was held on March 16, 1986, and Washington's bloc emerged victorious with a twenty-five to twenty-five council split; the mayor had the tie-breaking vote. The administration wasted little time in reorganizing council committees in its favor. The Washington appointees to boards and commissions who had been held hostage by the Vrdolyak 29 were freed to serve. The mayor was able to pass a budget without self-mutilating compromises. By the fourth year in Washington's tenure, he was finally able to govern. And although he had only about a year left in his term to work mayoral magic, the city's first black mayor put his shoulder to the wheel and began making believers of his former critics. The opposition began to plan for the next election.

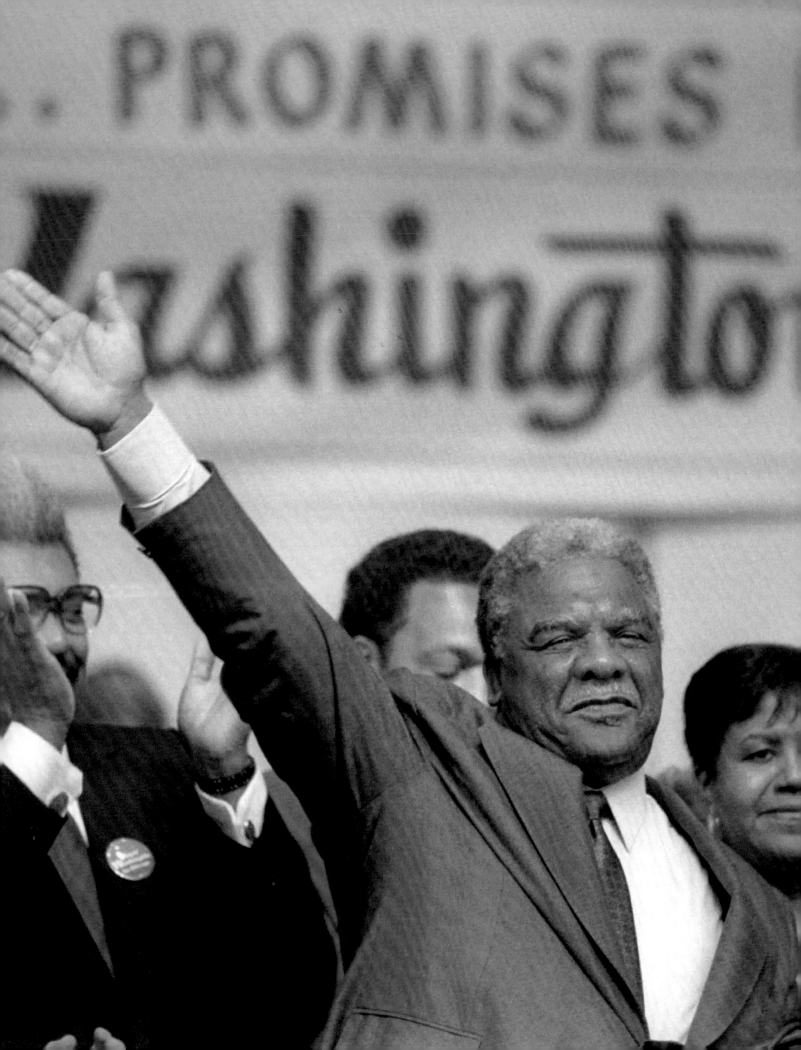

5!

Four More Years? Although

Washington gained control of the city council just ten months before the end of his first term, he had his people and programs ready and managed to move quickly on a number of priority projects. He quickly instituted the Housing Abandonment Prevention Program, which identified abandoned buildings and enlisted community groups to develop strategies for saving them. Although Washington took office during the height of Reagan's budget assault on urban America, he planned significant reforms of the embattled Chicago Housing Authority. Washington was also pushing a linked development program, in which developers of high-end property were obligated to provide low-income housing as well. Washington immediately pumped new energy into the effort to build a new city library—an embarrassing lack for a professed world-class city; it was finally dedicated in 1991, after almost two decades of temporary facilities. He also sought to quickly invigorate the city's Health Department with a new focus on developing community-oriented health clinics.

The opposition, which had remained solid during the gridlock years, began to fracture, with divisions fed by a growing dispute over which white candidate would be the best to challenge Washington in the 1987 election: Byrne, Vrdolyak, and Daley headed the three major factions. Byrne preempted the other candidates by announcing, in mid-1985, that she would run in the Democratic primary. Her canny move forced other white candidates to adjust their tactics lest they be cast as the dreaded "spoilers." Daley's forces initially

Left: Mayor Washington and Mary Ella Smith greet the crowd at a 1987 reelection campaign rally on Navy Pier.

153

tried to circumvent Byrne by inserting a referendum in the 1986 midterm election to transform the mayoral election process into a nonpartisan contest. This change would require the top two vote getters to face each other in a runoff should any candidate fail to get 50 percent of the vote. Thus, if two or more white candidates shared a majority of the votes, at least one of them would advance to the runoff. A nonpartisan contest would also neutralize Washington's threat to run as an independent. Daley's supporters felt it was the only way he could win; Washington's allies charged that the scheme was hatched by insidious forces trying to change the rules of the game for the sole purpose of ousting a black mayor. They joined with the Byrne faction and maneuvered successfully to keep the referendum off the ballot, leading Daley to drop out of the race.

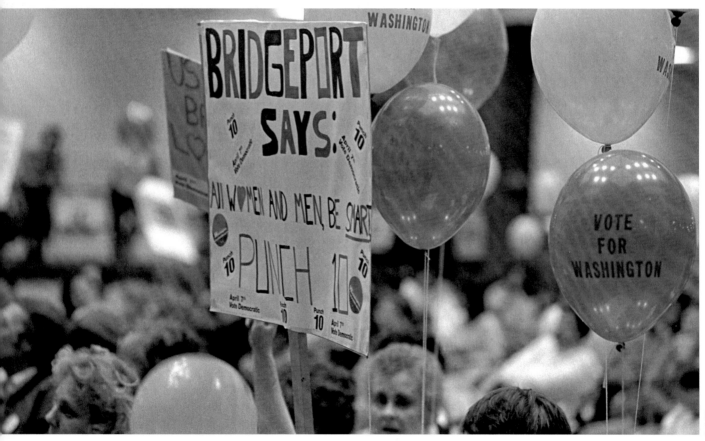

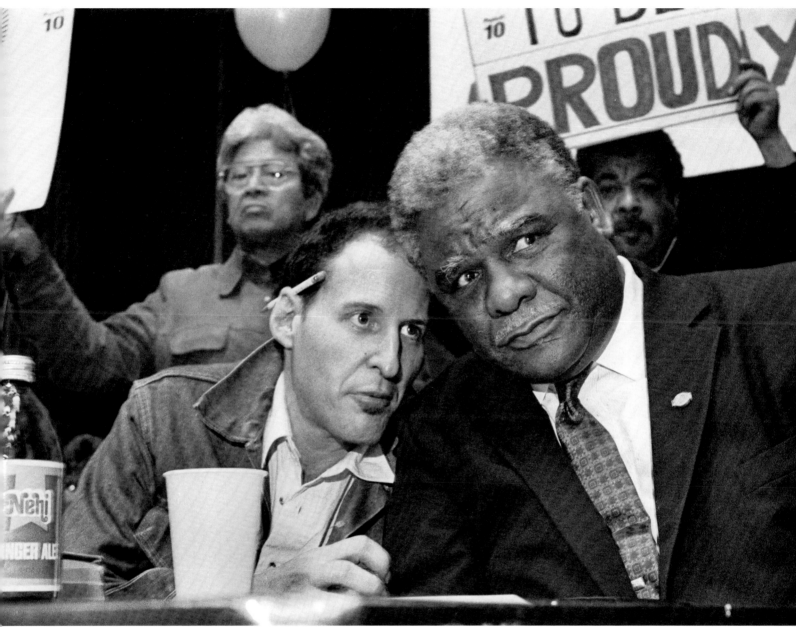

Left: A Washington reelection rally in Bridgeport, home
of the Daleys and previous Chicago mayors dating
back to 1933. *Above:* Mayor Washington scopes out a
crowd with his Bridgeport organizer, Curly Cohen.

"No hard feelings": Mayor Washington shakes hands with former mayor Jane Byrne, who supported his reelection after he won the 1987 Democratic primary. Waiting for the mayor's attention at the Democrats' "Unity Dinner" at the Palmer House is state senator Richard Newhouse.

But Daley's forces didn't completely abandon the field. Cook County assessor Thomas Hynes, a Daley man, entered the race perhaps just to bedevil Vrdolyak. Vrdolyak resigned his post as party chairman (formally, chairman of the Cook County Democratic Central Committee) to run in the general election as the candidate of the newly created Solidarity Party. Hynes also created a separate political vehicle to carry his candidacy: the Chicago First Party. And then there was the Republican candidate, Donald Haider, a Northwestern University professor who had served in the Byrne administration.

"The people have spoken," Byrne said. "We must unite the city."

Like Mayor Washington, the candidates representing these other parties had all been Democrats. The 1987 mayoral contest had fewer racial fireworks than the 1983 election, but it was clear that the two new parties created to oppose the city's first black mayor were race based. For his part, Washington highlighted the machine pedigrees of all his opponents. Byrne dodged the racial issue for most of her candidacy, but, as the campaign neared an end, she ran an ad implying that Washington had divided the city, concluding with the message, "Jane Byrne: A mayor for all Chicago." The media noted the racial implications of Byrne's ad, however, and she promptly pulled it. Washington beat Byrne with about 54 percent of the vote. Following her primary defeat, Byrne announced she not only would endorse Washington in the general election but would actively campaign on his behalf: "The people have spoken," she said. "We must unite the city."

© MP

Above: By providing city services to the neighborhoods in an open and equitable manner—as in this dedication of a new ward sanitation office in Little Village, with Washington's chief of staff Ernest Barefield cutting the ribbon and Alderman Jesus "Chuy" Garcia (*third from left*) looking on—the mayor had convinced many community activists that he was not really the ogre the opposition had made him out to be, though their leaders could never quite bring themselves to say so publicly. *Right:* Nevertheless, he made some friends, like those at this summer festival in Riis Park.

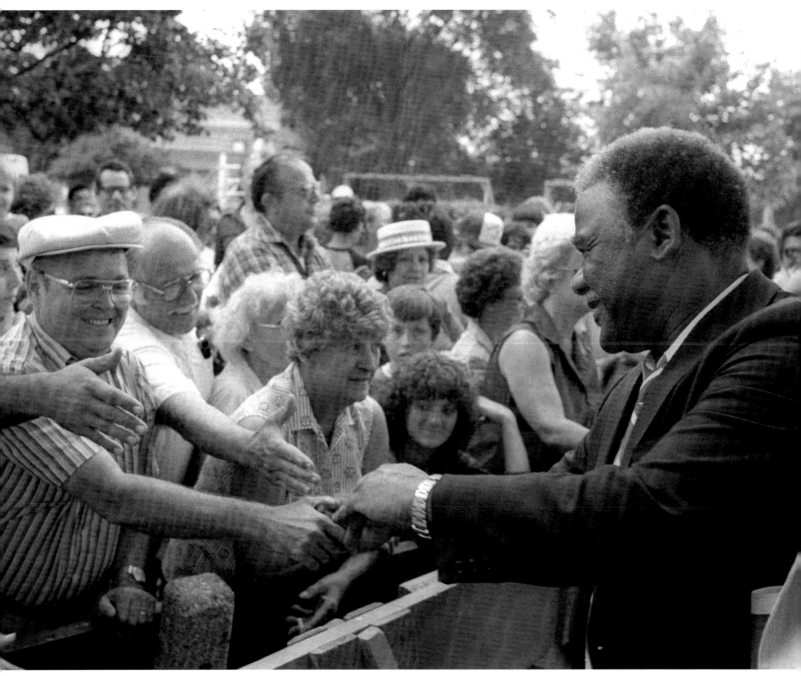

Dick Simpson

"

[Harold] won the primary election with only 36 percent of the vote and the general election with 52 percent. He used the theme of reform—but in the [campaign's] lexicon, reform was intended to mean three different things to three different constituencies:

First, good-government reform, meaning—for white Lakefront folk— honesty and efficiency in government.

Second, empowerment, meaning affirmative action to bring minorities and women into the highest levels of government and the awarding of more government contracts to blacks, women, and Latinos.

Third, citizen participation and control, meaning decentralized government decision making, funding for neighborhood organizations, and governmental accountability to grassroots community groups.

These are the diverse definitions of reform for which Harold Washington stood, and the planks of the platform that is a large part of his legacy. To have stood for any one reform would have been noble but would have ended in electoral defeat. Standing for all three created a movement, a coalition with which Harold could win the closest mayoral election in Chicago's history.

"

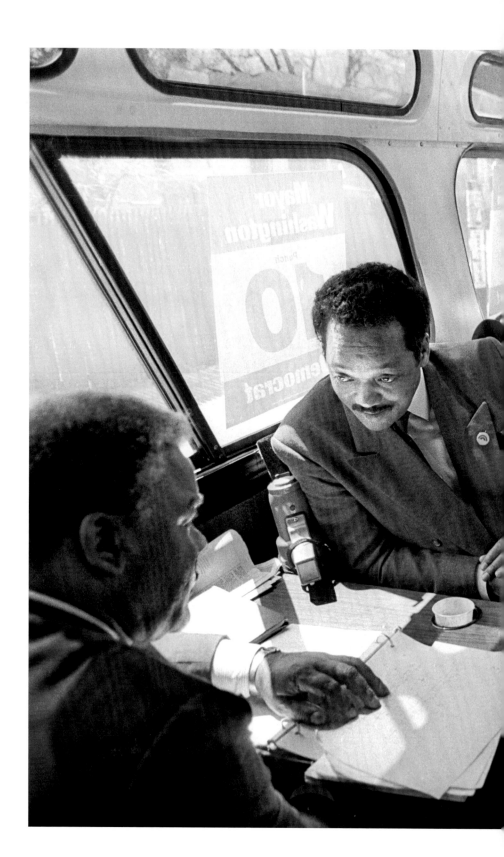

Mayor Washington, in his campaign bus, confers with Reverend Jesse Jackson and (*seated at right*) Press Secretary Alton Miller.

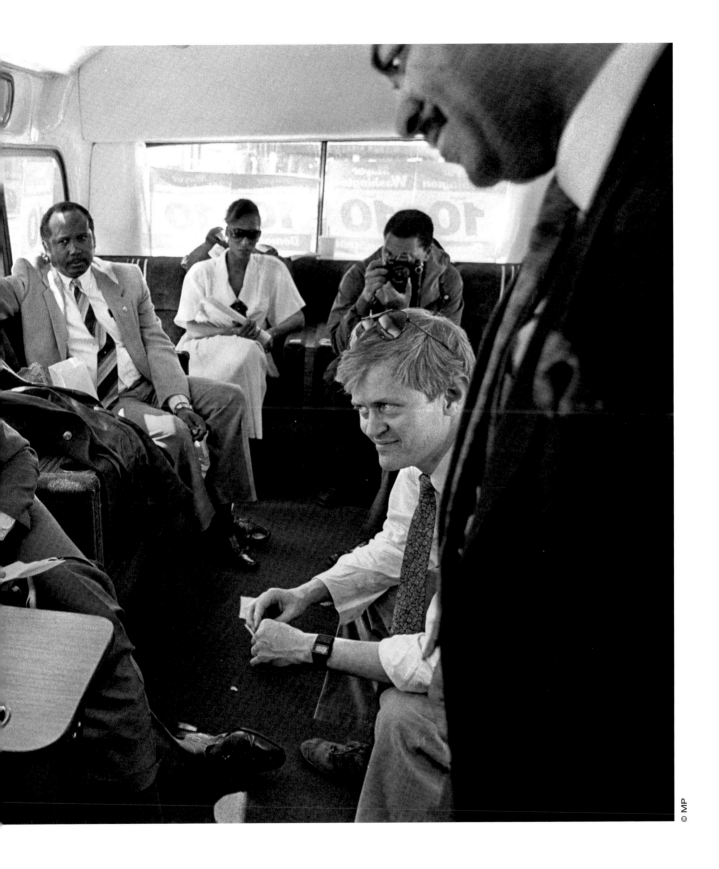

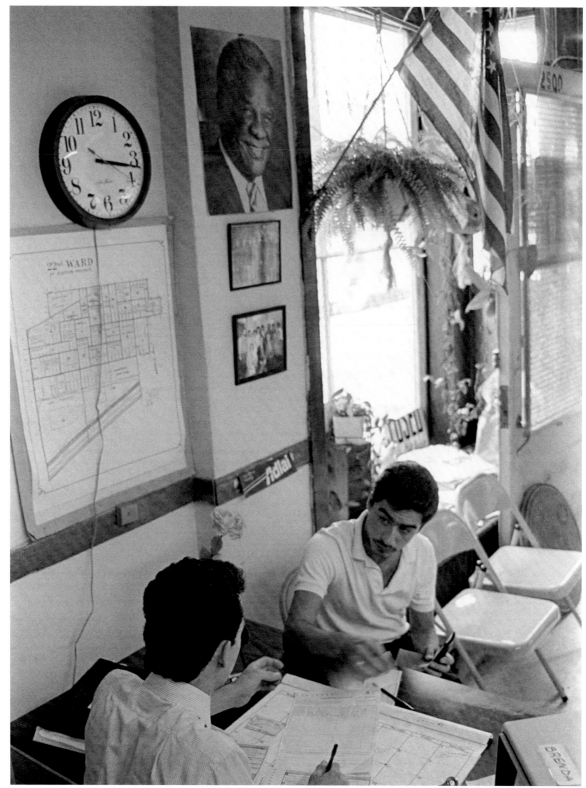

The incumbent would need all the help he could get. Having vanquished one white candidate, Washington had to face three more. Some of Washington's strategists feared that relentless political attacks from three directions could fatally cripple his candidacy. But since victory for any of his opponents depended on the others dropping out, the three aimed their attacks at one another, leaving Washington relatively unscathed.

The incumbent would need all the help he could get.

To unseat the mayor an opponent had to have a total lock on the white vote and take a serious chunk of the Latino electorate as well. In the face of white opposition, Washington had solidified his support in the black community. Although he had angered some elements of the black nationalist community—represented largely by the Task Force for Black Political Empowerment—by refusing to support militant journalist Lu Palmer for the congressional seat he had vacated and instead backing longtime labor leader Charles Hayes, the Task Force remained loyal and helped sustain the mayor's rock-solid support in the black community with its vigorous grassroots campaigning and its endorsement of his racial authenticity. In 1983, Palmer had played a major role in mobilizing the city's active black nationalist community—a group traditionally averse to electoral politics—to support Washington's candidacy, and many of them viewed the mayor's opposition to Palmer as a betrayal.

Opposite: Helping to make sure that Mexican Americans stayed with Mayor Washington through his reelection were precinct workers like these men in Alderman Garcia's Twenty-second Ward office.

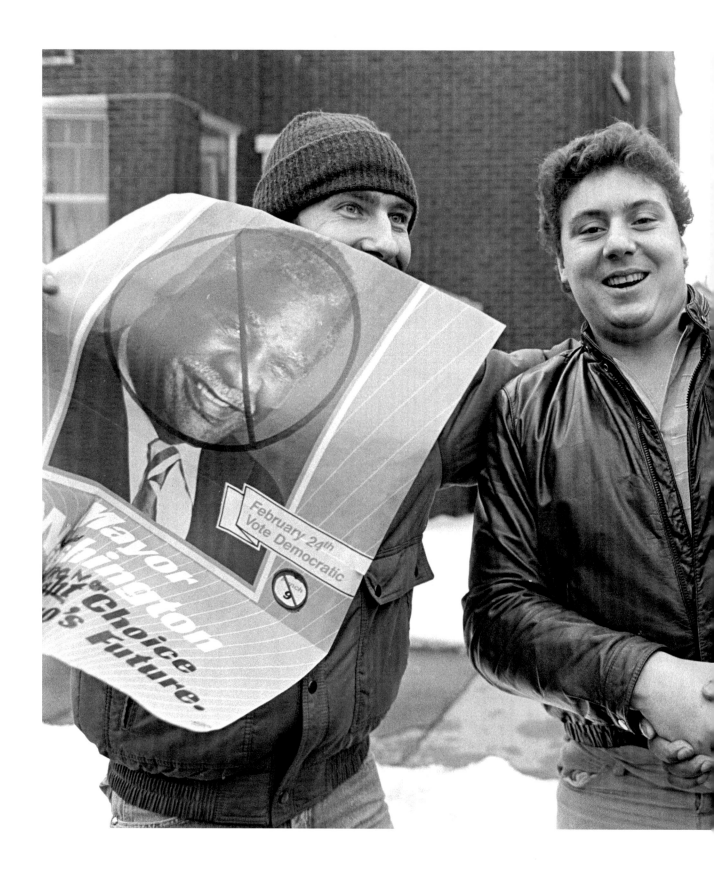

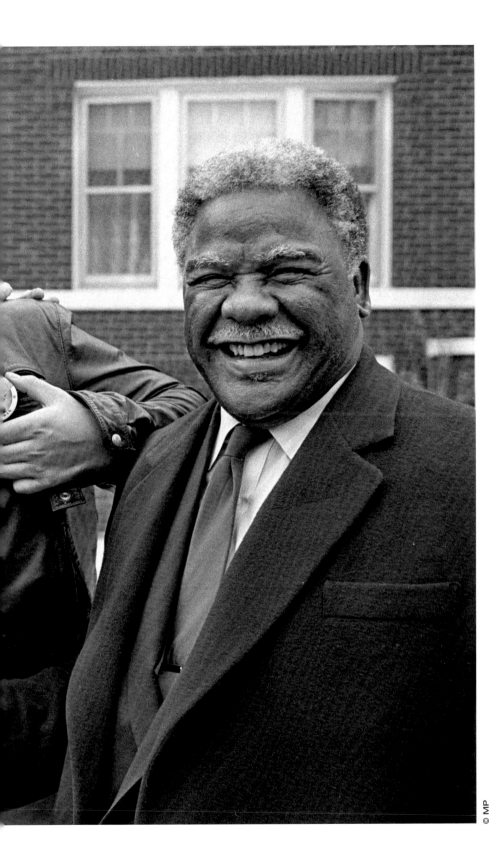

© MP

Two anti-Washington protestors succumb to the mayor's charm at a campaign stop on the Northwest Side.

Dissension and desertion loomed. Washington forthrightly took his case to the people in a whirlwind of appearances throughout black Chicago and persuaded most that Hayes was the right candidate, without burning his bridges to Palmer's hardcore supporters. Hayes personified the links Washington had forged with black organized labor during his political career—and this constituency was still a potent force in 1980s Chicago. There perhaps was no better example of Washington's political genius than his ability to reconcile the left-leaning positions of his labor backers with the "our turn" convictions of his black nationalist supporters. The mayor also raised his standing among Latinos, particularly in the Puerto Rican wards, and his conspicuous efforts to run a fair and open government won him increasing support among so-called lakefront liberals.

Meanwhile, the hostility between the Vrdolyak and Hynes camps offered relief from the anti-Washington chorus and reminded observers that race was not the sole cause of political divisions in the Windy City. Hynes's candidacy failed to derail Vrdolyak, so the Chicago First candidate dropped out a few days before the vote. Haider resumed the Republican candidate's traditional pre-Epton position of irrelevance. The 1987 general election thus boiled down to a man-to-man fight between Darth Vrdolyak and Harold Skytalker. Washington won with 54 percent of the vote. Vrdolyak pulled 42 percent, and Haider got the remaining 4 percent.

Having vanquished one white candidate, the mayor now had to face three more.

Opposite: On their marks for a televised debate, the four candidates in the 1987 general election for mayor were (*from left*): Donald Haider (Republican), Harold Washington (Democrat), Thomas Hynes (Chicago First Party), and Edward R. Vrdolyak (Solidarity Party).

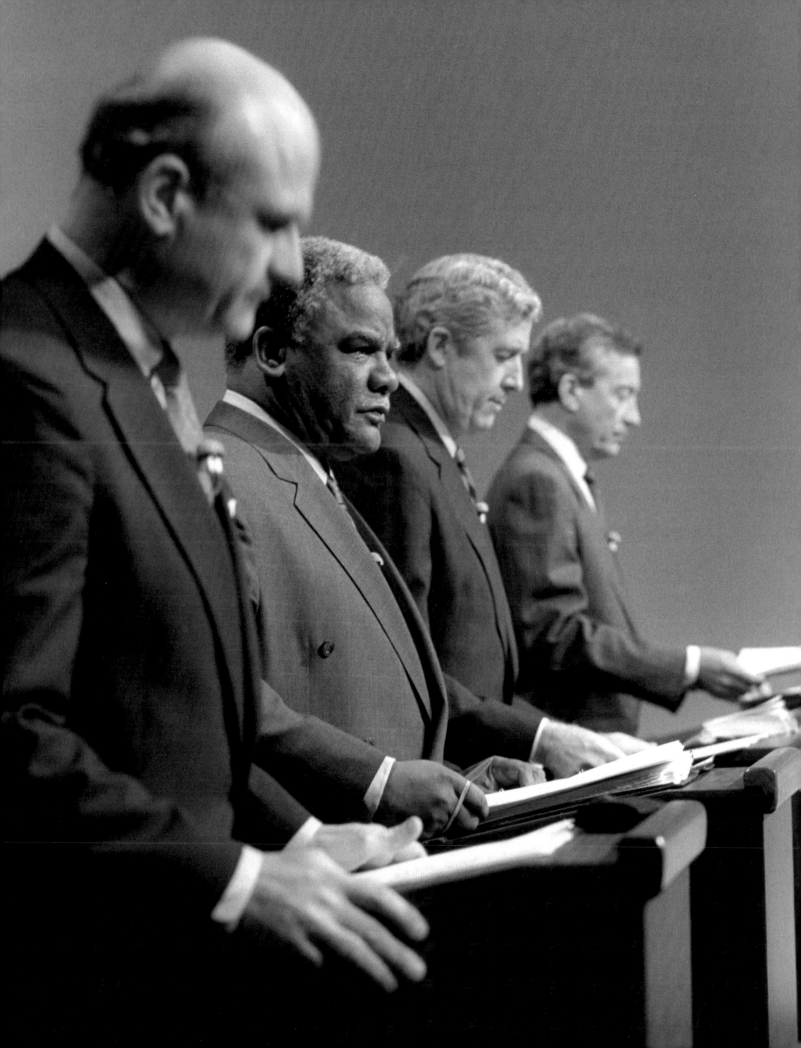

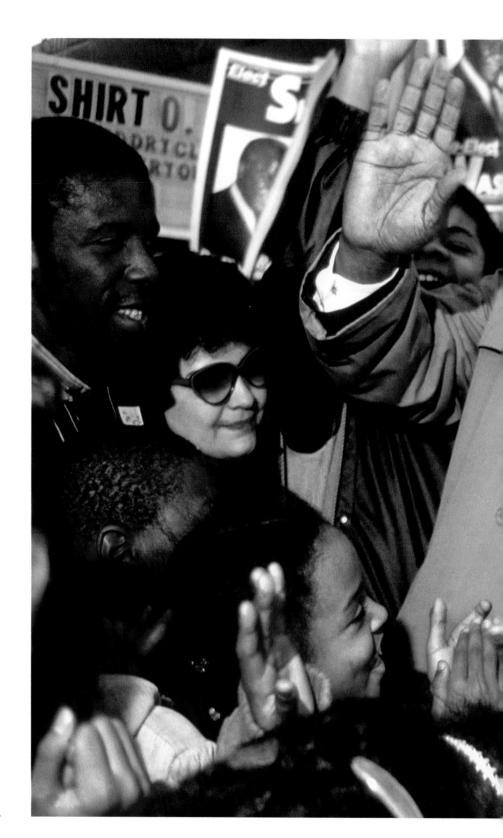

The mayor campaigns with boxing promoter Don King and aldermanic candidate Helen Shiller (*in sunglasses, center*). Shiller won her Uptown ward and has been in the city council ever since.

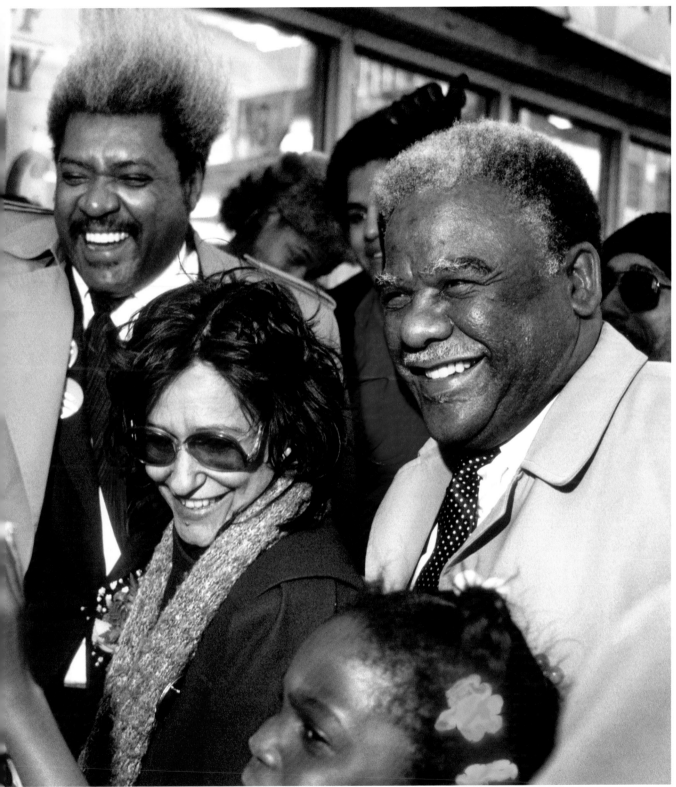

Four More Years? 171

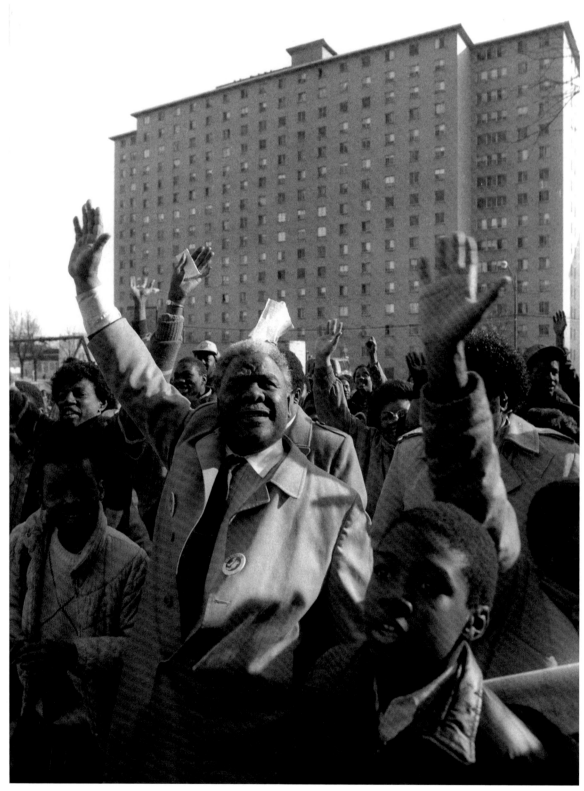

172 **Harold!**

The black electorate was again nearly unanimous in its support of the mayor. Although some of the white hostility to Washington had diminished since his initial election in 1983, the good feeling manifested itself mainly in a lower white turnout. He won the election with just 12 percent of the white vote—exactly as he did in 1983. Washington won over many of his critics with an administration that delivered a fairer and more transparent government, but most white Chicagoans still withheld their support. Nevertheless, he managed to attract a multiracial coalition, winning about 60 percent of the Latino electorate and 80 percent of the Asian American vote. For the black man who had to beat back a host of Great White Hopes to win another term, that was as much of a mandate as he was likely to get.

The election boiled down to a man-to-man fight between Darth Vrdolyak and Harold Skytalker. Washington won with 54 percent of the vote.

Opposite: However tempting it may have been to try to cultivate his improved relations with white groups, it would have been foolish for the mayor to neglect his base. Here he and his supporters wave to public housing residents in high-rise apartments as he campaigns for reelection.

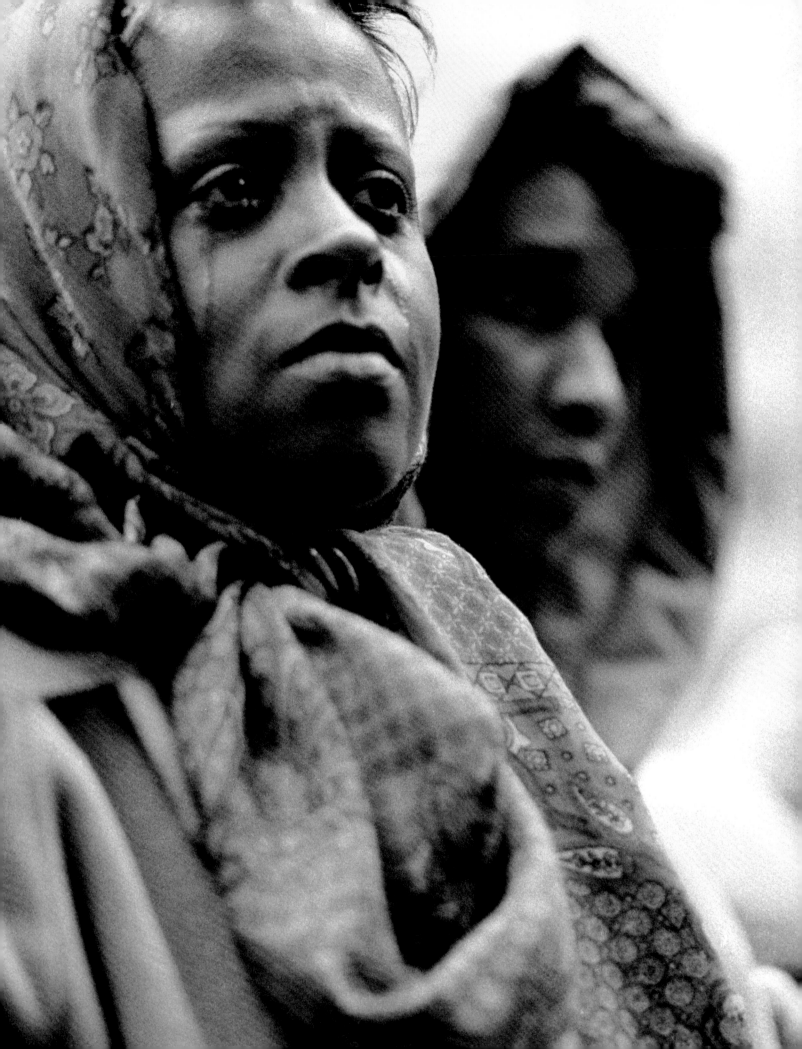

A Death in the Family

Beleaguered by three and a half years of malicious obstructionism during his first term, Washington finally gained a grasp on his political destiny with his reelection. Early in his second term, Washington forcefully pushed a program for affordable housing, in an open critique of the Reagan administration's federal policies. He also signed an executive order that struck questions about citizenship status from all city applications, unless required by federal laws, and issued a controversial order prohibiting city cooperation with federal immigration officials; Latino communities harassed by INS green-card raids were grateful for the limited relief these measures offered. Such policies embossed the mayor's progressive credentials and gained him the kind of favorable national attention he had formerly garnered as an Illinois congressman. What's more, this positive publicity counterbalanced emerging local criticism that Washington was making too many concessions to machine forces. For example, several council committees were chaired by former members of the Vrdolyak faction, and the mayor endorsed a future Democratic dream ticket that included Aurelia Pucinski, the daughter of one of his fiercest machine foes. Black nationalists were particularly miffed by Washington's determination to be "fairer than fair," especially since the mayor's evenhanded approach had failed to increase his share of the white vote. Lu Palmer told Chicago Public Radio's Ira Glass in a 2002 interview: "I used to cringe whenever Harold said he wanted to be fairer than fair. Since white mayors have always put white people first without any question or apology, we said that Harold had to put black people first."

Not only did Washington resist such racial appeals, he enlarged the black community's sense of shared interest by connecting its woes with the immigration problems of the city's Latinos. Talk of unity between the groups had long been the province of theorists and idealistic activists, but seldom had the black community made common cause with issues important to Latinos and vice versa. The Washington administration actively cooperated with progressive forces in both the Mexican and the Puerto Rican communities to craft policies for those groups and appointed a number of their leaders to administration posts. Washington thus infused a progressive agenda into an administration based on ethnic succession and justified by racial demographics. By the sheer power of his personality, he converted the "our turn" expectations of a long-denied black electorate into an acceptance of fairness and racial equity.

All this ended abruptly on November 25, 1987, the day Harold Washington died.

Right: Illinois state senator Emil Jones, distraught, updates the press on the mayor's condition outside Northwestern Memorial Hospital, where Washington was taken after he collapsed in his City Hall office. The mayor was pronounced dead soon after.

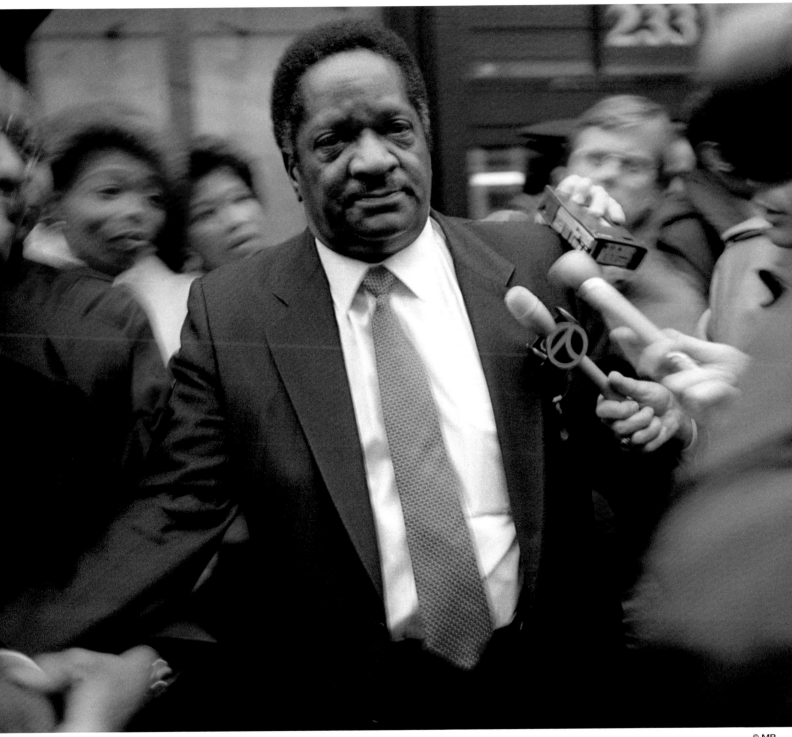

© MP

Press Secretary Alton Miller, the last person to see Harold Washington alive, speaks with reporters at the hospital. At 2:20 P.M. he told them: "It is my sad responsibility to let you know that Mayor Washington was pronounced dead this afternoon at 1:36 P.M."

Washington's revered status within the African American community enabled him to reconcile many intramural conflicts. Through his intercession, black business interests would join hands with representatives of black labor; the nationalists of the Task Force for Black Political Empowerment would coexist peacefully with the reform-minded lefties of the Independent Voters of Illinois. There were tensions between the black clergy and secular activists, not to mention intense divisions among the clergy's myriad denominations and personalities. And those were only some of the divisions that explained why Chicago's black community, despite its numerical heft, had seldom been able to muster the strength to effectively challenge white hegemony.

"Harold Washington was more than any of [his] accomplishments . . . He is a legend who symbolizes what Chicago can become. We remember him for his warmth, his wit, his compassion, and his vision."—DICK SIMPSON

All this ended abruptly on November 25, 1987, the day Harold Washington died of a massive heart attack while sitting at his desk. The black community seemed to instantly recognize the magnitude of its loss. The city's South and West sides were smothered in an eerie, somber silence. Their mourning was not just for the loss of Washington's presence but also for his promise. The city's future without Harold was a prospect of immense sadness. Tears flowed freely, even among street-hardened Chicagoans dedicated to coolness.

The city council chamber draped in purple bunting in mourning for the mayor.

A Death in the Family 181

The mourning was not just for the loss of Washington's presence but also for his promise.

Black cops wept openly as they carried out their varied duties; black bus drivers on the city's South Side offered condolences to their glum passengers. Typically ebullient DJs at black radio stations were abnormally solemn, the beat of their music undeniably slower. Washington had been fond of boasting that his tenure would last at least twenty years, and his outsized persona made it hard to imagine the city without him. But gone he was. And then there was the poetic injustice of Washington dying after working so hard to reach the point where he could survey his political horizons without endless obstruction. Long lines of mourners gathered at various tributes and memorial services, including a unique wake that was held in the City Hall lobby. Massive crowds lined the streets where his funeral cortege passed, standing mute and four deep. For black Chicago, there had been a death in the family.

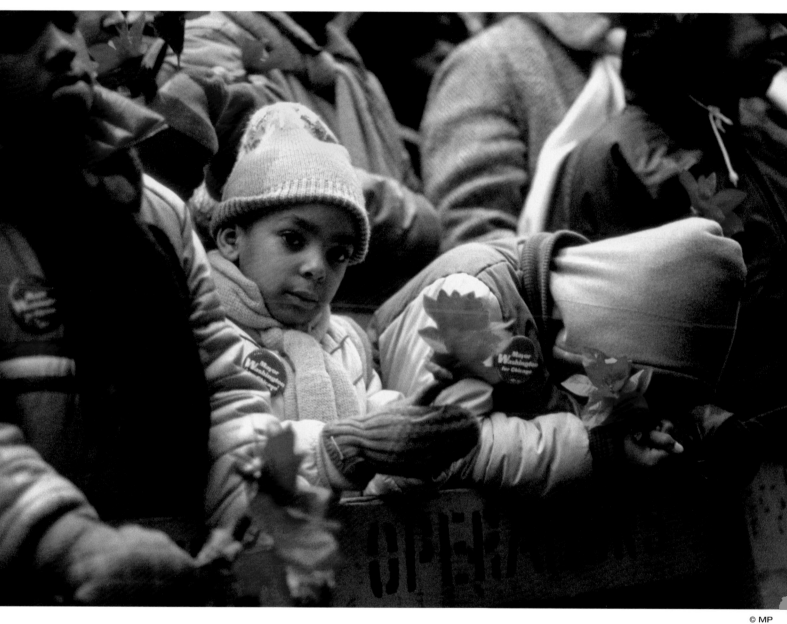

Above: Chicagoans young and old mourned the passing of their mayor at a memorial service in Daley Plaza. *Overleaf:* An honor guard of Chicago policemen and firefighters salutes as the mayor's casket is carried into City Hall. (Photograph © MP)

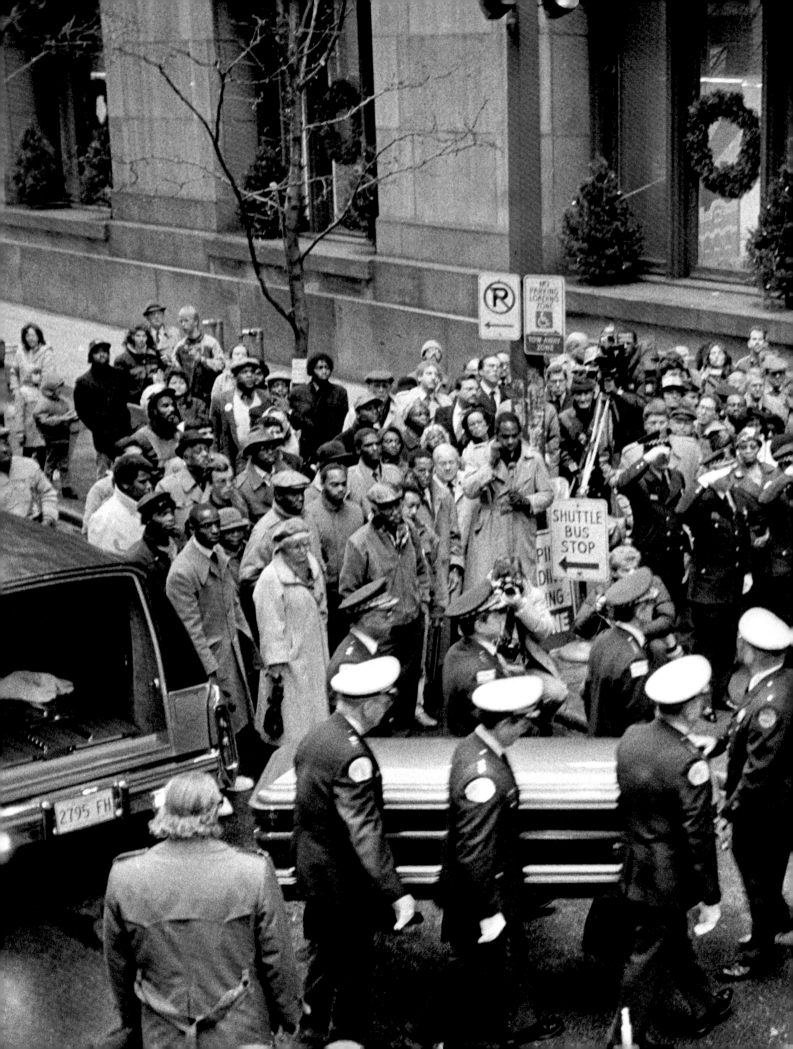

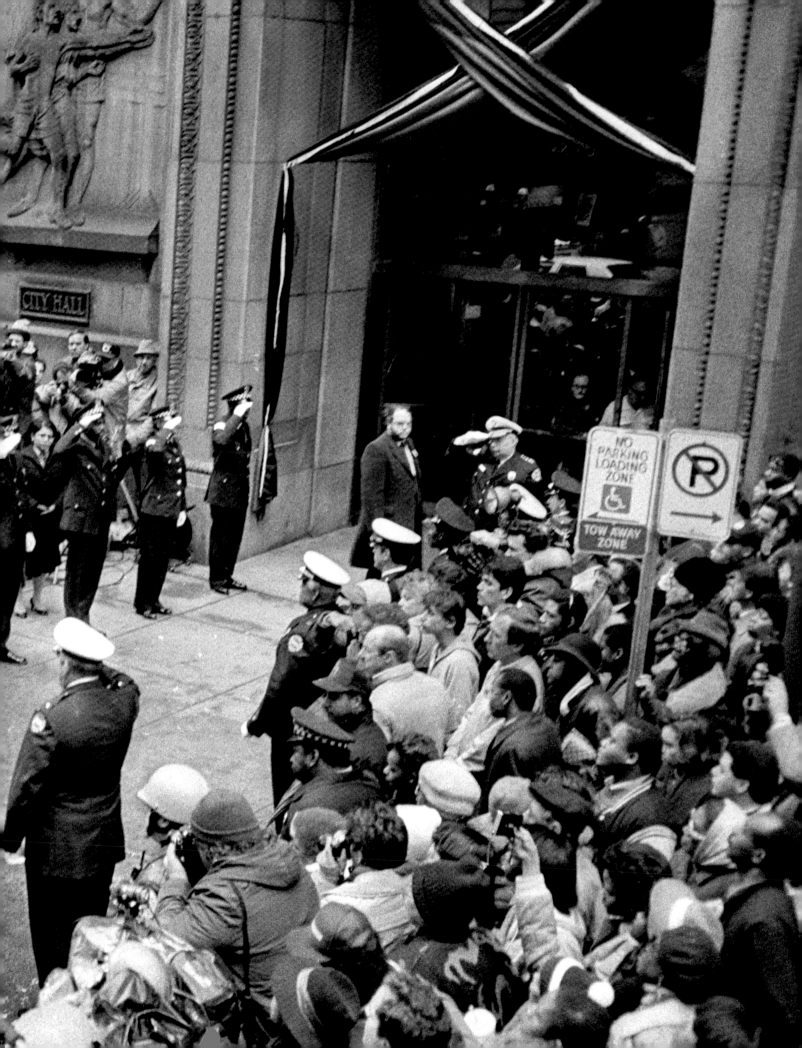

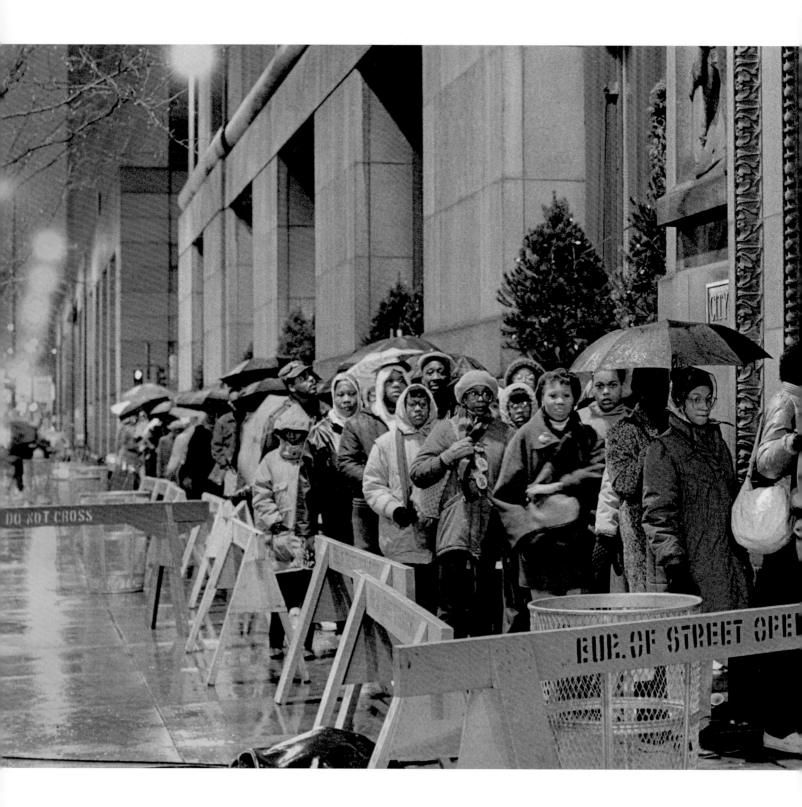

Left: Long lines of mourners gathered at various tributes and memorial services, including the one pictured here, a unique wake at City Hall. *Overleaf:* An estimated half-million Chicagoans came to pay their respects as the mayor lay in state in the lobby of City Hall. (Photograph © MP)

© MP

A Death in the Family 187

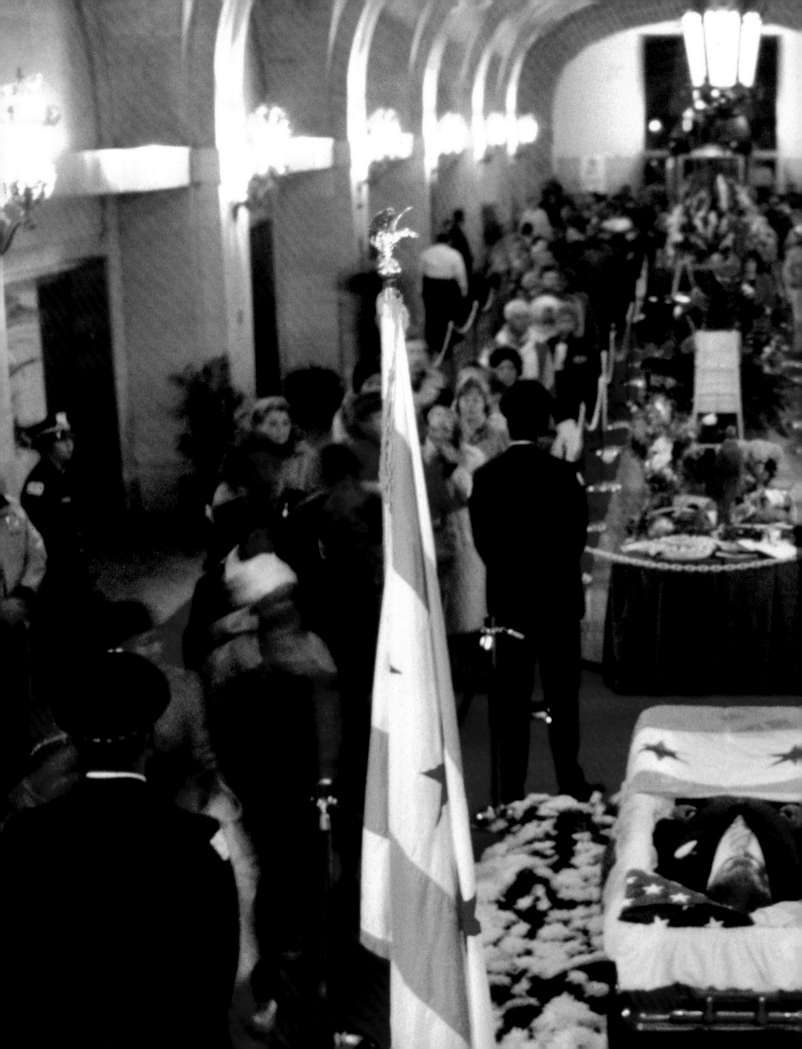

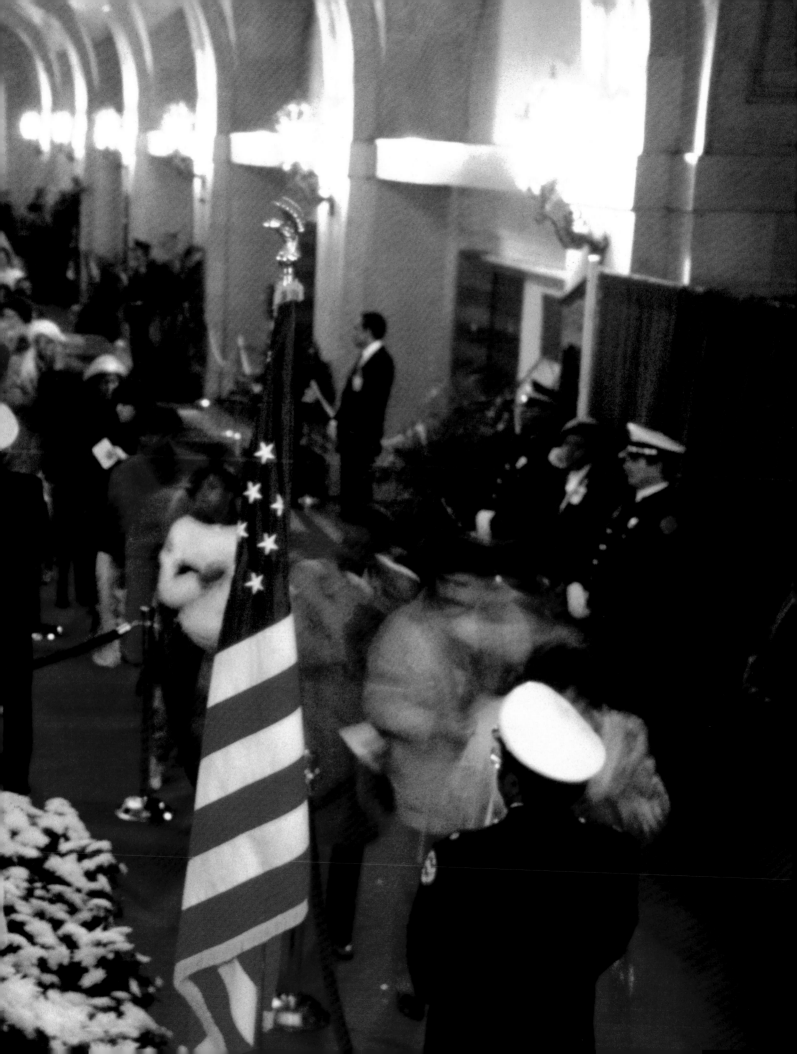

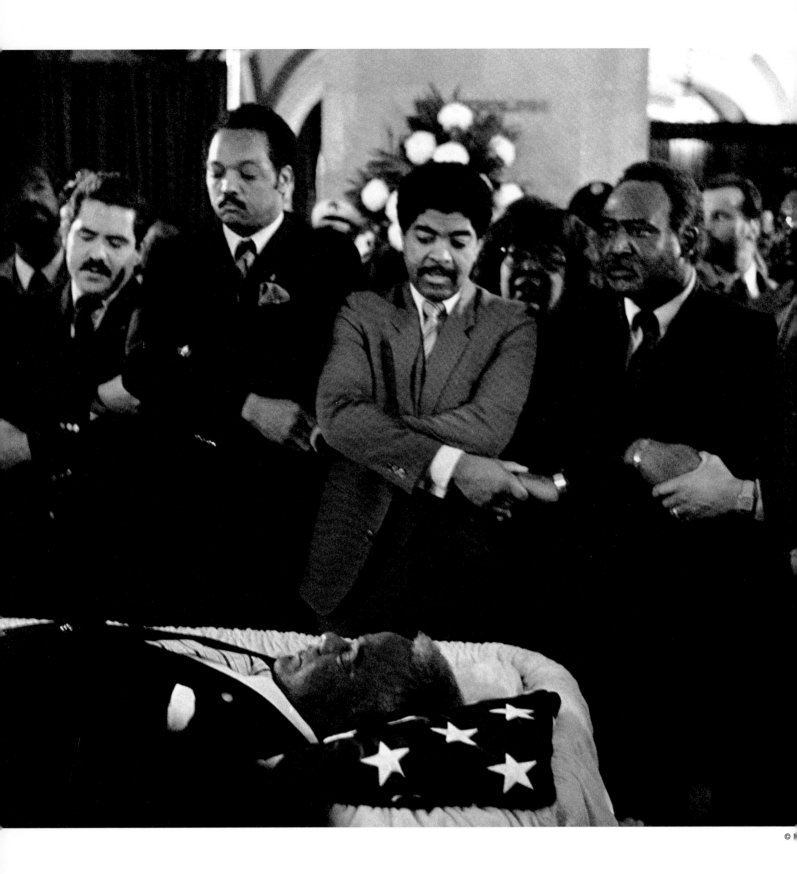

However, cracks in the finely wrought unity established under Harold's charismatic leadership were already visible. There was also some anger. People were angry at the white opposition that had relentlessly sniped at the mayor for political advantage. Some even talked of assassination, saying that Washington was poisoned by forces unprepared to accept the unobstructed reign of a black mayor. A series of cassette tapes entitled *What Really Happened to Harold Washington* sold briskly in black nationalist venues. Some Chicagoans were angered that the funeral of such a public man was closed to the public, although it was held at Christ Universal Temple, one of the city's largest megachurches. Finally, many were angry at the mayor himself for neglecting his health so egregiously. When he died, Washington weighed nearly three hundred pounds and was more than one hundred pounds overweight. He was too fond of fast food and seldom exercised, despite considerable prompting from his friends and warnings from his doctor. The medical examiner said his heart had expanded to nearly three times its normal size.

Washington had been fond of boasting that his tenure would last at least twenty years, and his outsized persona made it hard to imagine the city without him. But gone he was.

Left: Alderman Jesus "Chuy" Garcia, Reverend Jesse Jackson, Alderman Timothy C. Evans, and Alderman Danny Davis link arms in prayer beside the mayor's casket in City Hall.

Much of the television coverage focused on the large gatherings of uniformly grief-stricken black Chicagoans.

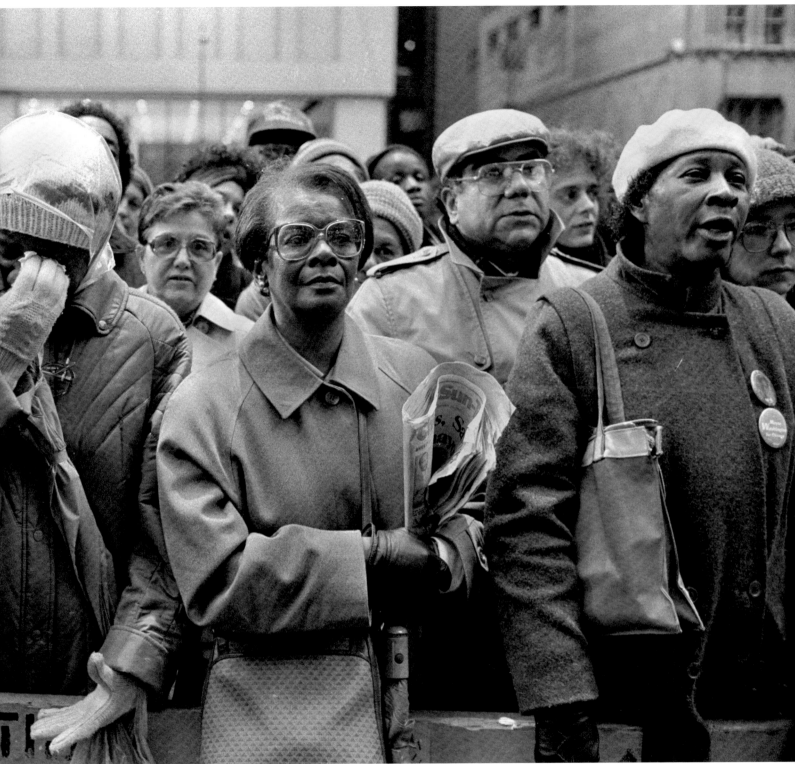

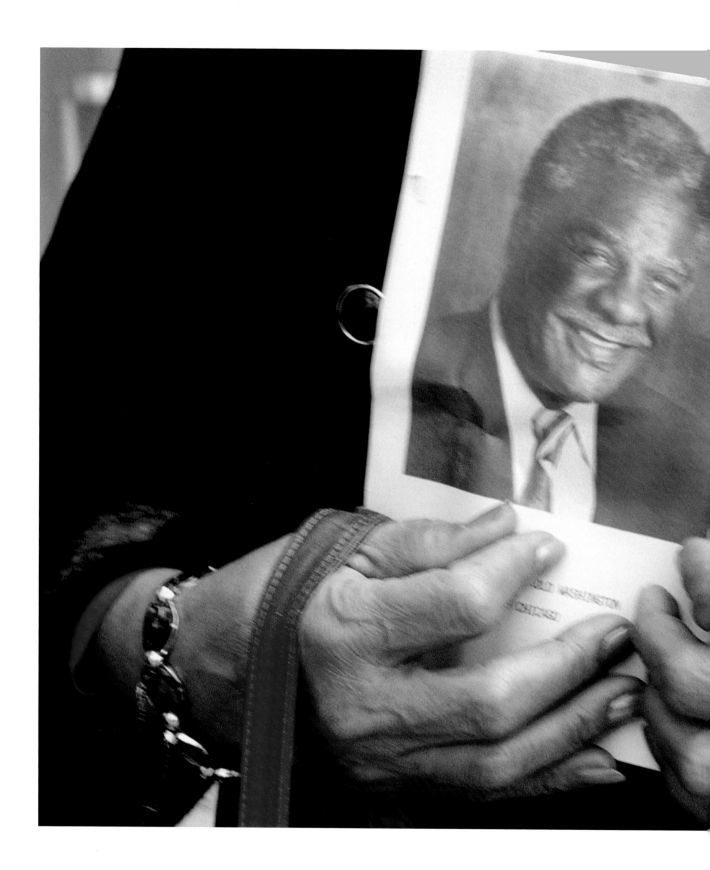

A mourner clutches the program for Mayor Washington's funeral service at Christ Universal Temple.

© MP

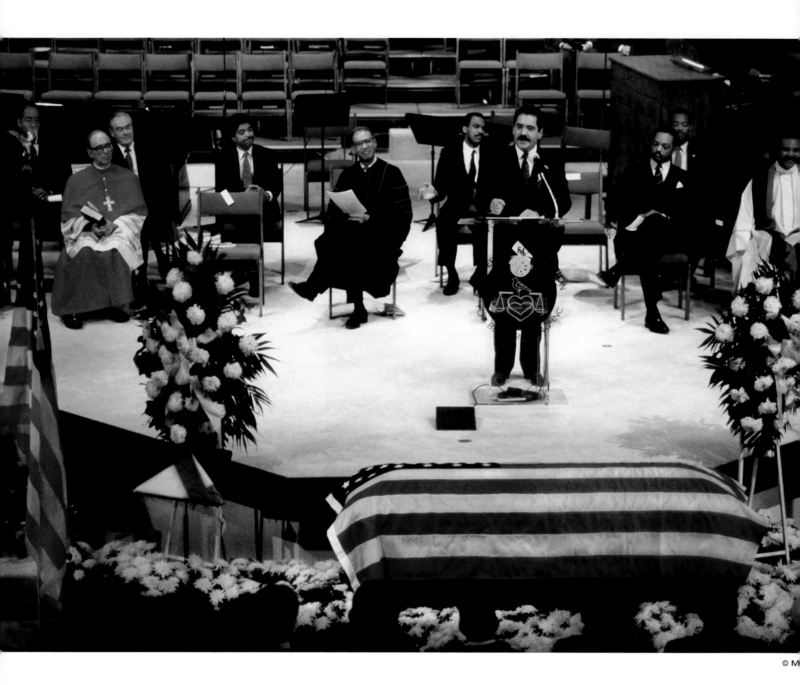

Alderman Jesus "Chuy" Garcia speaks at the mayor's funeral at Christ Universal Temple, Monday, November 30. His eloquent eulogy was remembered and repeated at many venues for years afterward. Among those onstage at the funeral (*from left*): Joseph Cardinal Bernardin, Cook County Board presiden and Democratic Party chairman George Dunne, Alderman Timothy C. Evans, Mayor Washington's pastor Reverend B. Herbert Martin, Washington's chief of staff Ernest Barefield, and Reverend Jesse Jackson.

Some Chicagoans were angered that the funeral of such a public man was closed to the public, although it was held at Christ Universal Temple, one of the city's largest megachurches.

Across the country, there was a sense among activists that one of the best hopes for a diverse coalition of progressive political forces had died along with Washington. During his last year, the mayor had become more involved in national organizations such as the National Conference of Black Mayors and had adopted an even more aggressive critique of the Reagan administration's urban policies. Washington's trenchant criticisms often gained a national hearing, so urban advocates nationwide felt diminished by the mayor's death. The national media converged on Chicago to recount the life and death of a big-city mayor turned black folk hero. Much of the television coverage focused on the large gatherings of uniformly grief-stricken black Chicagoans and the more varied responses of whites. His death was accorded front-page treatment in the *New York Times,* and the headline for his obituary was LEADER WHO PERSONIFIED BLACK RISE TO URBAN POWER.

White Chicago felt conflicted about Washington's exit. Some publicly demonstrated their relief; others were more restrained. Progressive reformers saw lost possibilities. Many were sad at the mayor's death but hailed the reforms he had implemented and predicted that city government would never be the same. They were right. City government has never recovered from Washington's fairness assault. There is more transparency and freedom of access, and considerably less patronage hiring, than was routine before 1983. Problems remain, as newspaper headlines continue to remind us. Still, there is little doubt that Harold Washington's fifty-five-month tenure was a milestone of fairness in Chicago's municipal history.

Death more completely revealed the combination of personal qualities that made Harold Washington such a unique political character.

Opposite: Citizens lined the streets for miles as the funeral cortege took a winding path through the South Side to Oak Woods Cemetery. *Overleaf:* In thousands of Chicago homes for years afer his passing, Harold Washington's portrait reminded residents of what had been. (Photograph © MP)

It was also a unique period for black politics. Washington managed to link the righteous indignation of civil rights activism to the self-determination quest of black nationalism and to the reform impulses of progressive politics in a way never before done. His complex knowledge of the machine's inner workings added a pragmatic expertise previously absent from reform challenges in Chicago. Death more completely revealed the combination of personal qualities that made Harold Washington such a unique political character. Immediately after he died, white politicians began maneuvering for the return of the machine, and the black electorate returned to its traditional fractured constellation of disparate interests.

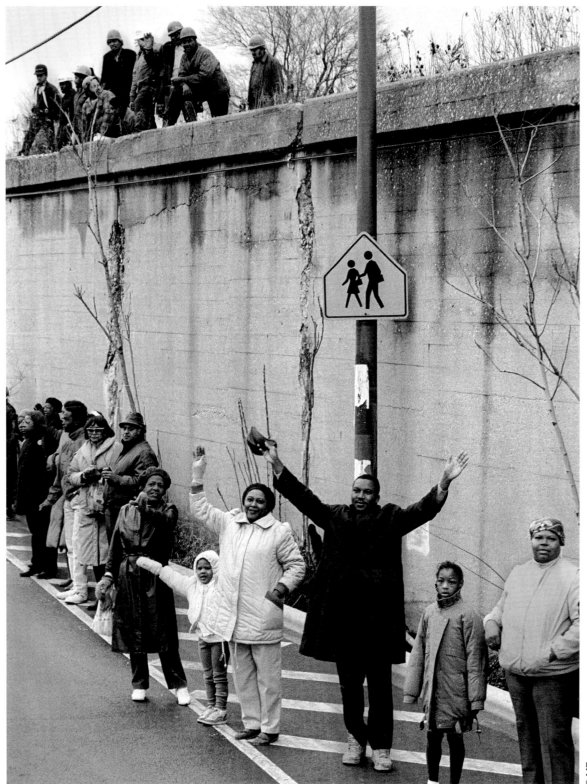

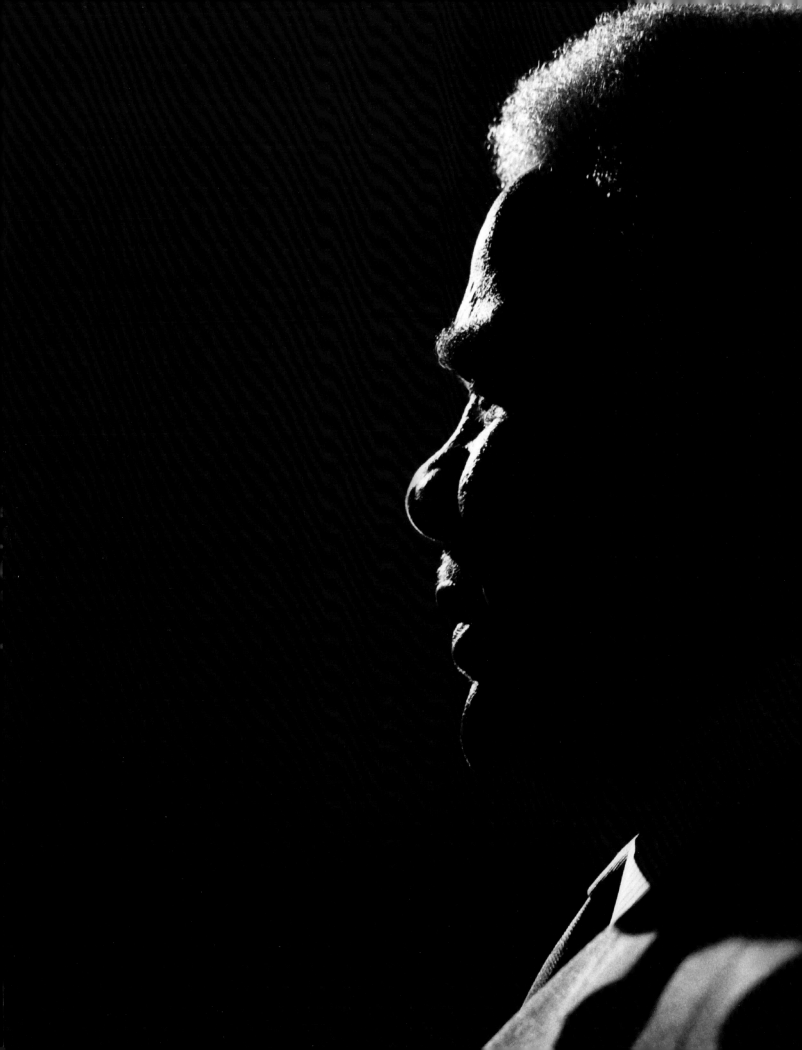

Barack Obama

The day before Thanksgiving, Harold Washington died.

It occurred without warning. Only a few months earlier, Harold had won reelection, handily beating Vrdolyak and Byrne, breaking the deadlock that had prevailed in the city for the previous four years. He had run a cautious campaign this time out, professionally managed, without any of the fervor of 1983; a campaign of consolidation, of balanced budgets and public works. He reached out to some of the old-time Machine politicians, the Irish and the Poles, ready to make peace. The business community sent him their checks, resigned to his presence. So secure was his power that rumblings of discontent had finally surfaced within his own base, among black nationalists upset with his willingness to cut whites and Hispanics into the action, among activists disappointed with his failure to tackle poverty head-on, and among people who preferred the dream to the reality, impotence to compromise.

Harold didn't pay such critics much attention. He saw no reason to take any big risks, no reason to hurry. He said he'd be mayor for the next twenty years.

And then death: sudden, simple, final, almost ridiculous in its ordinariness, the heart of an overweight man giving way.

It rained that weekend, cold and steady. In the neighborhood, the streets were silent. Indoors and outside, people cried. The black radio stations replayed Harold's speeches, hour after hour, trying to summon the dead. At City Hall, the lines wound around several blocks as mourners visited the body, lying in state. Everywhere black people appeared dazed, stricken, uncertain of direction, frightened of the future.

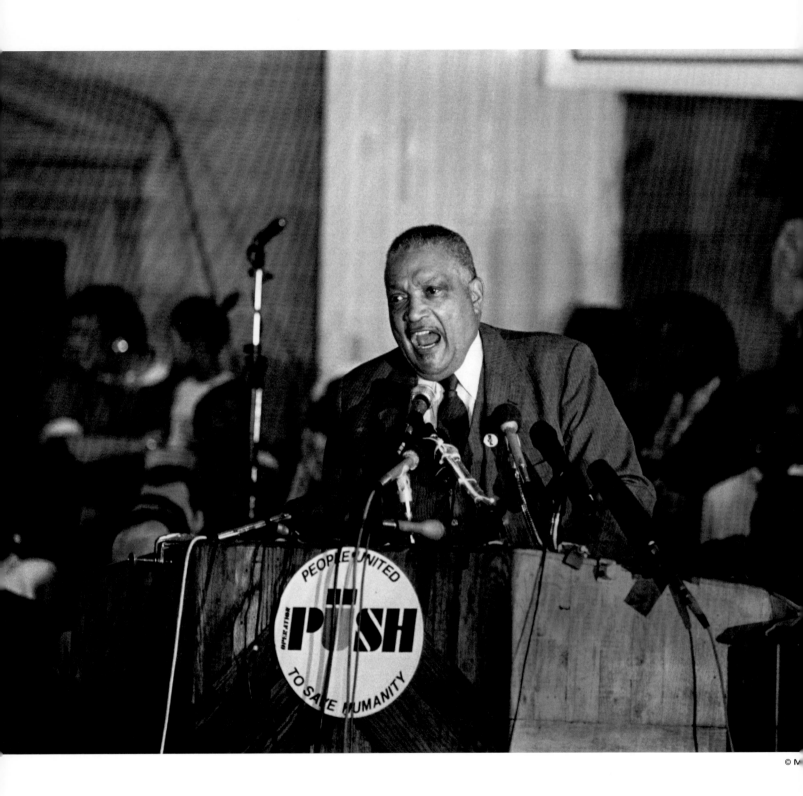

204 **Harold!**

Fearful that some black aldermen might endorse the opposition's choice, the Washington coalition mobilized supporters to descend on the council meeting in support of Alderman Timothy Evans.

Those resurgent divisions were on full display during a tumultuous December 1 city council session called to pick Washington's successor. The formula for the chaos was prepared by members of the opposition bloc by slating Eugene Sawyer, a black alderman, as their choice to complete Washington's term. Anticipating this gambit and fearful that some other black aldermen might endorse the opposition's choice, members of the Washington coalition mobilized thousands of supporters at a meeting the day following his funeral to descend on the city council meeting in support of Alderman Timothy Evans. Evans was Washington's former floor leader and the black community's overwhelming choice for successor.

Left: U.S. representative Charles Hayes, who succeeded Washington as congressman for the First District, addresses a meeting at Operation PUSH a few days after the mayor's death aimed at holding together the Washington coalition. *Overleaf:* Thousands besieged the city council session at which the mayor's successor was to be chosen. The raucous meeting, televised live, lasted into the early-morning hours of Wednesday, December 2. (Photograph © MP)

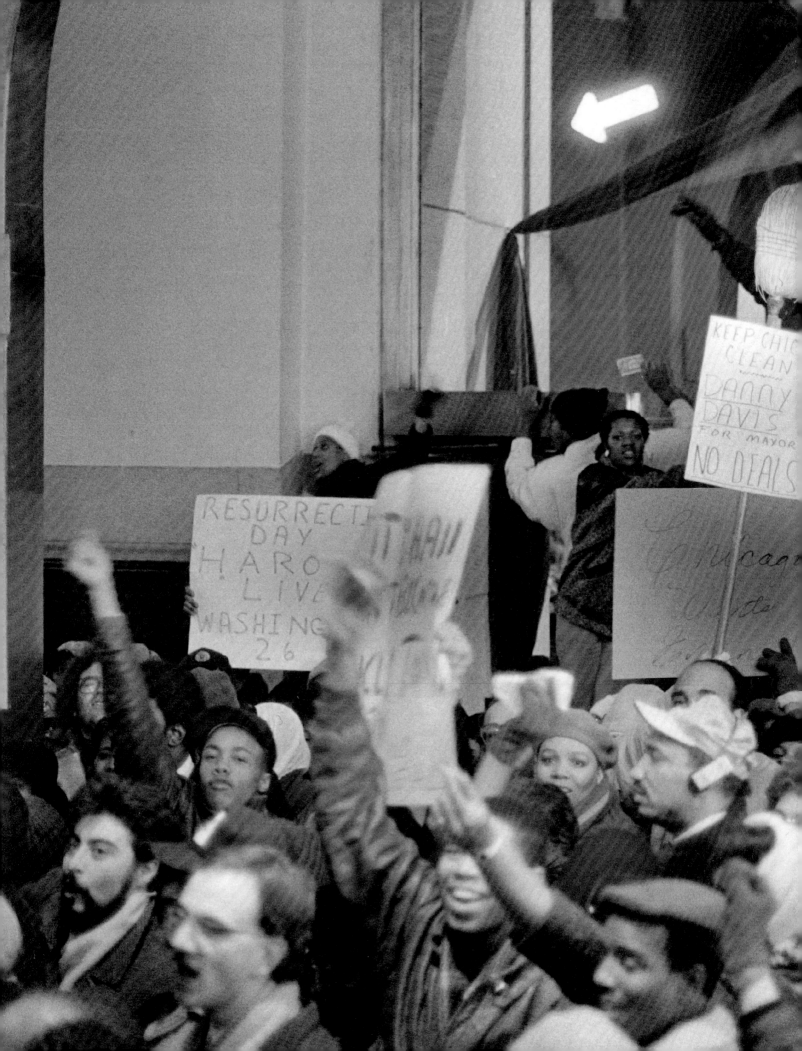

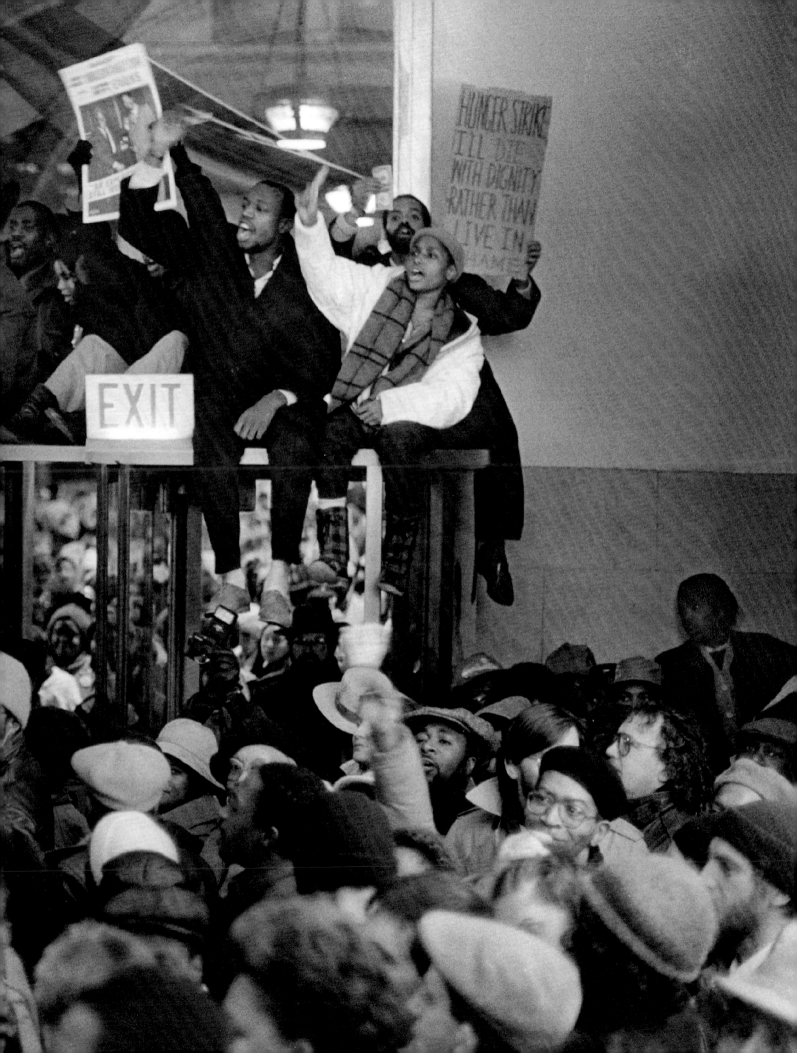

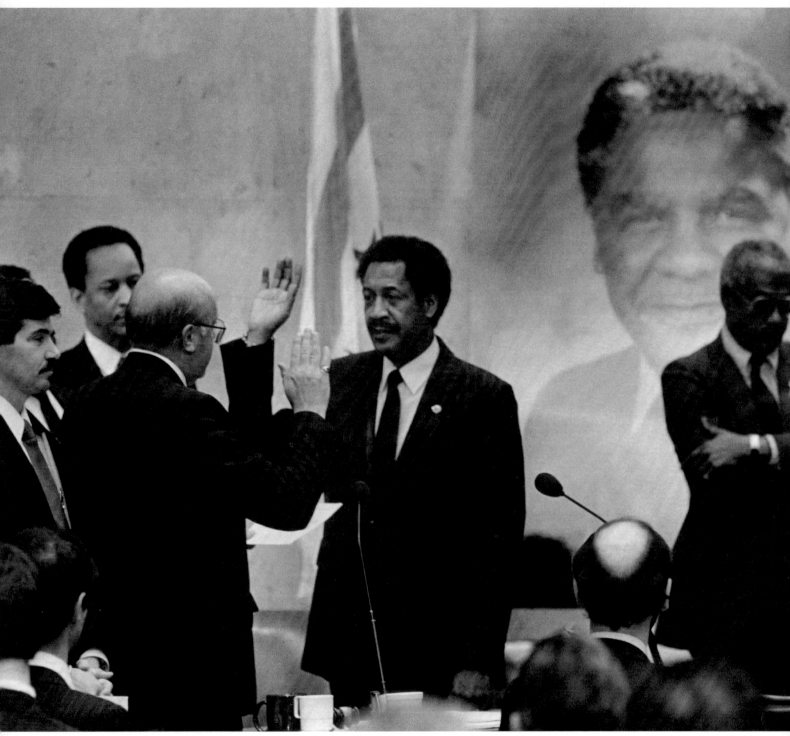

208 **Harold!**

As the council conducted the vote for Alderman Sawyer, a massive crowd gathered outside City Hall demanding Evans's selection. The marathon session, carried live on local television, featured many colorful speeches and dramatic gestures. Sawyer was elected by a vote of twenty-nine to nineteen at four o'clock in the morning. Following Sawyer's election, the Washington movement split into two mutually destructive factions and has never been revived—despite the emergence of political formations using the name, such as the Harold Washington Party.

Richard M. Daley, the son of the original, revived the moribund machine, and it has been chugging along for nearly twenty years.

With every passing year it's clearer that Washington was a brilliant political light who blazed too briefly across a firmament more accustomed to darkness.

Opposite: Alderman Eugene Sawyer takes the oath of office as acting mayor on December 2.

BIBLIOGRAPHY

Carlyle, Thomas. *On Heroes, Hero-Worship, the Heroic in History.* London: J. Fraser, 1841.

"Chicago, Illinois." In *Compton's Encyclopedia and Fact-Index.* Chicago: Compton's Learning, 1994.

Fremon, David K. *Chicago Politics, Ward by Ward.* Bloomington: Indiana University Press, 1988.

Grimshaw, William J. *Bitter Fruit: Black Politics and the Chicago Machine, 1931–1991.* Chicago: University of Chicago Press, 1992.

Grossman, James R. *Land of Hope: Chicago, Black Southerners, and the Great Migration.* Chicago: University of Chicago Press, 1989.

Grossman, James R., Ann Durkin Keating, and Janice L. Reiff, eds. *The Encyclopedia of Chicago.* Chicago: University of Chicago Press, 2004.

"Harold." *This American Life.* WBEZ-FM Chicago, November 21, 1997.

"History of Chicago from Trading Post to Metropolis." Roosevelt University External Studies Program. http://www.roosevelt.edu/externalstudies/default.htm.

Holli, Melvin G., and Paul M. Green, eds. *The Making of the Mayor: Chicago, 1983.* Grand Rapids, Mich.: Eerdmans, 1984.

Kleppner, Paul. *Chicago Divided: The Making of a Black Mayor.* DeKalb: Northern Illinois University Press, 1985.

Miller, Alton. *Harold Washington: The Mayor, the Man.* Chicago: Bonus Books, 1989.

———, ed. *Climbing a Great Mountain: Selected Speeches of Mayor Harold Washington.* Chicago: Bonus Books, 1988.

Muwakkil, Salim. "Harold Washington's Fractured Legacy." *In These Times,* June 1988.

———. "Mr. Washington Goes to Washington." *Chicago Reader,* May 8, 1981.

Obama, Barack. *Dreams from My Father: A Story of Race and Inheritance.* New York: Three Rivers Press, 2004.

Rivlin, Gary. *Fire on the Prairie: Chicago's Harold Washington and the Politics of Race.* New York: Henry Holt, 1992.

Travis, Dempsey. *The Autobiography of Black Chicago.* Chicago: Urban Research, 1981.

———. *"Harold": The People's Mayor.* Chicago: Urban Research, 1989.